Discovery of Scotland

The Appreciation of Scottish Scenery through Two Centuries of Painting

James Holloway
Lindsay Errington

NATIONAL GALLERY OF SCOTLAND

Cover: Horatio McCulloch (1805-67) **Glencoe** (detail) Glasgow City Art Gallery

ISBN 0 903148 18 8

Contents

1. Recording the Scene 1

2. The Country Seat 13

3. Decorative Painting 23

4. Paul Sandby and Scotland 33

5. The Falls of Clyde 47

6. Landscape of Fact and Fancy 57

7. Provincial and Border Antiquities: The Lothians and the Esk 71

8. Provincial and Border Antiquities: The Borders and Tweed 87

9. The Mountain and the Flood 103

10. Truth of Foreground 119

11. Village, Kailyard and Pastoral 137

12. Change and Decay 153

List of Lenders 167

Topographical Index 169

Foreword

When I stand at the lochside and admire the view, the hills lie in front of me, but generations of artists—writers and painters—lie behind me. The long cultural tradition that we have inherited has formed our ideas of what we should look at and how we should look at it. We cannot escape its influence, but we can learn about it. When did people begin to think that the scenery of Scotland was worth looking at, what did they look for, and where in Scotland did they find it? These are the first questions this exhibition sets out to answer. It goes on to explore how the idea of the natural beauty of Scottish scenery changed from one generation to the next. Of course it is landscape painters who show us these differences most clearly, and each of the pictures included here has been chosen with this specific intention in mind.

The exhibition examines an important seam of the history of visual ideas. It had been lying about for some years waiting for the people who had the perceptiveness and appetite for research that were needed to make a solid reality of it. They are James Holloway, Assistant to the Keeper of Prints and Drawings, who was responsible for the first six sections of the exhibition and Dr Lindsay Errington, Research Assistant (British Art) who was responsible for the last six sections.

They have relied on help from many people, first of all from the staff of the Galleries, especially Miss Sara Stevenson, Research Assistant in the Print Room of the Scottish National Portrait Gallery, and John Dick, the Conservation Officer. They would also like me to thank on their behalf Iain McIvor, Miss Catherine Cruft, Mrs Yolande O'Donoghue, Dr A. A. Tait, Dr Avril Lysaght, Miss Ierne Grant, Geoffrey Bertram, and especially Richard Emerson.

An exhibition of this kind, where particular pictures are needed and often none other will do, relies heavily on the willingness of owners to lend. Hardly any work we asked for was refused, either from public collections or from private people. There was no way we could have put on the exhibition without their co-operation, and we wish to record our great indebtedness to Her Majesty The Queen and all other lenders.

Colin Thompson
Director

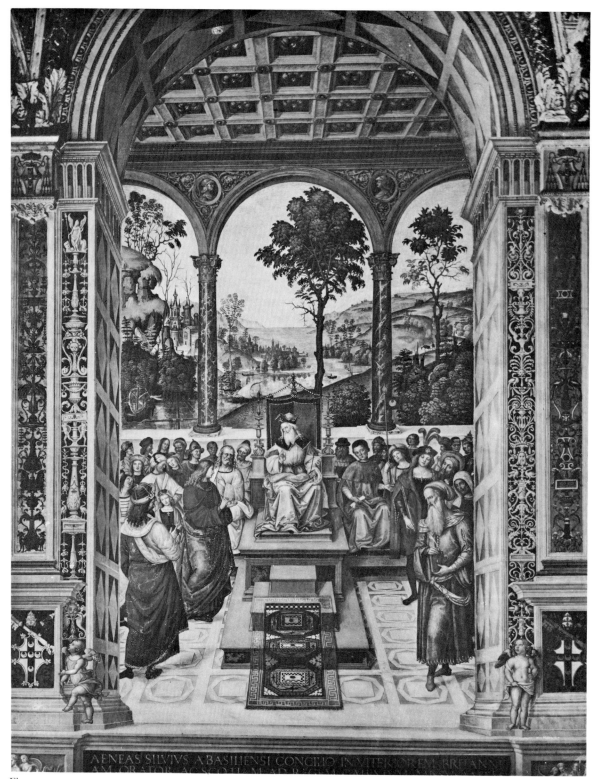

Fig. 1
BERNARDINO PINTURICCHIO
Aeneas Piccolomini at the court of King James I
Siena Cathedral, Piccolomini Library

1

Recording the Scene

In 1435 a young Italian was sent to Scotland on a diplomatic mission. His name was Aeneas Sylvius Piccolomini, later to become Pope Pius II. At the end of the fifteenth century his nephew built a library attached to the Cathedral of Siena and Pinturicchio was commissioned to decorate the walls of the library with episodes from the life of the Pope.

One of the frescoes shows Aeneas at the court of King James I. In the background is the first painted representation of the Scottish landscape (fig 1). Of course neither Pinturicchio nor his assistant the young Raphael had ever been to Scotland. What they painted was imaginary but imagination that must have had some factual foundation. Some idea of what Scotland was like would have reached Italy through the accounts of pilgrims on their way to Rome or from merchants sailing from Leith to Leghorn with cargoes of hides and pearls. What Pinturicchio painted, a land of castles, hills and water, was what a European of the Renaissance believed Scotland to be like.

Pinturicchio's image of Scotland is not the same as ours today nor would it have been shared by someone from the seventeenth, eighteenth or nineteenth centuries. It is not just that the look of the landscape has changed in five hundred years. The way we look at landscape has changed too, and this is just as subject to the whim of fashion as dress, language or social custom.

The first artists to paint the countryside of Scotland on the spot were not Scots but men from the Low Countries. Their way of depicting the Scottish landscape was conditioned by the conventions that they had learnt painting their own, very different countryside, a land-scape with low hills and wide vistas. The earliest surviving landscape actually painted in Scotland was done by an Antwerp artist, Alexander Keirincx. Some time in the 1630s he made at least ten views of royal residences and towns only one of which is known today. This is the painting of Falkland Palace (pl i). Keirincx's view was taken from a hill above the town of Falkland and his wide angle takes in a great extent of country. The Howe of Fife unfolds rather like a map, and like a map the painting is an accurate record of the palace buildings and surrounding country. It is a record, not an impression of a place and its value to King Charles I, for whom it was painted, was in its topographical exactness.

The same concern with accuracy character-ises the set of engravings, published as the *Theatrum Scotiae*, made by another Netherlandish artist working at the end of the seventeenth century. John Slezer and his draughtsmen visited the great houses and burghs of the country sketching them in most cases for the first time (fig 2). Jan Wyck's view of Hamilton (fig 3) was one of these drawings made for Slezer's book but although it was drawn about sixty years after Keirincx's painting of Falkland it is not very different. The two views share the same high vantage point and the same wide angle of vision. Both the landscape and the town are seen from a distance.

Only a few landscapes were painted in Scotland before the middle of the eighteenth century and those few were mainly panoramas or views of individual houses. The great pan-orama of Edinburgh made in the 1750s or early 1760s is one of the best of these (fig 4). What a pity though that Canaletto, the finest

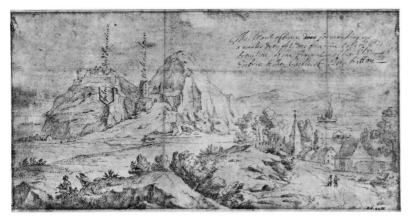

Fig. 2
JOHN SLEZER
Dumbarton Castle
no. 1.4

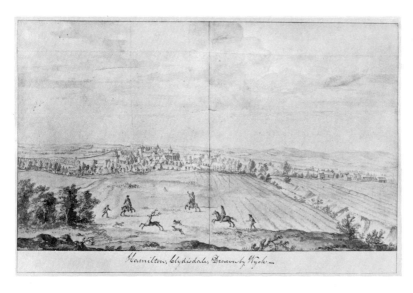

Fig 3
JAN WYCK
Hamilton
no. 1.5

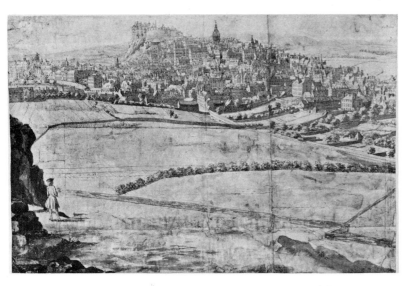

Fig. 4
ANON. circa 1750
Panorama of Edinburgh, detail
no. 1.7

of all townscape artists, was never commissioned to paint the silhouette of the capital from Arthur's Seat. He was in Northumberland in the early 1750s.

The mountains of Scotland were never painted before the middle of the eighteenth century. Where possible they were avoided. When it was necessary to cross them travellers viewed the scenery with the greatest distaste. Defoe visited Scotland in the mid 1720s and wrote of Drumlanrig (fig 40) that it 'is like a fine Picture in a dirty Grotto, or like an Equestrian statue set up in a Barn; 'tis environ'd with Mountains, and that of the wildest and most hideous Aspect in all the South of Scotland'.[1] This was not just an English point of view: Sir John Clerk of Penicuik making a tour of northern Scotland in 1739 felt the same about the Grampians 'From Dalwhinny, about 10 or 12 miles we came to Riven [Ruthen, near Kingussie] in Badenoch. By the way all along from the

Fig 5
ALEXANDER RUNCIMAN
View in East Lothian
no. 1.9

Blair to this place I cou'd see nothing but a barbarous tract of mountains on both hands and scarse a stalk of grass to be seen. Neither were there fowls or birds of any kind to entertain our views as in other places southward. We saw snow in many places and were told that it always continues.'[2]

Edinburgh, as the capital and largest town in Scotland, was the cultural centre of the country during the eighteenth century. And it was in Edinburgh during the 1760s that a group of young artists responded to their local landscape with a directness and freshness not to be found in any of the earlier more formal views. The group included Alexander

3

Runciman, Jacob More and John Clerk and the sort of places that they chose to sketch were not the standard house and town views favoured by the earlier foreign artists but parts of the countryside of the Lothians around Edinburgh. Alexander Runciman's set of watercolours painted in East Lothian capture the feel of the undulating cultivated landscape of the county rather than illustrate particular views (fig 5). Similarly Jacob More's drawings made in the vicinity of St Anthony's Chapel were not done to record architectural features or the precise outline of Salisbury Crags but as experiments in light and shadow, showing his interest in the texture of surfaces. More compiled a book of local views which he took with him on leaving Scotland for Rome in 1773.[3] John Clerk too made numerous drawings of the landscape around Edinburgh.

Runciman, More and Clerk all etched as well as drew (fig 8).[4] Clerk was in fact the most prolific etcher of the century and he wrote a description of his working methods:

'At the age of forty five years, [1773] when I began I could never expect to arrive at any degree of merit in ye art, but having for a long time been in the practice of making sketches and views from nature where ever I went, I had collected a great many drawings particularly such as take in a great extent of country. I was at last tempted after long and frequent importunity of virtuosi friends to attempt the same manner in etching which I had followed in drawing. However upon trial I was much discouraged not only with ye expected disapointments in managing the aquafortis, but with the incomprehensible difference I felt between giving the same effect, with white lines upon black ground, and that which I had done with black lines upon white ground—by which you must see I mean the bright trace of the point upon ye black grounded copper, compared with the black inky lines upon white paper—to get the better of this difficulty I have been led to make many trials which has produced so very many diminutive plates as unfortunately I have made. Also at this time from having very strong eyes for the nearest objects as well as for the most distant, I was driven to make use of spectacles which brought me to a confined manner of etching very unlike ye drawings which are all large and few lines expressing a great deal—living in the country I am obliged to go thro ye drudgery of not only preparing my plates, but of taking or *pulling off* the impressions myself having a small press for that purpose, and lastly from want of skill both in myself and those of this country my plates are foul and full of scratches, as you must perceive.'[5]

John Clerk was rich enough not to need to sell his etchings and drawings. He was the son of the same Sir John Clerk who had toured the north of Scotland in 1739 and he held a Government appointment as secretary to the Commissioners of Forfeited Estates. In his old age he was described by Lord Cockburn as 'an interesting and delightful old man, full of the peculiarities that distinguish that whole family—talent, caprice, obstinacy, worth, kindness and oddity; a striking looking old gentleman, with grizzly hair, vigorous features and Scotch speech.'

It was not just in Edinburgh that during the 1760s and 1770s artists were beginning to show interest in their local scenery. David Allan who was born in Alloa painted many views in Clackmannan and Stirlingshire (fig 9). Instead of serving an apprenticeship to Robert Norie in Edinburgh, as both Jacob More and Alexander Runciman had done, he was sent by his patrons, the Cathcarts of Schawfield, to study at the Foulis Academy in Glasgow. The Academy had been founded by Robert Foulis in 1754 with the purpose of training and educating professional artists. Young gentlemen like Charles Cordiner and Lord Buchan, the founder of the Society of Antiquaries of Scotland, studied there and Allan, who started at the Academy in 1755, would have made the acquaintance of future patrons as well as fellow artists. Instruction was given in landscape drawing and although this may have meant that students were set to copy sixteenth and seventeenth-century landscape prints rather than taught to sketch on

Fig. 6
ALEXANDER RUNCIMAN
The Bass Rock
no. 1.10

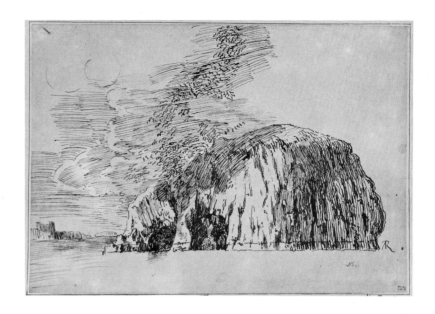

Fig 7
JOHN RUNCIMAN
Bothwell Castle
no. 1.12

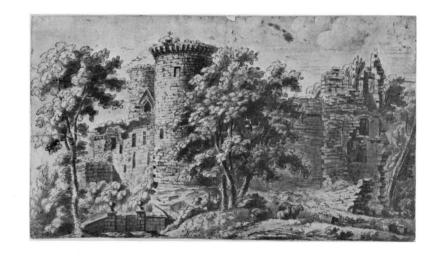

Fig. 8
JOHN CLERK
Carsewell
no. 1.15

5

the spot, it shows that the study of landscape was thought to be beneficial to students. Allan almost certainly did sketch the city of Glasgow and its neighbourhood as a student and only two years after he had left the Foulis Academy he made a finished drawing of a fair at Rutherglen. Charles Cordiner and another Foulis student, Robert Paul (fig 10), also made local views. Paul engraved several of Cordiner's drawings of Bothwell and Crookston Castles, and drew and engraved over twenty views in the west of Scotland. When Cordiner moved to Banff, to become the Episcopal minister there, he was one of very few men in the North East who was able to draw landscape views and his talents were in demand from English antiquaries and local landowners. Similarly Archibald Rutherford, the drawing master at the Academy in Perth, made many views of the city and county.

Although these artists explored their local scenery they naturally did not turn a blind

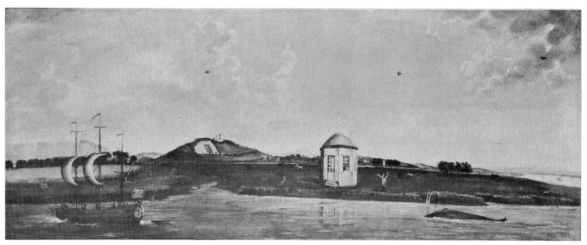

Fig 9
DAVID ALLAN
The River Forth at Alloa
no. 1.16

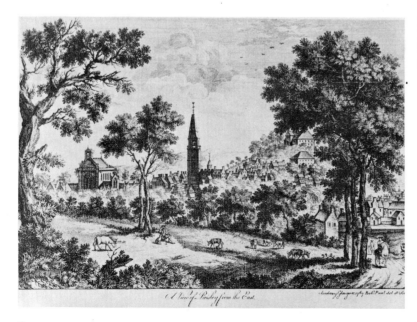

A View of Paisley from the East.

Fig. 10
ROBERT PAUL
Paisley
no. 1.17

eye to landscape elsewhere. Professional artists had to paint what their patrons chose. For Alexander Runciman this meant a journey to Inverness-shire to record the recently completed Fort George at Ardiseer for its architect William Skinner. Other patrons may have asked him to visit Ayrshire, Dumfriesshire and the Borders for Runciman is known to have made views of Lochmaben and the Abbeys of Kilwinning, Kelso, Jedburgh and Dryburgh.[6]

English artists in comparison with their Scottish counterparts were at a disadvantage. Living so far away they had no opportunity to take regular commissions or build up a clientele although some Englishmen made lengthy Scottish tours making pencil landscape studies in anticipation of future commissions. This had its drawbacks as William Tomkins found. He visited Sir James Grant of Grant in the late 1760s and made twenty four preparatory sketches on and around his estates in

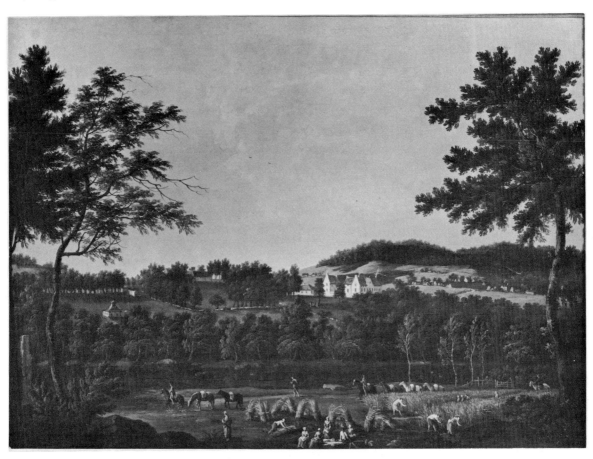

Fig 11
WILLIAM TOMKINS
Rothiemay House
no. 1.21

Strathspey. But ten years later Tomkins had still not received instruction to work up his sketches and his letters to Sir James show how worried the artist was that his patron might decide to downgrade the prospective commission and order watercolours instead of oils.

'They cannot have that forse of coulering in water as in oyl because of expressing the fine falls of water etc that make me recommend to you to have them in oyl coulers. I

7

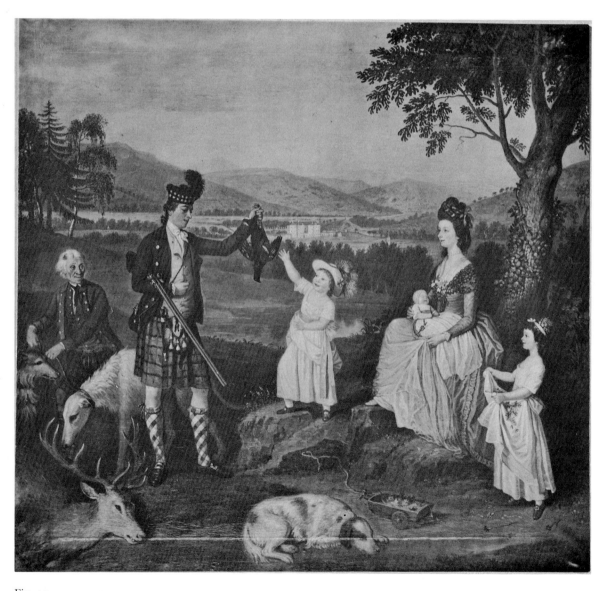

Fig. 12
DAVID ALLAN
The 4th Duke of Atholl and family
no. 1.22

will charge you no more for the one than for the other. I will also do them quite reasonable as I should take delight in painting of them. I only should take it as very great favour to lett me send these two for to show you and also to lett me know how to send them safe into your hands that you may see what sweet pictures they make they will pack up in a very small compass as ye size is 20 inch by 14 inch. They are quite finishd. On view is Invercauld on Spayside the other is Cragaliche looking toward Carngorm hills. I will send the price with picture because then you will be a better judge about the work and see ye difference between water and oyl—one little pair of picture will not hurt you nor me. I only want you to see them then I shall be contend and leave the rest to providence. One thing I must say that since they have been finish everybody like them and say what sweet places thier is in Scotland.'[7]

There was no difference in style between English and Scottish artists at the end of the eighteenth century. There was no difference of approach, or particular empathy with their native landscape, that made the Scots more successful than their English rivals. It was a matter of patronage. David Allan and Alexander Nasmyth had over many years been building up a clientele that no outsider could hope to storm (fig 12). That is why Farington was so jealous of Nasmyth's position in Edinburgh at the turn of the century. He knew that his own precise factual landscapes (fig 13) were the equal of Nasmyth's (fig 14) and would have suited Nasmyth's patrons equally well. What they wanted and what late eighteenth century landscape painters provided were accurate portraits of houses or estates not very different to the views of the Netherlandish artists of the previous century. Nasmyth and Farington were the last painters of that old tradition; their successors were to look at landscape quite differently. They were to do so because of the great changes in the appreciation of landscape that took place in the eighteenth and nineteenth centuries.

(1) D Defoe. *A tour thro' the whole island of Great Britain* published 1724–6. Reprinted by F Cass 1968 p 727.
(2) Sir John Clerk's comments are from an unpublished 'Trip to the north of Scotland as far as Inverness in May 1739'. Register House, Edinburgh GD 18/2110.
(3) There is a reference to More's book of drawings in a letter from George Paton to Richard Gough of 30/9/1779 National Library of Scotland MS29.5.7 (iii) fol 57.
(4) For evidence of More as a printmaker see a letter from George Paton to Richard Gough of 17/3/1772 National Library of Scotland MS29.5.7 (i) fol 39.
(5) For the full text of Clerk's hitherto unpublished letter see National Library of Scotland MS29.5.7 (iii) fol 32 + v + 33r.
(6) For a list of Alexander Runciman's landscape paintings see National Library of Scotland MS29.5.77 (iii).
(7) Tomkins' letter to Sir James Grant is in Register House, Edinburgh GD248/227/3.

Fig 13
JOSEPH FARINGTON
Loch Lomond
no. 1.26

Fig. 14
ALEXANDER NASMYTH
Edinburgh from the Dean Village
no. 1.28

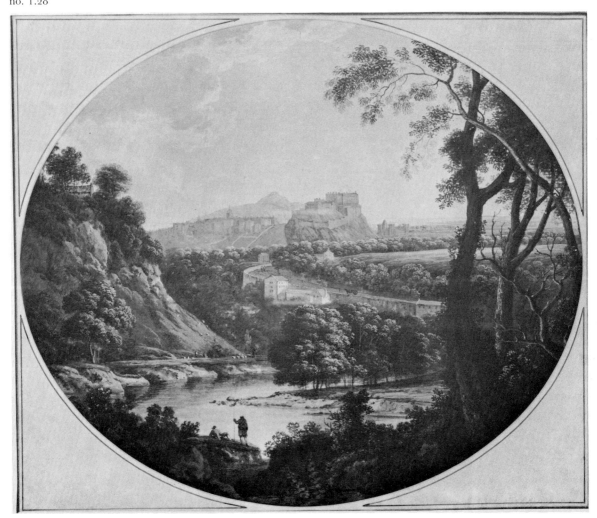

ALEXANDER KEIRINCX 1600–1652
1.1 **Falkland Palace and the Howe of Fife** pl i
Oil on panel. 45.6 × 68.6 cm
This view was painted in the 1630s for King Charles I.
That it was painted on the spot is known from an early
inventory and its topographical exactness
Lent by the Scottish National Portrait Gallery

JOHN SLEZER 1645–1717
1.2 **Musselburgh, East Lothian**
Pen and greywash 19.1 × 43.3 cm.
This drawing and the view of Dumbarton Castle
(no. 1.4) are attributed to Slezer whose book the *Theatrum
Scotiae* was the first set of views of Scotland ever
published
Lent by Keith Adam, Esq

JAN VAN DEN AVELE after JOHN SLEZER
1.3 **The coast of Lothian from Stony Hill**
Engraving. 26.7 × 42.0 cm
This print was made after 1.2 and published in Slezer's
Theatrum Scotiae in 1693
National Gallery of Scotland

JOHN SLEZER
1.4 **Dumbarton Castle** fig 2
Pen. 20.2 × 39.5 cm
Inscribed by the artist 'The want of time for maiking up
a neater drought does force me to send this Brouillon of
the prospect of the old Entrie to the Castle of
Dunbritton'
National Gallery of Scotland

JAN WYCK c1645–1700
1.5 **Hamilton, Lanarkshire** fig 3
Pen and wash over pencil. 24.1 × 42.0 cm
Wyck's view of Hamilton was engraved in Slezer's
Theatrum Scotiae
Lent by the visitors of the Ashmolean Museum, Oxford

GREGORY SHARPE 1713–1771
1.6 **Panorama of Aberdeen**
Pen. 32.5 × 142.0 cm
Inscribed: *East Prospect of Aberdeen by Gregory Sharpe 1732*
Sharpe, a theologian, was a native of Yorkshire. He
lived in Aberdeen from 1731–1735
National Gallery of Scotland

ANONYMOUS (MID EIGHTEENTH CENTURY)
1.7 **Panorama of Edinburgh** detail fig 4
Pen and grey wash. Approx 30.0 × 135.0 cm
Indistinctly inscribed: *S and N Buck*
The old attribution to the Buck brothers may not be
correct. They are not known to have visited Scotland.
Thomas Sandby, who was in Edinburgh in the late
1740s is a more likely artist. The date of the drawing
can be fixed between 1748 and 1764 by the buildings
represented.
National Gallery of Scotland

ALEXANDER RUNCIMAN 1736–1785
1.8 **View in East Lothian with the Firth of Forth**
Pen and watercolour. 18.9 × 32.5 cm
Runciman, More and Clerk made many drawings in the
countryside around Edinburgh. They were less interested
in recording buildings and towns than capturing the
general feel of the landscape
National Gallery of Scotland

ALEXANDER RUNCIMAN
1.9 **View in East Lothian** fig 5
Pen and watercolour. 19.5 × 32.5 cm
National Gallery of Scotland

ALEXANDER RUNCIMAN
1.10 **The Bass Rock, East Lothian** fig 6
Pen. 24.4 × 36.0 cm
Signed: *A.R.*
National Gallery of Scotland

J. COWAN after ALEXANDER RUNCIMAN
1.11 **Blackness Castle, West Lothian**
Proof engraving with pen additions. 24.4 × 35.8 cm
This print was dedicated to the Hon Charles Hope
Weir, Governor of the Castle
National Gallery of Scotland

JOHN RUNCIMAN 1744–1776
1.12 **Bothwell Castle, Lanarkshire** fig 7
Pen and brown wash. 16.9 × 30.8 cm
National Gallery of Scotland

JACOB MORE 1740–1793
1.13 **St Anthony's Chapel, Edinburgh**
Pencil and brown wash. 23.5 × 37.5 cm
Signed: *Jacob More f*
National Gallery of Scotland

JOHN CLERK 1728–1812
1.14 **Dunfermline, Fife**
Etching. 10.0 × 15.7 cm
Inscribed: *Dunfermline J. Clerk 72*
Although Clerk had been sketching for many years he
did not begin to make prints until the early 1770s. This
is one of his earliest works
National Gallery of Scotland

JOHN CLERK
1.15 **Carsewell, Midlothian** fig 8
Etching. 10.2 × 24.9 cm
Inscribed: *Farm House of Kerse Well 1778*
Carsewell is still a farm on the Clerk estate very close to
Penicuik House, John Clerk's home
National Gallery of Scotland

DAVID ALLAN 1744–1796

1.16 **The river Forth at Alloa, Clackmannan** fig 9
Oil on canvas. 53.8 × 133.0 cm
Allan is known to have painted several oils described as 'neither landscapes nor sea pieces, but composed of both. Harbours or headlands with shipping. These were painted above forty years ago, in Glasgow.... They have merit, and colouring preferable to the work of his latter days, for I thought his tints, latterly, were frigid and cold.' The Scot's Magazine December 1804 p 912
Lent by The Rt Hon The Earl of Mar and Kellie

ROBERT PAUL 1739–1770

1.17 **Paisley, Renfrewshire** fig 10
Engraving. 23.8 × 32.1 cm
Inscribed: *A view of Paisley from the east. Academy Glasgow 1767 Robt Paul del et Sculp*
Lent by Baillie's Library, Glasgow

ROBERT PAUL

1.18 **Port Glasgow, Renfrewshire**
Engraving. 34.5 × 68.0 cm
Inscribed: *A view of Port Glasgow from the south east Academy Glasgow 1768. Robt Paul del et Sculpsit*
Like Allan and Cordiner Paul was a student at the Foulis Academy in Glasgow
Lent by Baillie's Library, Glasgow

CHARLES CORDINER 1746–1794

1.19 **The Bridge of Alvah, Banffshire**
Gouache. 30.5 × 47.0 cm
Signed: *C Cordiner delineavit 1774*
This is almost certainly the view commissioned by the Earl of Fife which was hanging in the hall of Rothiemay House by 1807
Lent by Paul Harris, Esq

ARCHIBALD RUTHERFORD 1743–1779

1.20 **Perth from the south**
Pen and wash heightened with white. 34.0 × 50.7 cm
Signed and dated: *A Rutherford del 1774 A view of Perth from the south*
This view and its pair of the city from the north were engraved by Picot in 1776
National Gallery of Scotland

WILLIAM TOMKINS Active 1761–1790

1.21 **Rothiemay House, Banffshire** fig 11
Oil on canvas. 41.5 × 59.5
Signed: *Wm Tomkins 1767*
This is one of 11 views that Tomkins painted· in Banffshire, Moray and Aberdeenshire for the Earl of Fife
Lent Anonymously

DAVID ALLAN

1.22 **The 4th Duke of Atholl and Family** fig 12
Oil on canvas 91.5 × 101.5 cm
The Cathcarts of Schawfield were Allan's first and most constant patrons. The commission for this portrait group of 1780 came from Lord Cathcart's eldest daughter Jane, the Duchess of Atholl
Lent by His Grace the Duke of Atholl

ALEXANDER CARSE c1770–1843

1.23 **South view of Leith, Midlothian**
Pen and watercolour. 41.7 × 57.3 cm
Signed: *A Carse delint*
Carse was the apprentice and assistant of David Allan and as such he copied his master's drawings and coloured his master's prints
National Gallery of Scotland

HUGH W WILLIAMS 1773–1829

1.24 **Glasgow Cathedral**
Pen and watercolour. 27.8 × 38.0 cm
Signed: *H. W. Williams Delt*
National Gallery of Scotland

ARCHIBALD ROBERTSON 1748–1788

1.25 **Dumbarton Castle**
Watercolour. 30.0 × 41.6 cm
Although this is very much more sophisticated a work than Slezer's view (1.4) it is the same type of careful factual record
Lent by the visitors of the Ashmolean Musem, Oxford

JOSEPH FARINGTON 1747–1821

1.26 **Loch Lomond** fig 13
Pen, pencil and watercolour. 48.0 × 85.3 cm
Signed: *Joseph Farington* and inscribed *Loch Lomond from the hill above Luss October 5th 1788*
This view was one of a number Farington made for a projected but never published volume entitled 'Picturesque scenery of Scotland'
Lent by the Walker Art Gallery, Liverpool

EDWARD DAYES 1763–1804

1.27 **St Machar's Cathedral, Aberdeen**
Pen and watercolour. 16.6 × 21.6 cm
Dayes is not known to have visited Scotland. He based his watercolour views on drawings made by the antiquary James Moore. Moore drew Aberdeen Cathedral in September 1792. Another version of this watercolour is in the Fitzwilliam Museum, Cambridge. The view was engraved by Lizars.
National Gallery of Scotland

ALEXANDER NASMYTH 1758–1840

1.28 **Edinburgh from the Dean Village** fig 14
Gouache. 35.6 × 41.6 cm. Oval
Nasmyth made at least three similar oval views of the city painted, presmably, from a single sketch
Lent by the Syndics of the Fitzwilliam Museum, Cambridge

2

The Country Seat

'Th' outstretching lake, embossomed 'mong the
 hills,
The eye with wonder and amazement fills:
The Tay, meand'ring sweet in infant pride
The palace rising on its verdant side,
The lawns wood fring'd in Nature's native taste
The hillocks, dropt in nature's careless haste,
The arches, striding o'er the new born stream,
The village, glitt'ring in the noon tide beam.'

from *'lines written with a pencil'* by Robert
Burns

When Robert Burns visited Perthshire in 1787
and composed his celebrated 'lines written
with a pencil over the chimney piece in the
parlour of the inn at Kenmore, Taymouth' he
described the landscape surrounding
Taymouth Castle as 'in Nature's native taste'
unaware, apparently, that much of the view
before him had been created only a gene-
ration earlier. Indeed there had already been
three quite different gardens surrounding the
house during the eighteenth century, each one
reflecting the taste of its period. What Burns
so much admired was the third garden on the
site, a creation of the early 1750s. These three
successive gardens at Taymouth reflect the
changing opinion on the relationship of a
country house to its surrounding landscape
between 1720 and 1770. Fifty years which saw
faster and more fundamental changes than
any other half century before or since.[1]

William Adam was probably the designer of
the first of these gardens which is known from
a plan of 1720 (fig 15). The most striking
feature of the design was its formality. The
lines of the avenues and walks are straight,
the gardens near the house are designed in
patterns. The importance of the house, the

seat of the Earls of Breadalbane, is accen-
tuated by the six great radial avenues which,
taking no account of the lie of the land,
traverse the landscape for a mile in each
direction, climbing a thousand feet from the
valley bottom to the summits of the hills on
either side.

The design of the garden ignores the natu-
ral features of the area, which would now
be considered as one of the most magnificent
in all Scotland. Even the River Tay appears
to have been thought of as more of an
inconvenience around which the formal gar-
dens were awkwardly arranged than a superb
natural asset to be exploited. William Adam's
garden was designed to shield the house, to be
an oasis of order and regularity in the wilder-
ness around.

No other paintings or drawings survive to
show the early eighteenth-century gardens in
their magnificence, but some idea can be
gained from a view that was almost certainly
painted by James Norie in 1733 (fig 16). An
entry in Lord Glenorchy's account book for
September 3rd 1733 lists a payment to 'a
painter at Edinburgh' of nine pounds 'for a
view of Taymouth and his going thither to
take it'. James Norie the elder would have
been almost the only choice of a local land-
scape painter in the early 1730s and com-
parison with other signed paintings by the
artist supports the attribution.

James Norie's painting was altered at the
end of the 1730s but under the darker blue/
green overpaint some of the features of William
Adam's 1720 garden can still be made out.
The three radial avenues running up the hill
behind the house are just visible, but the
foreground has been quite repainted. When

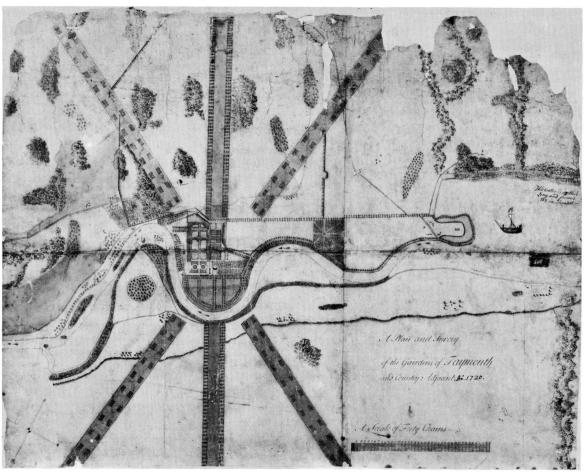

Fig 15
WILLIAM ADAM
Plan of the gardens at Taymouth 1720
no. 2.1

Fig 16
JAMES NORIE and JAN GRIFFIER II
Panorama of Taymouth and Loch Tay
no. 2.2

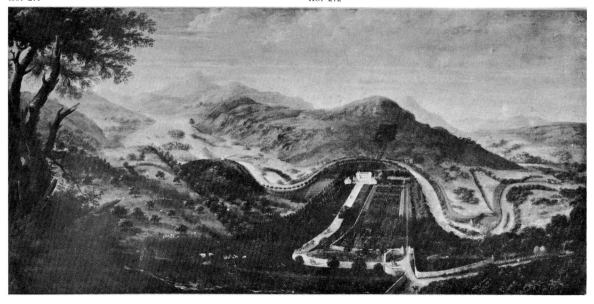

Norie made his view in 1733 the gardens were still such as William Adam had designed, but by 1739 when 'Greffier', probably Jan Griffier II, was paid for making changes to a view of Taymouth Adam's garden had been cut down and the second of the three Taymouth gardens had been planted to take its place.

The designer of the second garden is not known though it seems quite possible that William Adam again at least gave advice. Adam was primarily an architect and build-ing contractor and at some time between 1720 and 1733 designed and built the two wings flanking the main house. These additions necessitated the alteration of the two parterres on either side of the building which are shown clearly in the 1720 plan and Adam would have been on hand to re-landscape the area which was now planted much more simply than before.

All the other alterations to the 1720s garden were also made to simplify the design or

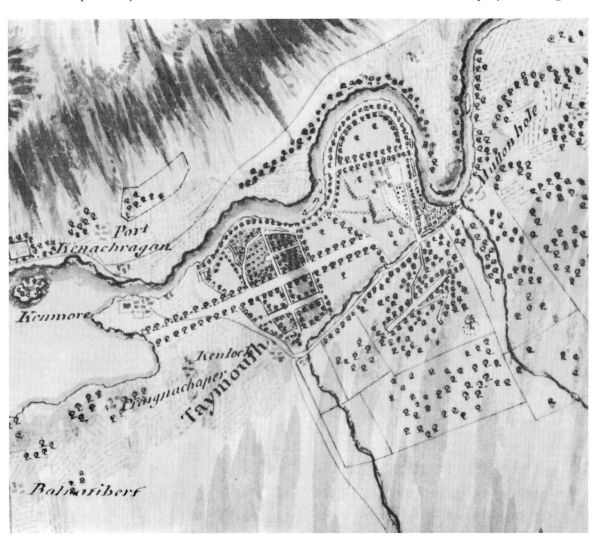

Fig 17
Taymouth from sheet 16 of the military survey of Scotland
no. 2.3

lessen the inconvenience of the formal layout. One of Griffier's alterations to Norie's painting was to shorten slightly the straight driveway leading up to the house. Previously it had started higher up the hill before turning and descending steeply towards the walled garden. The change must have been made for

convenience, to eliminate the awkward steep slope at the start of the final approach. At about the same time, that is between 1733 and 1739, the great radial avenues were cut down, at once reducing the size of the gardens and at the same time concentrating activity on the area to the south of the Tay, the area where the main innovations of the next two decades were to be made.

Most proprietors would have been satisfied by these changes but Lord Glenorchy's appe-

Fig 18
THOMAS WINTER
Plan of Taymouth 1754
no. 2.4

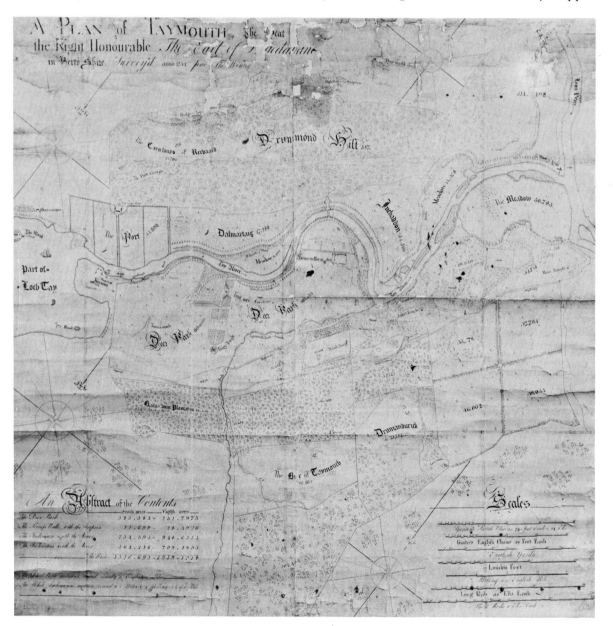

tite was merely whetted. He was a keen gardener and a keen visitor of gardens, in touch with the latest developments in England. He employed Bridgeman, one of the great landscape gardeners of the century, at his London house in Grosvenor Square. He probably employed another outstanding land-scape gardener, Switzer, at his wife's house in Staffordshire. However, the evidence suggests that the changes that were made at Taymouth during the 1740s and early 1750s were Lord Glenorchy's own.

In 1754 Thomas Winter surveyed the estate at Taymouth for Lord Glenorchy, or rather as

Fig 19 (*top*)
JOHN SANGER
Taymouth from the south
Kenmore Hotel, Perthshire

Fig 20 (*bottom*)
JOHN SANGER
Taymouth from the north
no. 2.5

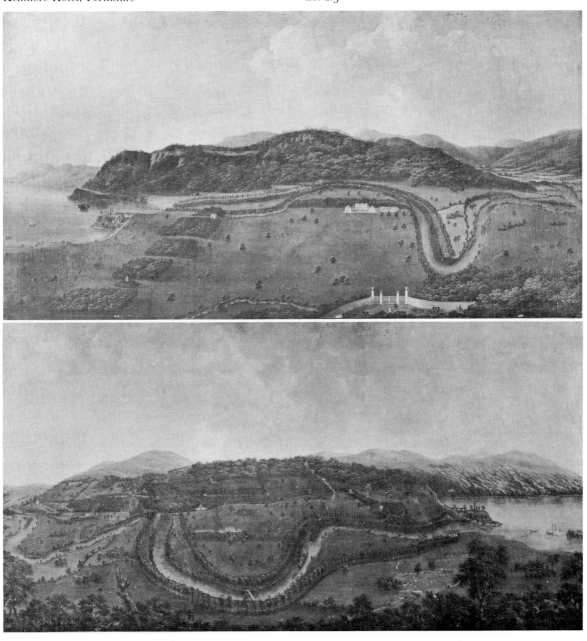

he had by then become, the third Earl of Breadalbane. Winter's plan (fig 18) shows how completely the gardens had been transformed in the fifteen years since 1739 when Griffier made his alterations to Norie's painting. Gone is the formal approach flanked on one side by a belt of trees and on the other by the walled garden. In its place is an English park. This park is best seen in a painting made in the mid 1750s. James Sanger painted two views of Taymouth for Lord Breadalbane, one from the north (pl ii and fig 20) the other from the south (fig 19). The latter was painted from the same spot that Norie had chosen only twenty years before; although the vantage point was the same the view was quite different.

The garden as it was surveyed by Winter and painted by Sanger was not created immediately but evolved over a number of years. In part it developed to satisfy the practical needs of Lord Breadalbane and his family. The driveway up to the house was a constant preoccupation and even after the realignment shown in Griffier's painting it was still far from satisfactory. The slope might have been eliminated but the coachmen still had to negotiate an awkward right angle turn. Once again early in the 1740s it was altered, the main gateway moved and part of the old walled garden was sacrificed to make the approach easier. The garden was also redesigned to satisfy the aesthetic needs of the Breadalbanes. Some time before 1750 a walk was constructed on the slopes of Kenmore Hill south of the Tay. Winter labelled it 'the surprise' for as one walked along from east to west a superb view of Loch Tay and Ben Lawers gradually unfolded. It is the first indication at Taymouth that the landscape beyond the bounds of the park was worthy of attention. Instead of the garden protecting the house from the wilderness outside, that wilderness was brought into the garden (fig 21).

The surprise walk is shown on the map made by the army after the Jacobite uprising of 1745 (fig 17). Kenmore and Taymouth were surveyed around 1749. In the 1715 uprising the Breadalbanes had supported the Jacobites and as a consequence their titles and fortunes had suffered. At the time of the '45

they came out in support of the House of Hanover, entertaining the Duke of Cumberland on his return from Culloden. Afterwards the family fortunes were strong enough for Lord Breadalbane to embark on another long and extensive campaign of landscape gardening.

Lord Breadalbane's gardening bills remained steady during the 1740s with regular annual payments of about £10 to the Edinburgh gardening firm Miller. During the early 1750s Miller's bills rose steeply so that in December 1754 Lord Breadalbane paid the firm almost £50. There were other bills too, 2000 chestnuts cost two pounds ten shillings, five guineas were paid for a box of American seeds. Six wheelbarrows at ten shillings and sixpence each were ordered from another Edinburgh gardening firm, Johnston of Jocks Lodge. The Earl followed the example of his neighbours. He paid ten shillings in 1751 for seeds from the gardener at Castle Menzies, the next large estate down the Tay. It was probably the example of the Duke of Atholl, another energetic gardener, that encouraged Lord Breadalbane to buy statues from John Cheere.

By the mid-1750s expense and activity had transformed the Taymouth gardens. In only a few years new walks, new avenues, a Chinese bridge, a small encampment of summer houses and temples had been introduced. All vestiges of the old formal layout were swept away—even what remained of the old walled garden, shrunk by the successive realignments of the driveway, was banished to a distant corner of the park.

Richard Pococke, Bishop of Meath, was impressed when he visited Taymouth in 1760 and he described in detail the layout of the pleasure grounds.

'The river winds and forms the shape of a Swan's neck, so that the house stands in a peninsula, the Isthmus of which is about half a mile broad: The house is near the East side of it, and behind it and the offices is a fine lawn of uneven ground adorned with single trees; to the west of it by the river is a broad walk finely planted which extends to within a quarter of a mile of the

mouth of it; and where it makes the greatest bow, a fine walk of lime trees of great size and meeting at top forms the string; towards the end of the walk on an eminence is a pleasant summer house commanding a view of the rich country to the east and of the Lake to the west, with the hills to the south of it highly cultivated, and at the end of the walk is a triangular mount for a turning Seat: on a mount to the South is an arched summer house; and on a long

passes to the village, and to a short way up the hill leading to the south: From this road there is a walk up the hill which leads to the west to the end of a broad walk with trees planted on each side and leading to the east, at the end of it is an open building with seats; This walk has the most retired and quiet look that I ever saw. From this there is a walk up the hill to a lawn in which there is a very large beech tree with a seat round it, that commands a fine view

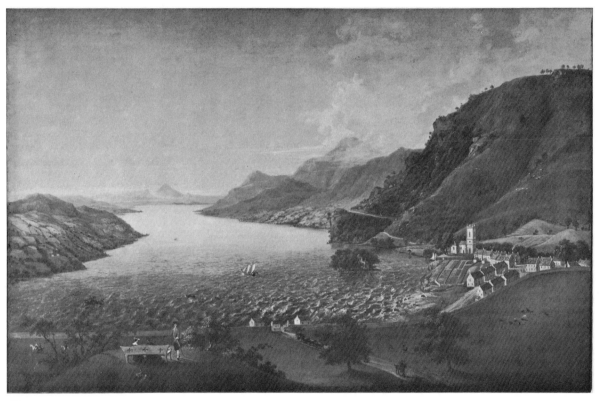

Fig 21
CHARLES STEUART
Loch Tay and Ben Lawers from the park at Taymouth
no. 2.6

mount nearer the village a fortification is designed as an object for prospect. On the other side upon a terrace is a beautiful broad walk, with a fine summer house at the west end and an open Cross house at the other just over the river at the south end of the Isthmus. This walk is 2800 yards long, the other taking in the string of the bow is 1900 yards in length. To the south of the lawn at the foot of the hill a road

to the west; From this lawn there is a narrow winding walk with several seats at proper distances leading to the round tower, the walls of which are about three feet thick, and the tower 18 in diameter, and there is a way up to the leads, the top being finished with Battlements; from which there is a very fine prospect to the West and North. From this height we descended to the North East to a seat called AEolus which affords the most pleasing prospect especially from the North: It is built with two square pillars of hewn stone supporting an angular pediment in front,

and it is open on both sides, except a little part which is closed for shelter to the Seat; and the trees are high behind it: From this we descended half a mile, passing mostly through fields to the Octagon Summer house on an Eminence, near which is a small Druid Temple, and to the west of it on the plain, a Kitchen Garden walled in of above four Scotch acres.'[2]

By 1760 Lord Breadalbane's gardening acti-

'The whole scene is capable of great improvement: but when we saw it, nothing like taste had been exercised upon it. The house was formerly a turreted castle, and is now by the addition of two wings, a large, convenient tho unpleasing mansion. The grounds around it were laid out with little beauty; and the walks were formal, and ill contrived; pacing under the paling of the park, instead of winding around, and taking such circuits as might shew the lake,

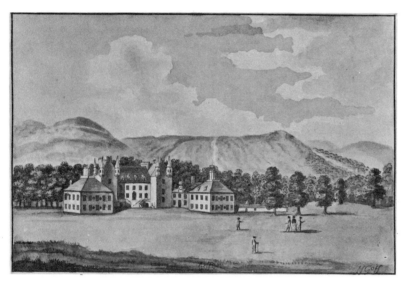

Fig 22
MOSES GRIFFITH
Taymouth
no. 2.7

vities had come to an end. There may have been minor changes but the garden created in the early 1750s survived intact at least until the mid-1780s when it was again surveyed (fig 22). However, while the gardens at Taymouth had remained the same, tastes in landscape gardening had changed. For the first time in the eighteenth century advanced opinion considered Lord Breadalbane's garden old fashioned and ill-planned. The Rev. William Gilpin who visited Taymouth in 1776 wrote as follows:

and mountains to most advantage. There was a grand walk also beyond the Tay; which had cost more than it deserved. Indeed the walks on neither side of the river seemed intended to shew the scenery; but rather as avenues to a few tawdry, inelegant buildings, which terminated them. Nothing could shew a more thorough inattention to every idea of beauty and taste, than the whole contrivance of the place.'[3]

(1) Many of the facts on which this essay is based can be found in the Breadalbane papers in Register House, Edinburgh (GD112). I have been greatly helped by Dr A. A. Tait of Glasgow University who has generously shared his knowledge of eighteenth century gardens and of the gardens at Taymouth in particular.

(2) R Pococke *Tours in Scotland*. Published by the Scottish History Society 1887 pp 235–6.

(3) W Gilpin *Observations on several parts of Great Britain particularly the Highlands of Scotland, relative chiefly to Picturesque beauty, made in the year 1776*. 1st Edition 1789 vol I pp 157–8.

WILLIAM ADAM 1689–1748

2.1 Plan of the gardens at Taymouth Perthshire 1720 fig 15

Pen and wash. 80 × 107 cm

Although the date 1720 was added later it is probably accurate. The gardens were planned as a formal pattern without regard to the lie of the land or the flow of the Tay

Lent by the Scottish Record Office

JAMES NORIE 1684–1757 and JAN GRIFFIER II Died 1750

2.2 Panorama of Taymouth and Loch Tay fig 16

Oil on canvas. 66 × 133 cm

James Norie painted this view in 1733. Much of the lower half of the canvas was repainted in 1739 by Jan Griffier to show the alterations made to the gardens in the past six years

Lent by the Scottish National Portrait Gallery

2.3 Part of Sheet 16 of the Military Survey of Scotland: Taymouth fig 17

Strathtay was surveyed by the army in about 1749. The map shows evidence of recent garden changes; the 'surprise' walk is shown for the first time. The fact that many important alterations, visible in both Winter's plan and Sanger's painting of the mid 1750s, were not yet made suggest that the design of the third garden evolved gradually from the mid 1740s onwards

Not on exhibition

THOMAS WINTER active 1746–1759

2.4 Plan of Taymouth 1754 fig 18

Photograph

Although Winter designed gardens elsewhere in Scotland he was employed at Taymouth merely as a surveyor. His plan shows the design of the third garden.

Photograph supplied by the Royal Commission on the Ancient and Historical Monuments of Scotland

JOHN SANGER active 1756–1773

2.5 Taymouth from the North fig 20 and pl ii

Oil on canvas. 105 × 200 cm

In April 1756, the English artist John Sanger was paid £23 2s 0d for making a picture of Taymouth. The following year he was paid a guinea for altering a picture and a further £23 2s 0d for another painting of Taymouth. This view and its companion (fig 19) which correspond almost exactly with Winter's 1754 plan, must be the pair by Sanger

Lent by the Trustees of the National Museum of Antiquities of Scotland

CHARLES STEUART active 1760–1790

2.6 Loch Tay and Ben Lawers from the park at Taymouth fig 21

Oil on canvas. 100 × 160 cm

Steuart was paid 15 guineas in 1767 for painting this view. It is the earliest painting known that shows the interest in and appreciation of the landscape beyond the garden

Lent Anonymously

MOSES GRIFFITH 1747–1819

2.7 Taymouth fig 22

Pen and watercolour. 10.8 × 16.7 cm

The design of the garden was not altered after the mid 1750s. By 1772, the date of this watercolour, fashionable opinion criticised the landscape setting of the house for ignoring the natural beauty of Loch Tay and the surrounding mountains

National Gallery of Scotland

Fig. 25
ROBERT NORIE
Classical architecture and landscape
The Duke of Hamilton

Fig 26
ROBERT NORIE
Classical architecture and ruins
The Duke of Hamilton

22

3

Decorative Painting

In 1733 Lord Glenorchy commissioned James Norie to paint a view of Taymouth Castle his Perthshire seat (fig 16). He had little choice if he wanted to employ a Scottish artist for there was no-one else in Edinburgh, let alone in any of the other Scottish burghs, who was able to paint a competent landscape view.

James Norie was exceptional. He had come to Edinburgh from Moray in the second decade of the eighteenth century and set up as a painter in the capital city. His business encompassed both fine art and what today would be the work of a painter-decorator. Much of the firm's business was probably of this second category; painting walls, doors and skirting boards at so much the yard. A bill which he sent to Lord Glenorchy for work done both at Taymouth and in his apartments at Holyroodhouse in 1750, lists the following items.[1]

To painting in his lodging in the Abby a room in the first story and a closet measuring 107 yeards at 5d the yard	£2 4 7d
To colouring on the outsides of seven doors 31 yards chocolate colour in oil at 6d the yard	15 6d
To painting the corners of the old castle in imitation of stone	£1 12 0d
To part of a boat with different colours marking the inside and doing the gun ports	10 0d
To 19 oars bright red thrice over and marking them at 2s each	£1 18 0d

James Norie had ambitions both for himself and for his sons, two of whom worked with him as painters. There were several attempts in Edinburgh during the first half of the eighteenth century to establish an academy where young artists could be trained and James Norie was one of the signatories on the document founding the Academy of St Luke in 1729, along with William Adam and Allan Ramsay. The Academy did not prosper and it may have been on its closure in 1731 that James Norie sent his sons James and Robert to London to be apprenticed under the landscape painter George Lambert.

Lambert could not have been a better choice. He was one of the most accomplished landscape painters working in London in the first half of the eighteenth century; specialising in classical landscapes based on the work of the great seventeenth-century Roman artists. What made Lambert one of the most original landscape artists of his time were his fresh realistic views of the countryside of southern England. The two young Nories would have served their apprenticeship in a forward looking workshop at the centre of important new developments in landscape painting.[2]

James Norie the younger died in 1736, possibly while still in London but his younger brother Robert served his term with Lambert, completed his apprenticeship around 1740, and was back working for his father the following year. What must have been the first paintings of importance that he made on his return to Scotland is the set of four upright landscapes dated 1741 which belong to the Duke of Hamilton. Two show classical scenes (figs 25 and 26) but they are paired with two other recognisably Scottish landscapes (figs

23

Fig 23
ROBERT NORIE
**Landscape with
a view of
Ben Lawers**
no. 3.2

24

Fig 24
ROBERT NORIE
**Landscape with a
waterfall and
ruins**
no. 3.3

23 and 24). In one of these no actual spot has been painted but the scene is composed from a number of typically Scottish features, a waterfall, castellated ruins and a flock of sheep. In the other a fisherman and shepherd are painted beneath the distinctive silhouette of Ben Lawers which Robert Norie would have known well from his several visits with his father to Taymouth. Robert Norie's achievement was in realising that his native Scottish landscape with its waterfalls and

scrutiny and theatre managers just as much as the artists themselves understood its importance.

On July 23 1757 the Edinburgh Evening Courant reported:

'On Monday 25 inst will be presented the tragedy of Douglas.... This night for the first time the stage on the sides and back will be decorated with an entire new wood

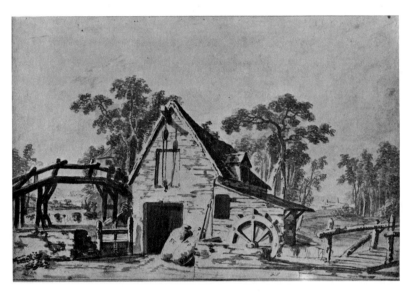

Fig 27
JACOB MORE
Design for a stage set
no. 3.6

sheep, its castles and mountains was as worthy a subject for his landscapes as the classical ruins of the two companion paintings.

There may have been another reason why James Norie chose to send his sons to Lambert. During the 1720s Lambert was employed as scene painter at Lincolns Inn Fields Theatre and in 1732 started working for the newly built theatre at Covent Garden. For the two young artists experience in this branch of painting would have been most useful both in work for the Edinburgh stage and, more generally, in large scale decorative painting.

Stage scenery is ephemeral and its loss distorts an appreciation of the development of landscape painting in the eighteenth century. Its importance must have been considerable for the best landscape painters in Scotland all worked for the theatre where their reputations were made and maintained. Nowhere else did landscape painting come under such general

scene painted for the occasion by De la Cour.'[3]

Delacour's prices were not excessive, they are comparable with those charged by James Norie's firm.

'For the front scenes, such as towns, chambers forests etc of 15' square each, never above £7 7s for the wings £1 1s and so in proportion to the rest.'[4]

None of Delacour's drawings for the stage are known to have survived but a design for a set by Alexander Runciman does. Runciman served his apprenticeship with Robert Norie and may have been a rival of Delacour.

After Runciman's departure from Italy in 1767 and Delacour's death the following year the way was opened for another Norie-trained artist, Jacob More, to try his hand on the stage (fig 27). The success which greeted More's designs, probably the scenery for 'The

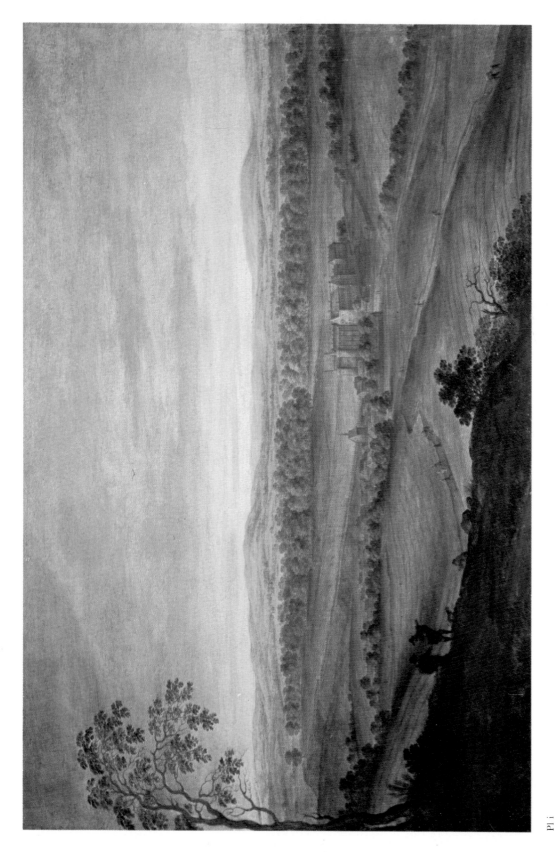

Pl i
ALEXANDER KEIRINCX
Falkland Palace
no. 1.1

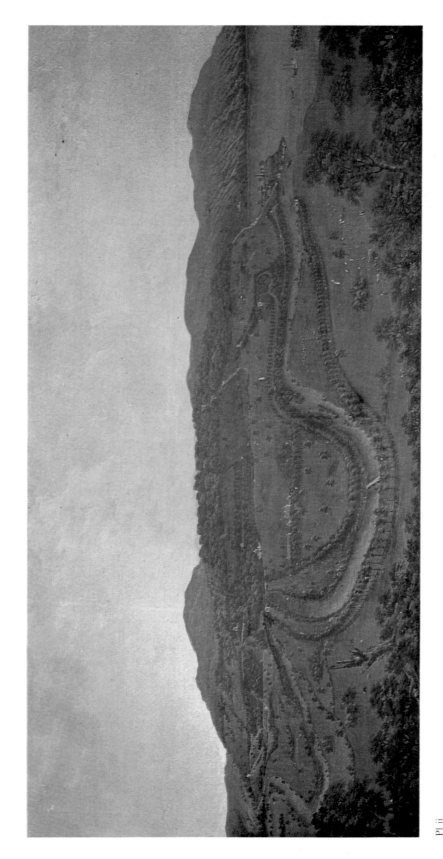

Pl ii
JOHN SANGER
Taymouth from the North
no. 25

Fig 28
ALEXANDER NASMYTH
Design for a theatre wing
no. 3.7

Royal Shepherd' with which he made his debut in 1769, is said to have persuaded him to become an independent landscape painter.

Enough of Alexander Nasmyth's work for the theatre survives to give some idea of how he produced his stage sets. The preliminary drawing of a tree to fill the side wing of a Glasgow theatre shows that he wanted as naturalistic a wing as possible and that he was prepared to make preliminary drawings for the wing from nature (fig 28). Similarly with his set of scenes for the play 'Heart of Midlothian' the preliminary sketches for which were made around the city of Edinburgh (fig 29). Whether this was the practice of Delacour, Runciman and More is not known but it is probable. Delacour certainly made drawings of foliage which were used for teaching at the Trustees' Academy in Edinburgh and at the art school in Aberdeen.

It would be wrong to think that the sole interest of painters was in realistic landscape representation. An artificial decorative style existed and prospered side by side with naturalistic painting and was even employed by the same artists. James Norie who had painted the accurate view of Taymouth Castle in 1733 could turn his hand with equal ability to paint the stylish non-topographical landscape (pl ii) three years later. Alexander Runciman too could on the one hand make accurate watercolours of the East Lothian countryside (fig 5) and on the other produce delightful rococo landscapes, like the frontispiece to Richard Cooper Junior's scrapbook (fig 30), or the design which Cooper engraved as Robert Norie's trade card (fig 31). This light artificial and unnaturalistic style was particularly suited to interior decorative work and

Fig 29
ALEXANDER NASMYTH
Six designs for stage sets
no. 3.9

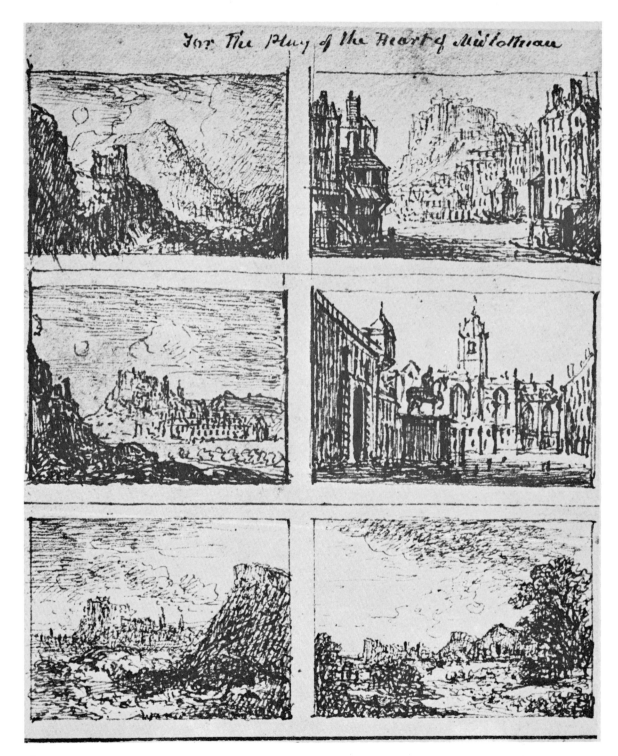

was used by the Norie firm, at Caroline Park and Drylaw House for instance, as well as by Richard Cooper Junior when he designed the decoration of a series of rooms in the form of of grottoes and rocky landscapes (fig 32).

By the 1750s this decorative artificial style was moving out of fashion. It was the discovery by both patrons and artists that they lived in a country with a natural beauty of its own, a beauty which was worthy of being painted, that caused the decline of the artificial landscape style. In 1757 James Norie had drawn up a programme for the decoration of a dining room at Blair Castle. It included such subjects as a winter frost, a sea storm and a cascade and rocks. However, when the Duke of Atholl came to have his main dining room at Blair redecorated ten years later it was not such general subjects that he chose but exact representations of the picturesque scenes in and around his estate at Blair Atholl.

Fig 30
ALEXANDER RUNCIMAN
Frontispiece
no. 3.10

(1) James Norie's bill is in Register House, Edinburgh GD112/21/78.

(2) For a full account of Norie's apprenticeship under Lambert see James Holloway *Robert Norie in London and Perthshire* Connoisseur January 1978.

(3) Quoted by Dr J D MacMillan in an unpublished thesis on Alexander Runciman.

(4) The Edinburgh Evening Courant March 5th 1763. Also quoted in MacMillan's thesis.

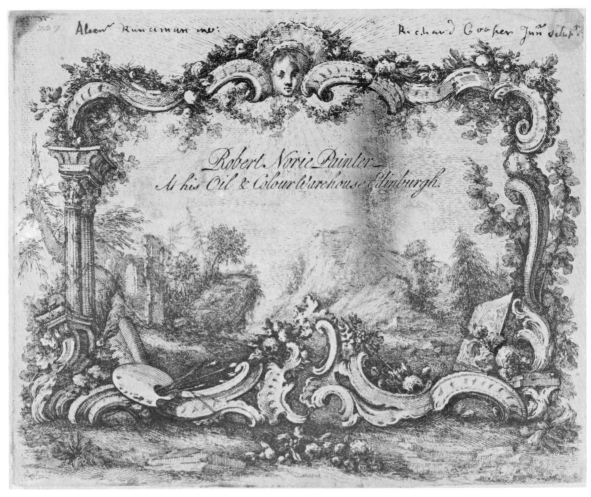

Fig 31
After ALEXANDER RUNCIMAN
Robert Norie's trade card
no. 3.11

Fig 32
RICHARD COOPER, Jnr
Design for a rock room
no. 3.12A

JAMES NORIE 1684–1757
3.1 **Classical landscape with architecutre** pl iii
Oil on canvas. 64.8 × 132.0 cm
Signed: '*Ja Norie Edin 1736*
National Gallery of Scotland

ROBERT NORIE after 1711–1766
3.2 **Landscape with a view of Ben Lawers** fig 23
Oil on canvas. 175 × 107 cm
This and the following painting are two of a set of four
decorative canvases. Two Scottish landscapes (figs 23
and 24) are contrasted with two classical scenes (figs 25
and 26)
Lent by His Grace the Duke of Hamilton

ROBERT NORIE
3.3 **Landscape with a waterfall and
 castellated ruins** fig 24
Oil on canvas. 175 × 107 cm
Lent by His Grace the Duke of Hamilton

ALEXANDER RUNCIMAN 1736–1785
3.4 **A Terrace: design for a Stage Set**
Pen and watercolour. 48.5 × 67.5 cm
Signed: *A. Runciman*
National Gallery of Scotland

JACOB MORE 1740–1793
3.5 **A landscape view: design for a Stage Set**
Bodycolour. 24.9 × 38.9 cm
National Gallery of Scotland

JACOB MORE
3.6 **A flour mill: design for a
 Stage Set** fig 27
Black chalk and brown wash. 36.4 × 54.2 cm
National Gallery of Scotland

ALEXANDER NASMYTH 1758–1840
3.7 **Tree** fig 28
Black chalk. 52.4 × 23.0 cm
Inscribed: *Design for a side wing for Glasgow Theatre*
National Gallery of Scotland

ALEXANDER NASMYTH
3.8 **View of Edinburgh**
Pencil. 10.3 × 16.0 cm
Signed: *Alex Nasmyth 1817*
National Gallery of Scotland

ALEXANDER NASMYTH
3.9 **Six designs for stage sets** fig 29
Pen. 16.0 × 11.8 cm
Inscribed: *for the play Heart of Midlothian ... six scenes 24
feet by 16–6 inches begun 29 December 1819 and finished
Feb 8 1820 by AN for the Theatre Edinburgh*
The preliminary drawings for Nasmyth's theatre scenery
were made after nature. The view of Edinburgh on the
bottom left was drawn from an earlier sketch (3.8)
National Gallery of Scotland

ALEXANDER RUNCIMAN
3.10 **Frontispiece** fig 30
Pencil and watercolour. 21.3 × 16.9 cm
Runciman painted this light and decorative frontispiece
for the scrapbook of a fellow artist Richard Cooper
Junior
National Gallery of Scotland

RICHARD COOPER, Jnr after ALEXANDER
RUNCIMAN
3.11 **Robert Norie's trade card** fig 31
Engraving. 16.4 × 20.9 cm
Inscribed: *Alex. Runciman inv Richard Cooper Junr Sculpt*
Runciman's rococo design is an early work, made not
long after he finished his apprenticeship to Robert Norie
Lent by Edinburgh University Library

RICHARD COOPER, Jnr c 1740–1814
3.12 **Two designs for Rock rooms** A—fig 32
 A 9.6 × 39.4 cm. Grey wash
 B 10.2 × 45.8 cm. Pencil
National Gallery of Scotland

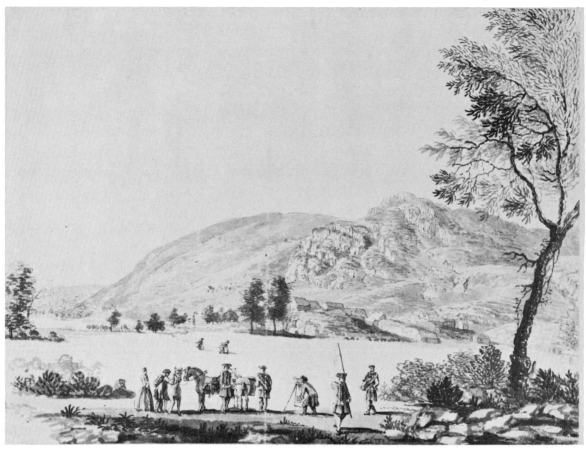

Fig 33
PAUL SANDBY
Survey party at Kinloch Rannoch
no. 4.1

Fig 34
PAUL SANDBY
Duart Castle
no. 4.6

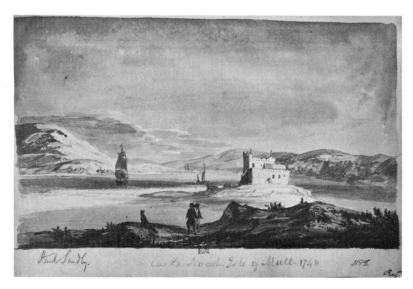

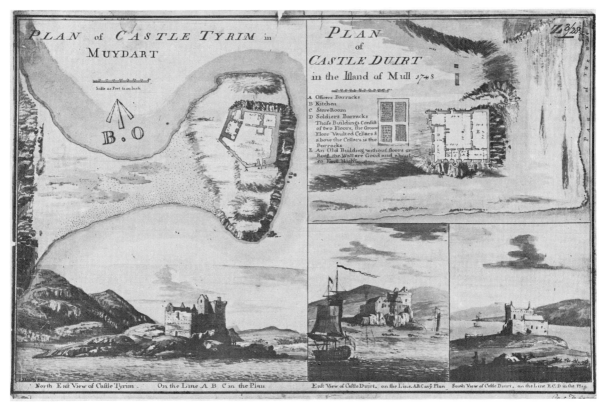

Fig 35
PAUL SANDBY
Maps and views of Duart and Tioram Castles
no. 4.8

The defeat of the Jacobite uprising at the Battle of Culloden in 1746 marked the end of the Stuart's attempts to regain the thrones of England and Scotland. At the time, though, the British Government could not be so sure. Plans were immediately prepared to strengthen the army in the north; barracks were repaired and rebuilt, garrisons were reinforced, roads were constructed and a detailed survey of the Highlands was begun.

The director of the survey was Lieutenant Colonel David Watson, Deputy Quartermaster General in North Britain. He and his Assistant Quartermaster William Roy, another lowland Scot, supervised the survey which lasted nine years, from 1747 to 1755. Its purpose was to map the mainland of Scotland starting in the Highlands and working south to the Border (fig 17). The official draghtsman of the survey was a young Englishman, Paul Sandy. He had joined the Board of Ordnance Drawing Room at the Tower of London in 1741, at the age of 16. Sandby seems to have come north to

Edinburgh early in 1747 where one of his main tasks was to prepare the first draft, the 'original protraction', of the huge map of Northern Scotland from information provided by surveying parties in the field.[1]

Sandby occasionally accompanied the survey team in the country for he drew the elegant view (fig 33) of army engineers at work with chains, flags and a theodolite from a sketch that he had made on the spot near Kinloch Rannoch in 1749. Improved communications (fig 34) shows how Sandby adapted the map-making technique to his own topographical ends—the conventional colours of the ordnance maps, blue green for water and yellow for land under cultivation are repeated in Sandby's landscape views. The military practise of showing the shape of a mountain by aligning the brush stroke with the direction of the slope was one that the artist also adopted.

Most of Sandby's time in Scotland, however, would have been spent at the

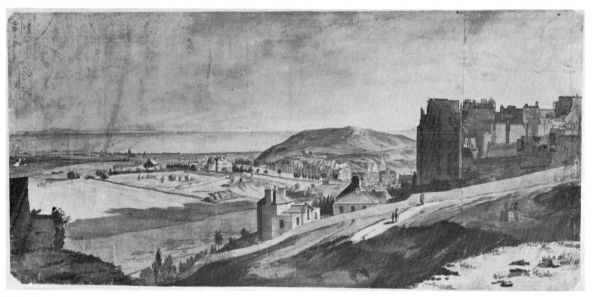

Fig 36
PAUL SANDBY
Edinburgh from the castle
no. 4.13

Ordnance Office in Edinburgh. Naturally he drew the principal sites of the city; the Castle, Heriot's Hospital and the High Street (fig 38), as well as panoramas of the city and the Forth (fig 36). He had time to sketch every aspect of life in the busy and overcrowded city: the life in the coffee houses and parks (fig 39), incidents in the streets, an execution or a woman washing clothes at a well (fig 46). Some of these scenes he also etched but in his etchings unlike his watercolours, Sandby was not concerned with topographical accuracy. He was quite happy to combine the gothic ruins of the Collegiate Church at Hamilton with Edinburgh Castle, or to remove the Mackenzie Monument from its home in Greyfriars Kirkyard to the fields near the Meadows where he transformed it into a summer house.

Sandby's Edinburgh friends were an in-

were just as important a part of Government policy in controlling the Highlands as accurate mapmaking so the Government extended the programme of road and bridge building began by General Wade in 1724.

In 1748, David Watson and a party of 20 soldiers visited some of the more remote castles of Argyll to report on their situation, structure, and on the cost of repairing them. Watson sent back a written report to his headquarters accompanied by Sandby's watercolour (fig 35) in which the young draughtsman combined ground plans and landscape views of the castles worked up from separate watercolours he had already made. The style of drawing and colouring in the preliminary watercolour of the south view of Duart Castle

Fig 37
PAUL SANDBY
Leith
no. 4.14

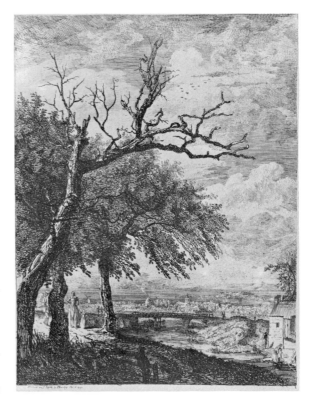

telligent and highly ambitious group in a city that was just beginning a period of remarkable intellectual achievement. Two men who Sandby came to know well were Robert Adam and his brother-in-law John Clerk. He may first have met them through Robert's father William Adam who was master mason to the Board of Ordnance and who worked for the army rebuilding the highland forts and strengthening the lowland castles. John Clerk's father, Sir John Clerk of Penicuik, one of the Barons of the Exchequer, was a most useful connection too. Sir John's introduction to the factor of the Duke of Queensberry's estate at Drumlanrig sent the young landscape artist to Dumfriesshire in the spring of 1751. The factor was delighted with Paul Sandby's performance and he wrote to thank Sir John[2]

'My Lord
I have been extremely oblidged to you for the pleasure of Mr Sandby's company here. He has made several drawings of the house

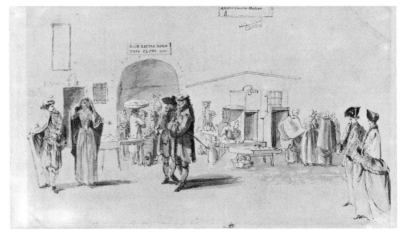

Fig 38
PAUL SANDBY
The High Street, Edinburgh
no. 4.17C

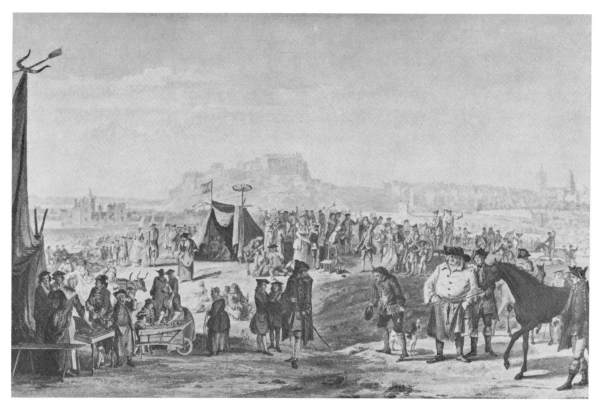

Fig 39
PAUL SANDBY
Horsefair on Bruntsfield Links
no. 4.19

Fig 40
PAUL SANDBY
Panorama of Nithsdale with Drumlanrig
no. 4.21

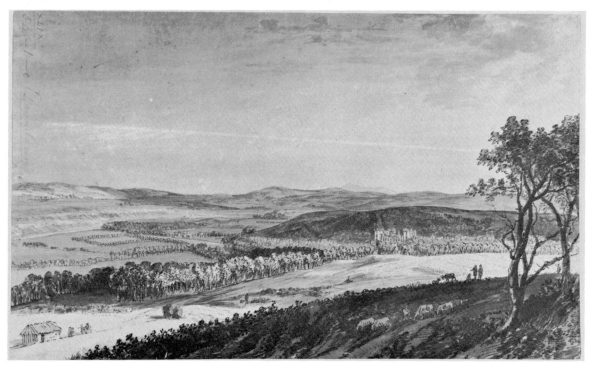

and policy which I am persuaded you will be much pleased with. I was with him last week in Dumfries but the weather was so bad it was impossible for him to do anything material there—I dare say the Duke and Duchess will be much pleased with him. I hope we will have the happiness of your company here in April. My wife joins me in our respectfull compliments to my Lady Clerk and all the family.

> I ever am with the greatest regard My Lord, Your most faithfull and obdt humble Servant

JA: FERGUSON

Drumlangrig
March 22ᵈ 1751'

With a mixture of private commissions and army travel Sandby would have seen more of the Scottish countryside than any artist before, either English or Scots, ranging from Argyll and Dumfriesshire in the west to Moray and Inverness-shire in the north. He was in Fort William in 1747 and at Culross in Fife the following year.[3] Not surprisingly, for one so involved with the army, the castles of Scotland held a particular fascination for Sandby. Those at Dumbarton, Stirling and Edinburgh which he drew were military fortresses, but others including Kilchurn, Dunstaffnage, Dunglass, Rothesay and Tantallon he must have enjoyed sketching for their dramatic silhouettes and spectacular situations.

Bothwell Castle on the Clyde was one that especially appealed to Sandby. He sketched three views from beyond the river (fig 41) and two from within the ruins themselves, building up a stock of views of the castle which he could make use of later (pl iv and fig 42). His highly finished views of the castle in gouache or watercolour were made for exhibition at the Royal Academy many years after he had left Scotland.

It was not just the castles and fine houses that appealed to Sandby. He was interested too in the industrial life of the country and he sketched lead mines in Dumfriesshire (fig 43) and a fulling mill in Fife.

The precision with which Sandby recorded architectural details make it almost certain that before he left Scotland in 1752 he must have had in mind the possibility of publishing engravings after his views. It was not until 1778, over twenty years after he had left the country, that engravings of Scottish views were issued first in the Virtuosi's Museum and then republished with additions a few years later in 'A collection of 150 select views in England, Wales, Scotland and Ireland'.

The comparison of a view made by Sandby in 1747 (fig 44) with the print which was engraved after it over thirty years later (fig 45) reveals an interesting change of attitude to the Scottish landscape. Sandby's view shows the rich farming country of Strathtay as he saw it, in fact very much as it is today. But by 1780 the view was not thought to be sufficiently 'Highland' and several additions were made to dramatise the landscape; the mountains were heightened and their outlines made more rugged, fir trees and a kilted onlooker were introduced.

Unlike his engravings, Sandby's etchings of Scottish landscape have never been widely known, even in Scotland, despite the fact that three sets of etched views were published during his stay in Edinburgh. Even the identity of some of the places which he represented have been forgotten. Tradition relates that Sandby learnt printmaking from an Edinburgh engraver called Bell. Sandby's friend John Clerk may also have been taught by Bell, but Clerk received help in printmaking from Sandby and had a very large collection of his work. In 1763 he wrote to his sister-in-law, Margaret Adam, describing a meeting with Hannan a professional artist employed by Lord Bute.

> 'He did not know anything of my talent, but upon his shewing a drawing of Bothwell Castle by Paul Sandby, whose hand you may sure I knew, I told him I had about 30 of Sandbys drawings, and criticised so much to his satisfaction, upon this drawing, which is one of the noblest that ever he did, that he paid me great respect.'[4]

Clerk's admiration for Sandby's work did not

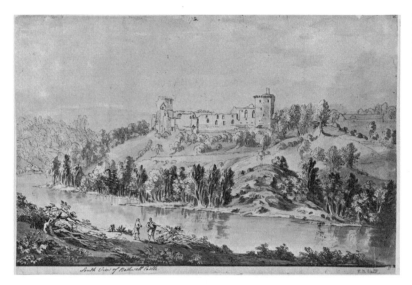

Fig 41
PAUL SANDBY
Bothwell Castle
no. 4.31

Fig 44 (*opposite*)
PAUL SANDBY
View in Strathtay, 1747
National Library of Wales

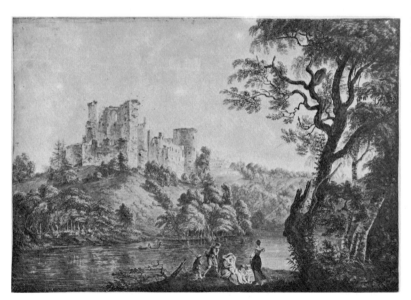

Fig 42
PAUL SANDBY
Bothwell Castle
no. 4.34

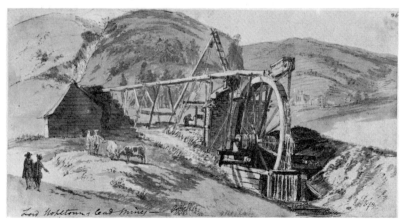

Fig 43
PAUL SANDBY
Lead mine, Dumfriesshire
no. 4.27

Fig 45 (*opposite*)
After PAUL SANDBY
View in Strathtay, 1780
National Gallery of Scotland

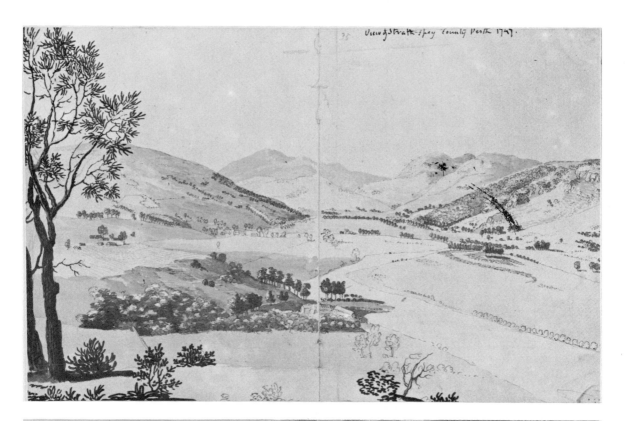

View of Stratto-Spey County Perth 1747.

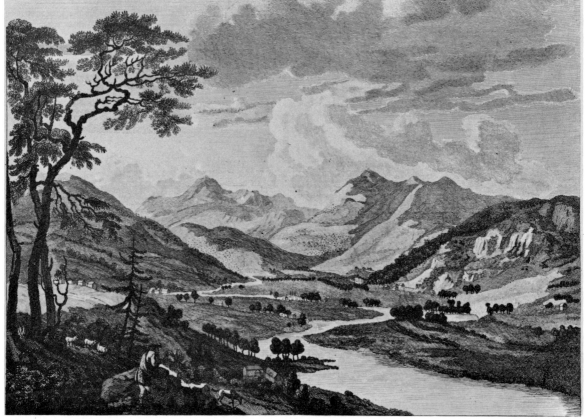

stop at owning them. He copied his water-colours and it is very likely that one of the 30 drawings which he owned was the south view of Duart Castle (fig 34) which he carefully copied and adapted to one of his small etchings.

It was as a master of the new aquatint process that Sandby collaborated with another Scottish artist when he bought the eight sepia drawings that David Allan had made of the Roman Carnival and in 1787 published prints

of Ramsay's poem was in its local pastoral setting and like Allan he also set his scenes in local surroundings. One print shows the two lovers with the silhouette of Edinburgh High Street and the Castle in the far distance. In the scene showing the fight between Madge and Bauldy (fig 47), Sandby has etched the well at Broughton (fig 46), a village then close to and now part of Edinburgh. Allan must have been familiar with the set for when he came to illustrate the same scene he copied

Fig 46
PAUL SANDBY
Draw well at Broughton
no. 4.36

from them at a guinea a set. Later in the 1780s David Allan had the idea of illustrating Allan Ramsay's poem *The Gentle Shepherd* but this time he made the drawings and the aquatints himself. Allan's illustrations are famous, but what is not widely known is that Paul Sandby had made a set of five etchings illustrating the poem which predate David Allan's set by thirty years. In his dedicatory letter to Gavin Hamilton, Allan wrote 'This piece it is well known, he composed in the neighbourhood of Pentland Hills, a few miles from Edinburgh, where the shepherds to this day sing his songs, and the old people remember him reciting his own verses. I have studied the same characters on the same spot, and I find, that he has drawn faithfully, and with taste, from nature.'

Sandby too realised that part of the charm

the detail of Bauldy's dog with its teeth in Madge's skirts directly from Sandby. The incident is quite in character with the poem but is not in fact part of it.

Besides John Clerk's collection, Sandby's drawings were known in Scotland long after he left in the mid 1750s. He was in correspondence with a group of antiquaries that included the Scotsmen George Hutton and Robert Riddell and the Englishmen Francis Grose and Thomas Pennant. The group exchanged drawings and Riddell owned at least two Sandby drawings of Dumfries Bridge, probably made on the 1751 excursion to Drumlanrig. One of these drawings Riddell lent to Francis Grose which was then illustrated in the latter's *Antiquities of Scotland*. Grose also got his servant Tom Cocking to copy Sandby's drawing of the ruined

Fig 47 PAUL SANDBY **Illustration to The Gentle Shepherd** no. 4.37E

Collegiate Church at Hamilton and this too was engraved for the book. Pennant also made use of Sandby's drawings in his Tours in Scotland. It was the circulation of the prints after Sandby's Scottish watercolours that introduced the country for the first time to a wide British public. Sandby's contribution to the discovery of Scotland was in selecting and recording so many of the places that were to become the picturesque sites of succeeding generations.

Fig 48
GEORGE HUTTON and PAUL SANDBY
Inchmahome Priory
no. 4.42

(1) For a full account of the military survey of Scotland see Yolande O'Donoghue *William Roy 1726–1790 Pioneer of the Ordnance Survey* British Library 1977.

(2) The letter from James Fergusson to Sir John Clerk of Penicuik is in Register House Edinburgh GD18/4676.

(3) The drawings of Fort William and Culross are in the National Library of Wales, Aberystwyth.

(4) Clerk's comments are from a letter of 4/9/1763 to Margaret Adam. Register House, Edinburgh GD18/5486/41.

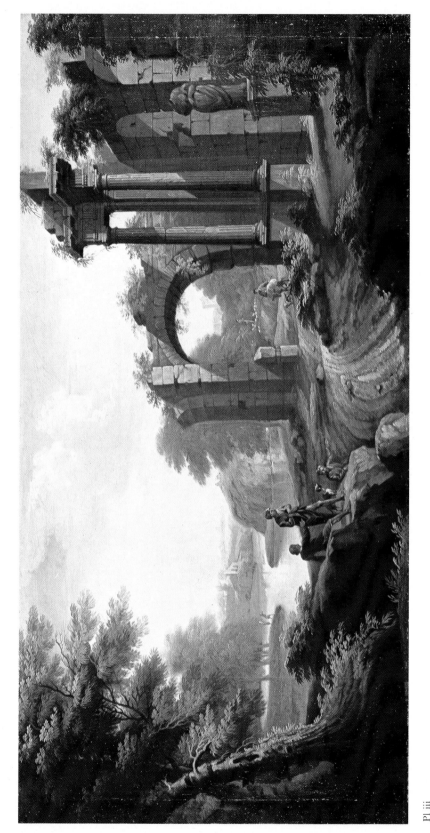

Pl iii
JAMES NORIE
Classical Landscape with Architecture
no. 3.1

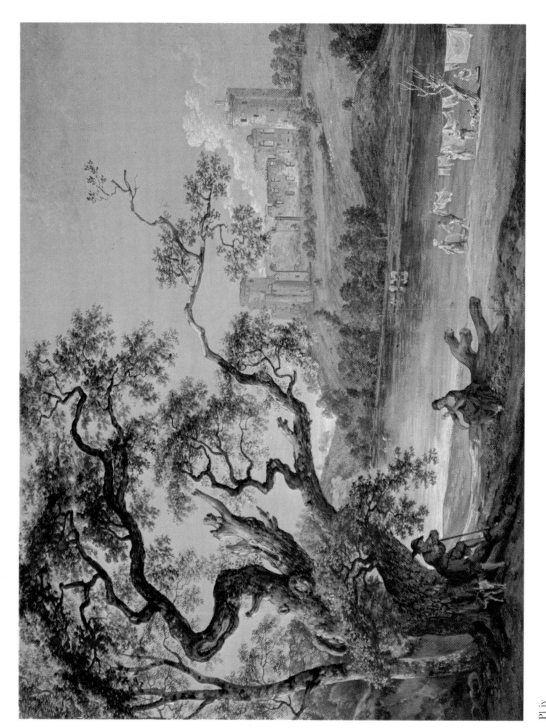

Pl iv
PAUL SANDBY
Bothwell Castle
no. 4:33

PAUL SANDBY 1725–1809

4.1 **Survey party at Kinloch Rannoch, Perthshire** fig 33
Watercolour. 17 × 24 cm
Each surveyor was accompanied by a non-commissioned officer and six soldiers as assistants
Lent by the British Library Board. Map Library K. Top. L83.2

4.2 **Part of Sheet 16 of the military survey of Scotland**
The map shows Kinloch Rannoch where in 1749 Sandby had sketched the surveying team at work. Sandby probably helped paint this map. The style of army map making influenced his watercolour technique
Lent by the British Library Board. Map Library C9a2

JOHAN VAN DIEST active 1730s

4.3 **Portrait of General Wade**
Oil on canvas. 75.0 × 63.2 cm
The construction of the road across the Corrieyairack Pass, between Fort Augustus and Dalwhinnie, is shown in the background of the portrait. By a trick of perspective the artist has shown both the ascent and descent of the new road.
Lent by the Scottish National Portrait Gallery

ROBERT ADAM 1728–1792

4.4 **General Wade's Bridge at Aberfeldy, Perthshire**
Pen and watercolour. 30 × 50 cm
William Adam, Robert's father, designed this elegant and strategically important bridge across the Tay
National Gallery of Scotland

PAUL SANDBY

4.5 **Road builders shifting boulders**
Pen, wash and coloured chalks on blue paper. 28.5 × 32.7 cm
A preparatory sketch for this watercolour is in the Victoria & Albert Museum. A companion sketch shows the removal of the boulders in carts, probably to be broken up for hard core for the new roads
National Gallery of Scotland

PAUL SANDBY

4.6 **Duart Castle, Mull** fig 34
Pen, blue and grey wash. 19 × 30 cm
Sandby went to Argyll with Lieut. Col. David Watson in 1748. His job was to make views and draw plans of Tioram and Duart Castles to explain their strategic positions
National Gallery of Scotland

PAUL SANDBY

4.7 **Plan of Duart Castle**
Pencil, pen and coloured wash. 27.1 × 37.5 cm
Lent by the British Library Board. Map Library K. Top XLIX.38.1

PAUL SANDBY

4.8 **Maps and views of Duart and Tioram Castles** fig 35
Pen and watercolour. 35.5 × 54.0 cm
Signed: *P. Sandby delin*
The following report dated October 3rd 1748 from Lieut Col. David Watson accompanied this watercolour to his headquarters

> 'Castle Duirt stands on the east side of the Isle of Mull, its situation is very strong but the entrance of the sound is too broad to be commanded from the castle. The walls are sufficient but the roof the barracks where the party is lodged quite ruinous. If this castle was properly repaired it might accommodate 150 men, which repairs would cost 1500£. The repairs necessary for quartering the present detachment which consists of a subaltern and 20 men must cost 300£.' (National Library of Scotland MS1648 Z/3/28f)

Lent by the Trustees of the National Library of Scotland MS 1648 Z 3/28e

WILLIAM ROY 1726–1790

4.9 **Survey of part of the Moray Firth**
Pencil, pen and coloured wash. 54.6 × 129.0 cm
The old Fort George in Inverness was badly damaged in the '45. Construction of a new Fort at Ardiseer was started in 1748 and was completed in 1769
Lent by the British Library Board. Map Library K. Top L.22

ALEXANDER RUNCIMAN 1736–1785

4.10 **Fort George, Inverness-shire**
Watercolour. 23 × 128 cm
Inscribed: *Handed over to Lieut Monier Skinner Re Esqer by his father in 1872*
In his annotations to Gough's Scottish Topography (Library of the Society of Antiquaries of Scotland) Robert Riddell records that Runciman painted several views of the Fort for its architect General Skinner. This view similar in style to other Runciman landscapes belonged to the Skinner family
Lent by the British Library Board. Department of Manuscripts MS 33.233 f 10

PAUL SANDBY

4.11 **East view of Edinburgh Castle**
Pen. 12.7 × 22.5 cm
Signed: *Paul Sandby delint 1746–7*
This drawing was made early in 1747 (new style) and must be one of the earliest drawings made by the artist in Scotland
Lent by the Trustees of the British Museum

PAUL SANDBY

4.12 **Heriot's Hospital, Edinburgh**
Pen and watercolour. 14.1 × 17.2 cm
National Gallery of Scotland

D

PAUL SANDBY
4.13 View of Edinburgh and the Forth from the Castle fig 36
Watercolour. 24.9 × 54.3 cm
Lent by the British Library Board. Map Library K. Top. I. 96b

PAUL SANDBY
4.14 View of Leith from Broughton fig 37
Etching. 23.5 × 18.5 cm
Inscribed: *etched on the spot by P. Sandby Sep 6 1750*
This and the following two numbers are from a set of six etchings made in Edinburgh in 1750
National Gallery of Scotland

PAUL SANDBY
4.15 Capriccio with Edinburgh Castle and Arthur's Seat
Etching. 23.3 × 18.4 cm
Inscribed: *etched on the spot by P. Sandby Sep 27 1750*
National Gallery of Scotland

PAUL SANDBY
4.16 Capriccio with the Mackenzie Monument
Etching. 23.6 × 18.5 cm
Inscribed: *P. Sandby [erased] Delin et Sculp Sepr 20 1750*
National Gallery of Scotland

PAUL SANDBY
4.17 Three scenes in Edinburgh C—fig 38
 A. **British Soldiers.** Pen and coloured wash. 8.2 × 14.2 cm
 B. **Horse fair.** Pen and coloured wash over pencil. 10.5 × 24.2 cm
 C. **Life in the High Street.** Pen and coloured wash over pencil. 12.1 × 20.8 cm
Inscribed: *Drawn in the high Street at Edinburgh March 1st 1750*
Lent by the Trustees of the British Museum

PAUL SANDBY
4.18 John Balfour's Coffeehouse
Etching. 11.1 × 8.4 cm
Inscribed: *John Balfour's Coffee house at Edinburgh 1752*
The young man may be a self portrait of Paul Sandby
Lent Anonymously

PAUL SANDBY
4.19 Horse fair on Bruntsfield Links, Edinburgh fig 39
Pen watercolour and bodycolour. 24.4 × 37.3 cm
Signed and dated 1750
Sandby has worked up this finished watercolour from his preliminary sketch (4.17B).
Lent Anonymously

PAUL SANDBY
4.20 Drumlanrig, Dumfriesshire
Pen and watercolour over pencil. 12.0 × 18.8 cm
This view was engraved by W. Watts in 'The Seats of the Nobility and Gentry' 1779.
Lent by the Trustees of the British Museum

PAUL SANDBY
4.21 Panorama of Nithsdale with Drumlanrig fig 40
Pen and watercolour. 15 × 41 cm
The view was engraved in the *Virtuosi's Museum* 1778 and in *150 select views in England Wales Scotland and Ireland* 1782. Sandby visited Dumfriesshire in the spring of 1751
Lent by the British Library Board. Map Library K. Top. XLIX 54.1.c

4.22 Letter from James Fergusson to Sir John Clerk of Penicuik, Bt
The letter is quoted in the accompanying essay
Lent by Sir John Clerk of Penicuik, Bt

THOMAS SANDBY 1721–1798
4.23 Inveraray, Argyll
Pen, wash and watercolour. 45 × 126 cm
Signed: *Thos Sandby delin 1746* and inscribed *View of Inverary a seat belonging to his Grace the Duke of Argyle*
This detailed drawing was made presumably to be engraved. Paul, who visited Inveraray the following year made two large panoramas of the town (National Library of Wales, Aberystwyth and British Library Map Library)
National Gallery of Scotland

PAUL SANDBY
4.24 Inveraray
Pen and watercolour. 16.2 × 26.3 cm
National Gallery of Scotland

PAUL SANDBY
4.25 Castle Menzies, Perthshire
Pen and watercolour. 16.2 × 26.2 cm
Sandby made three preliminary sketches of the house, (all National Library of Wales) from one of which this watercolour was painted
National Gallery of Scotland

PAUL SANDBY
4.26 Fulling Mill
Pen and watercolour. 16.4 × 30.5 cm
Inscribed: *C Scotch laundresses* and *a fulling mill, Fife*
National Gallery of Scotland

PAUL SANDBY
4.27 Lead Mine, Dumfriesshire fig 43
Pen and watercolour. 13.5 × 34.2 cm
Inscribed: *Lord Hopetouns lead mines.*
Lent by Somerville and Simpson Ltd, London

PAUL SANDBY
4.28 **Lead mine, Dumfriesshire**
Pen and watercolour. 12.1 × 23.6 cm
Inscribed on the verso *Ennoch Wack Mill near Drumlanrig*
Lent by Somerville and Simpson Ltd, London

PAUL SANDBY
4.29 **Tantallon Castle, East Lothian**
Pen and watercolour. 25.0 × 36.2 cm
On the verso is a contemporary inscription *Tam Tallin
Ruins of a castle N.W. Berwick opposite the Bass Rock 1750
P.S. Bothwell here first carried Mary Queen of Scotland*
National Gallery of Scotland

PAUL SANDBY
4.30 **Haddington, East Lothian**
Etching. 18.4 × 23.4 cm
This is one of a set of six etchings made in 1748
National Gallery of Scotland

PAUL SANDBY
4.31 **South view of Bothwell Castle, Lanarkshire** fig 41
Pen and grey wash. 24.5 × 37.8 cm
Inscribed: *South view of Bothwell Castle* and signed *P.
Sandby delin*
On the verso is a wash drawing of Calderwood Linn on
the Clyde. This view of the castle is one of four sketches
made on the spot. The others are all in the National
Library of Wales
National Gallery of Scotland

PAUL SANDBY
4.32 **South view of Bothwell Castle**
Etching. 27.9 × 38.3 cm
Sandby published two views of the castle in his set of six
large Scottish landscapes the other shows the interior of
the castle.
National Gallery of Scotland

PAUL SANDBY
4.33 **South view of Bothwell Castle** pl iv
Gouache. 47 × 62 cm
Signed: *P. Sandby 1770*
Like the etching (4.32) this gouache has been worked up
from Sandby's preliminary sketch (4.31)
National Gallery of Scotland

PAUL SANDBY
4.34 **South west view of Bothwell Castle** fig 42
Pen and watercolour. 32.1 × 47.4 cm
Signed: *Paul Sandby pinxit* and inscribed *Bothwel Castle in
Clydsdale*
Like the gouache view (4.33) this watercolour was made long
after Sandby left Scotland. It may have been one of a number
of views of the castle that he exhibited at the Royal Academy
National Gallery of Scotland

PAUL SANDBY
4.35 **Interior of Bothwell Castle**
Pen and pencil. 31.8 × 41.7 cm
Inscribed: *Sandby* twice
National Gallery of Scotland

PAUL SANDBY
4.36 **Drawwell at Broughton, near Edinburgh** fig 46
Watercolour. 16.5 × 23.0 cm
Sandby shows the well in the background of 4.37E
where it emphasises the local flavour of the poem, the
Gentle Shepherd, which is set in the vicinity of
Edinburgh
Lent by the Trustees of the British Museum

PAUL SANDBY
4.37 **Five illustrations to the Gentle Shepherd** E fig 47
A. Etching. 26.9 × 19.6 cm
Signed: *P. Sandby invt sculp 1758*
An illustration to the opening lines of the poem the
prologue to Act I scene 1
'Beneath the south side of a craigy beild,
Where crystal springs the halesome waters yield,
Twa youthful shepherds on the gowans lay
Tenting their flocks ae bonny morn of May'

B. Etching. 26.6 × 19.2 cm
An illustration to the prologue to Act I scene 2
'A flowrie howm between two verdant braes,
Where lasses use to wash and spread their claiths,
A trotting burnie wimpling thro' the ground,
Its channel peebles, shining, smooth and round,
Here view twa barefoot beauties clean and clear;
First please your eye, next gratify your ear,
While Jenny what she wishes discommends,
And Meg with better sense true love defends'

C. Etching. 26.8 × 19.7 cm
An illustration to the prologue to Act II scene 4
'Behind a tree, upon the plain
Pate and his Peggy meet,
In love, without a vicious stain
The bonny lass and chearfu' swain
Change vows and kisses sweet'
In the background is a view of Edinburgh and the
Firth of Forth

D. Etching. 27.2 × 19.6 cm
An illustration to the prologue to Act III scene 3
'Jenny pretends an errand hame,
Young Roger draps the rest
To whisper out his melting flame
And thow his lassie's breast.
Behind a bush, well hid frae sight, they meet:
See Jenny's laughting; Roger's like to greet.
Poor shepherd!'

E. Etching. 27.1 × 19.7 cm
 Signed: *P. Sandby invt sculp 1758*
 An illustration to the following passage in Act IV
 scene I
 'Madge "Ye filthy dog!"
 Flees to his hair like a fury—A stout battle Mause
 endeavours to redd them
 Mause "Let gang your grips, fy Madge! howt
 Bauldy leen
 I wadna wish this tulzie had been seen
 Tis sae daft like"
 Bauldy gets out of Madge's clutches with a bleeding
 nose'

This set of etchings are the earliest known illustrations of
Allan Ramsay's poem
National Gallery of Scotland

DAVID ALLAN 1744–1796
4.38 **Illustration to Act IV scene I of
 'The Gentle Shepherd'**
Etching and aquatint. 26.2 × 20.0 cm
Allan must have been familiar with Sandby's etchings
for he has shown Bauldy's dog attacking Madge. This
was etched by Sandby but is not in fact part of
Ramsay's poem
National Gallery of Scotland

PAUL SANDBY
4.39 **The Collegiate Church, Hamilton,
 Lanarkshire**
Watercolour and bodycolour. 16.7 × 23.0 cm
Signed and dated 1750
Lent by the Trustees of the British Museum

THOMAS COCKING active 1783–1791
4.40 **The Collegiate Church, Hamilton**
Watercolour. 16.2 × 19.8 cm
This watercolour is a copy of 4.39 by Francis Grose's
amanuensis
Lent by the Trustees of the National Library of
Scotland MS 30.5.23.65

HOOPER after FRANCIS GROSE c1731–1791
4.41 **The Collegiate Church, Hamilton**
Engraving from Grose's *Antiquities of Scotland* 1797. 15.5
× 20.5 cm
Sandby's Scottish views had a wide circulation for they
were published in many eighteenth century accounts of
the country
National Gallery of Scotland

GEORGE HUTTON died 1827 and PAUL SANDBY
4.42 **Inchmahome Priory, Perthshire** fig 48
Pencil, Pen and wash. 29.0 × 46.5 cm
Hutton wrote to his friend and fellow antiquary John
Spottiswoode 'It will give me the greatest pleasure
should my sketches be of any service to you, I regret
extremely they are not finished but if Mr Sandby can be
prevailed upon to throw a few shades upon them,
perhaps it may be sufficient to direct the engraver, as
the outlines are drawn very minutely.' National Library
of Scotland MS29.33 f 189
Lent by the Trustees of the National Library of
Scotland MS 30.5.23.113

JOHN CLERK 1728–1812
4.43 **Duart Castle**
Grey and brown wash. 14.8 × 25.8 cm
Clerk's drawing is a copy of 4.6 a drawing which he
most likely owned
National Gallery of Scotland

JOHN CLERK
4.44 **Duart Castle**
Etching. 3.9 × 13.6 cm
National Gallery of Scotland

ALEXANDER RUNCIMAN
4.45 **Blackness Castle, West Lothian**
Brown grey and blue wash. 11.2 × 19.9 cm
Signed: *AR*
This is probably a very early watercolour by Runciman.
It shows how close his style was to Sandby's
National Gallery of Scotland

DAVID ALLAN
4.46 **Scenes in the High Street, Edinburgh**
Pen and watercolour.
A. 12.6 × 11.1 cm B. 12.3 × 15.0 cm
Allan's High Street scenes are similar to Sandby
(4.17c). Allan's series of Edinburgh characters may also
have been based on Sandby's London cries
National Gallery of Scotland

E SCOTT after PAUL SANDBY
4.47 **North west view of Dunstaffnage Castle,
 Argyll**
Engraving from Sandby's *150 select views in England,
Wales, Scotland and Ireland* 1782. 16.0 × 20.3 cm
Sandby's engraved views helped introduce Scotland to a
British audience. The preliminary drawing of
Dunstaffnage Castle is in the National Library of Wales
National Gallery of Scotland

5

The Falls of Clyde

Paul Sandby was the first professional artist to record the series of spectacular waterfalls on the stretch of the River Clyde a few miles above and below Lanark. Sandby sketched his views in the late 1740s. Fifty years later the Falls, in particular the three most impressive, Bonnington Linn, Cora Linn and Stonebyres Linn, were firmly established on the Scottish tourist circuit and admired by increasing numbers of visitors each year. The Wordsworths and Coleridge, Farington and Turner all visited the Falls of Clyde and each was struck by the majesty of the scene, the violence of the water and overwhelmed by the force of nature untamed by man. Thomas Newte who visited Cora Linn in 1785 expressed his reactions vividly:

'At the distance of about a mile from this magnificent object, you see a thick smoke ascending to Heaven over the stately woods. As you advance you hear a sullen noise, which, soon after, almost stuns your ears. Doubling, as you proceed, a tuft of wood, you are struck at once with the aweful scene which suddenly bursts upon your astonished sight. Your organs of perception are hurried along, and partake of the turbulence of the roaring waters. The powers of recollection remain suspended by this sudden shock; and it is not till after a considerable time, that you are enabled to contemplate the sublime horrors of this majestic scene.... At both these places, [*Cora Linn and Stonebyres*] this great body of water, rushing with horrid fury, seems to threaten destruction to the solid rocks that enrage it by their resistance. It boils up from the caverns which itself has formed,

as if it were vomited out of the lower regions. The horrid and incessant din with which this is accompanied, unnerves and overcomes the heart. In vain you look for cessation or rest to this troubled scene. Day after Day, and year after year, it continues its furious course; and every moment seems as if wearied Nature were going to general wreck.'[1]

Sandby too was interested in the Falls as natural phenomena but his watercolour of Bonnington Linn (fig 49) shows that his reactions were more prosaic than those of later visitors. He took pains to record exactly what he saw, without exaggeration or effect. Sandby needed to record his views with precision for they were to form a body of work that was later to be engraved in illustrated books of views. A similar factual accuracy, even understatement, characterises the earliest written accounts of the Falls. The peripatetic Richard Pococke travelling in Scotland in 1760 saw the Falls from the same detached position:

'As you come nearer you are most agreeably surprised in seeing a most extraordinary cataract of the whole river.... The high rocks on each side are most beautifully adorned with trees, being altogether the finest cascade I ever saw. It falls about five feet down, and about fifteen feet wide. It then widens on both sides, and runs down fifty, and for ten feet before the next fall the water forms a froth by the breaking on the rocks, it then falls about twelve feet, and there are two streams divided by the rocks on the west side. After running fifty

feet it falls first about ten feet on a shelf, and then about twenty in a sheet a little broken by the rocks, forms a large basin, and turns to the west.'(2)

Jacob More would probably never have seen Sandby's drawings of the Falls. The engravings after them were not published until well after More had exhibited his views and had left Britain. Like Sandby, More painted the Falls from different heights and angles to give

themselves. In narrowing the angle of his view he gained a greater impact, emphasising the feeling that the spectator is actually at the bottom of the Falls. More had learnt this more direct approach to landscape from the French artist, Claude Vernet. In fact one of the few very modern continental paintings of quality that could be seen by an art student in More's day was Vernet's *Landscape with a Waterfall* which hung at Dalkeith Palace (fig 54). More must have studied Vernet's

Fig 49
PAUL SANDBY
Bonnington Linn
no. 5.1

his set of views variety. Unlike Sandby his concern was not with factual reporting but in producing a fine work of art. The drawing for the view of Stonebyres (fig 51) encompasses the wide panorama that an earlier artist might have drawn, but in his painting (fig 50) More abandoned the landscape to the right hand side and concentrated on the Falls

technique, but just as important he learnt the new and fashionable vocabulary of modern landscape painting; the gnarled tree, the jagged rocks and the picturesque group of spectators were all transported from Vernet's painting to the banks of the Clyde (fig 52). More blended the accessories of Vernet's view with his own vision of a Scottish waterfall and produced an image much more sophisticated than Sandby's, where human and natural interest is finely balanced. The human figures in More's three paintings are all important in

48

Fig 50
JACOB MORE
Stonebyres Linn
no. 5.5

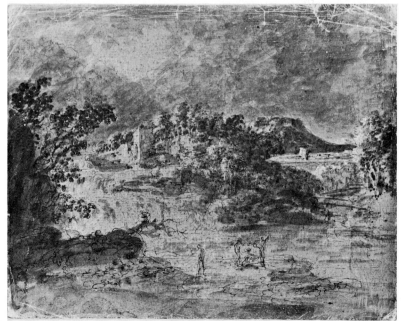

Fig 51
JACOB MORE
Stonebyres Linn
no. 5.6

49

leading the spectator into the painting. They are all deliberately painted pursuing activities, collecting driftwood or sightseeing, that would be quite feasible where the figures are shown (pl iv and fig 53). All More's figures would have reached their position in the landscape without undue difficulty, not so the figures in views by later artists. Francis Nicholson, painting thirty years later than More at the beginning of the nineteenth century was happy enough to paint washerwomen laundering their clothes in one of the most inaccessible points on this stretch of the Clyde (fig 55). Turner's Naiads too show no sign of exertion after their precipitous descent to the rocks below Cora Linn (fig 56).

The Rev William Gilpin was one of the first writers to suggest that an association whether poetic or historical could enhance a view. He wrote of the Falls of Clyde:

'In our travels through Scotland I have

Fig 52
JACOB MORE
Bonnington Linn
no. 5.4

mentioned many scenes, which were ennobled by being called the retreats of Wallace. This was one. Among these wild rocks, and in the tower, that adorns them, we were told, he lurked, during a period of distress. These traditional anecdotes, whether true, or fabled, add grandeur to a scene.'[3]

By 1800 fantasy had overtaken fact, exaggeration and inaccuracy were accepted without qualm. Naiads were at home on the banks of the Clyde, the spirit of Wallace lived in the caves and castles by its side.

The circular building that stands above Bonnington Linn was not one of Wallace's haunts. Sandby's view makes it clear that the building was the doo'cot of the Bonnington estate. It may have become dilapidated in the twenty years between Sandby and More's visits but it was More's picturesque imagination that converted the practical doo'cot

Fig 53
JACOB MORE
Cora Linn
no. 5.3

Fig 54
CLAUDE VERNET
Landscape with a waterfall
The Duke of Buccleuch and Queensberry

Fig 55
FRANCIS NICHOLSON
Bonnington Linn
no. 5.9

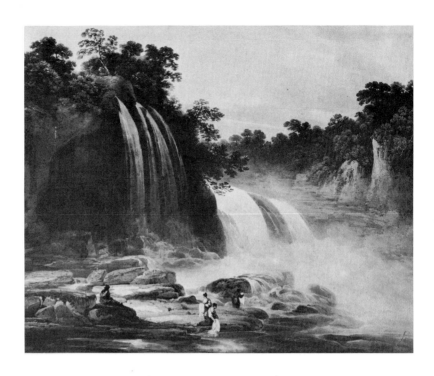

Fig 56
JOSEPH M. W. TURNER
Cora Linn
no. 5.10

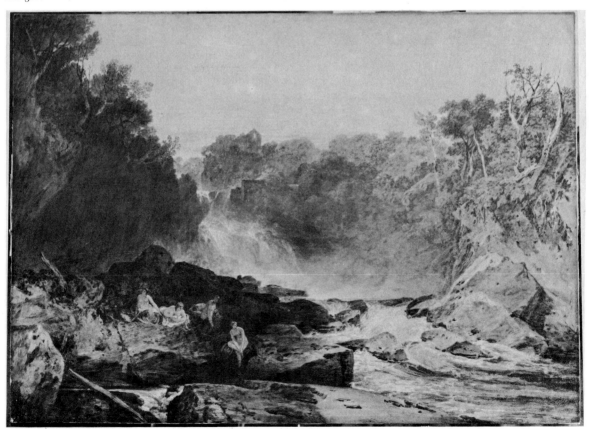

into an overgrown ruined tower, skilfully adapting the real scene to an ideal one.

Alexander Nasmyth's view (fig 57) painted around 1790 shows the building much closer to its original doo'cot shape—showing incidentally just how much More's imagination and not time had altered it. By Nasmyth's day the building had been carefully adapted by the proprietor of the Bonnington Estate. It was this building that Dorothy Wordsworth described after her visit to the Clyde in 1803.

'We came to a pleasure-house, ... called the Fog house, because it was lined with 'fog', namely moss. On the outside it resembled some of the huts in the prints belonging to Captain Cook's Voyages and within was like a hay-stack scooped out. It was circular, with a dome-like roof, a seat all round fixed to the wall, and a table in the middle,—seat, wall, roof and table all covered with moss in the neatest manner possible. It was as snug as a bird's nest.'[4]

In only half a century the same building had been seen by different generations as an eighteenth-century doo'cot, a ruined medieval castle and a rustic belvedere in the style of the South Pacific indians.

(1) T Newte *A Tour in England and Scotland* 1791 pp 56 + 7.

(2) R Pococke *Tours in Scotland* published by the Scottish History Society 1887 p 46.

(3) W Gilpin *Observations on several parts of Great Britain, particularly the Highlands of Scotland relative chiefly to picturesque beauty made in the year 1776.* 1st edition 1789 Vol II p 73.

(4) D Wordsworth *Recollections of a Tour made in Scotland AD 1803.* Edited by J C Shairp 1874 pp 37–38.

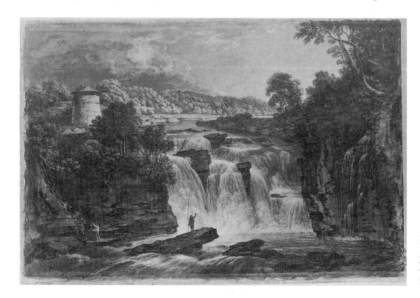

Fig 57
ALEXANDER NASMYTH
Bonnington Linn
no. 5.7

PAUL SANDBY 1725–1809
5.1 **Bonnington Linn, Lanarkshire** fig 49
Pen and watercolour. 25.7 × 37.6 cm
Sandby's view of about 1750 is the earliest known drawing of the waterfall. It was first engraved in the *Virtuosi's Museum* 1778
National Gallery of Scotland

RYDER after PAUL SANDBY
5.2 **Cora Linn, Lanarkshire**
Engraving. 16.0 × 20.8 cm
This engraving was first published in 1778
Lent by the Royal Commission on the Ancient and Historical Monuments of Scotland, Edinburgh

JACOB MORE 1740–1793
5.3 **Cora Linn** pl v and fig 53
Oil on canvas. 79.4 × 100.4 cm
More painted at least two versions of this painting one of which was exhibited in London in 1771
National Gallery of Scotland

JACOB MORE
5.4 **Bonnington Linn** fig 52
Oil on canvas. 70.5 × 90.2 cm
More has used his artistic licence to rebuild as a romantic ruin what Sandby (5.1) shows as a doo'cot
Lent by the Syndics of the Fitzwilliam Museum, Cambridge

JACOB MORE
5.5 **Stonebyers Linn, Lanarkshire** fig 50
Oil on canvas. 81.0 × 101.5 cm
Lent by the Trustees of the Tate Gallery, London

JACOB MORE
5.6 **Stonebyers Linn** fig 51
Pen and wash on prepared paper. 26.2 × 32.9 cm
This is More's preliminary sketch from which 5.5 and other views of the fall would have been painted
National Gallery of Scotland

ALEXANDER NASMYTH 1758–1840
5.7 **Bonnington Linn** fig 57
Gouache on grey paper. 38.8 × 58.0 cm
By 1791 Nasmyth had already painted three sets of views of the three main waterfalls. His patrons included the Duchess of Buccleuch
Lent by the visitors of the Ashmolean Museum, Oxford

ALEXANDER NASMYTH
5.8 **Cora Linn**
Gouache on grey paper. 38.8 × 58.0 cm
Lent by the visitors of the Ashmolean Museum, Oxford

FRANCIS NICHOLSON 1753–1844
5.9 **Bonnington Linn** fig 55
Watercolour. 52.5 × 66.3 cm
Nicholson visited Bonnington Linn in 1806
Lent by the Laing Art Gallery, Newcastle-upon-Tyne

JOSEPH M W TURNER 1775–1851
5.10 **Cora Linn** fig 56
Watercolour. 74.5 × 105.8 cm
This watercolour was based on sketches that Turner made on his first Scottish tour in 1801. It was exhibited at the Royal Academy in 1802 as 'The fall of the Clyde, Lanarkshire: Noon-vide Akenside's Hymn to the Naiads.'
Lent by the Walker Art Gallery, Liverpool

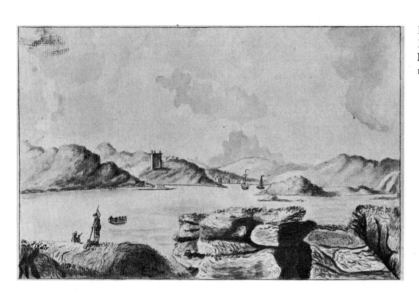

Fig 58
MOSES GRIFFITH
East Loch Tarbert
no. 6.2

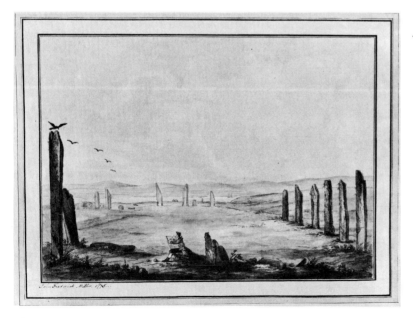

Fig 59
JOHN MILLER
The Stones of Stenness
no. 6.6

6
Landscape of Fact and Fancy

The idea promoted by the Rev William Gilpin and accepted by Dorothy Wordsworth that a natural beauty spot could be enhanced by association with the historical or literary past gained general acceptance as the eighteenth century drew to a close. Perhaps the earliest example in Scotland of this kind of association between the historic past and the landscape stood in the grounds of Taymouth Castle for in the 1750s Lord Glenorchy had built a Druid Temple in an area rich in prehistoric settlements. The Temple was exceptional. A solitary swallow whose summer did not come until the end of the century. Then Lord Glenorchy's temple would have seemed much less remarkable for by 1800 Wallace's caves, Wallace's trees and Ossian's seats were to be found throughout the country.

Information about the historical past of the nation became much more accessible with the publication of two important books; Francis Grose's *Antiquities of Scotland* in 1797 and Thomas Pennant's two Tours in Scotland in 1771 and 1774–5. Pennant's curiosity was wide-ranging, interested in anything from natural history to fine art. He could not cover the whole country completely in his two visits in 1769 and 1772 so he relied on correspondents throughout Scotland, men like the Rev Charles Cordiner of Banff, the Rev George Low on Orkney and George Paton in Edinburgh, to supplement and correct his facts. Pennant had no draughtsman in 1769. He intended to take William Tomkins on his second tour but as he wrote to George Paton on 13 May 1772 'By the usual folly and desultoriness of artists I am disappointed of my landscape painter at a moments notice. As

one is essential to my scheme, I must trouble you to look out for one at Edinburgh one that is alert quick in inking sketches, with some taste, a fair character, peacable disposition. I shall be at or near Glasgow from the 8th of June to the 19th and glad to see specimens of his performance in India ink.'[1]

Paton, however, cannot have found a suitable candidate in Edinburgh for the Welshman Moses Griffith was Pennant's draughtsman that year. Griffith's drawings are not elegant or picturesque but they are packed with the same factual information that Pennant wanted to convey to his readers (fig 58).

'Turn Northward, leave the point of *Skipnish* to the S. West, and with difficulty get through a strait of about a hundred yards wide, with sunk rocks on both sides, into the safe and pretty harbour of the Eastern *Loch-Tarbat*, of capacity sufficient for a number of ships, and of fine depth of water. The scenery was picturesque; rocky little islands lie across one part, so as to form a double port; at the bottom extends a small village; on the *Cantyre* side is a square tower, with vestiges of other ruins, built by the family of *Argyle*, to secure their Northern dominions from the inroads of the inhabitants of the peninsula: on the Northern side of the entrance of the harbour the rocks are of a most grotesque form: vast fragments piled on each other; the faces contorted and undulated in such figures as if created by fusion of matter after some intense heat; yet did not appear to me a *lava*, or under any suspicion of having been the recrement of a *vulcano*.'[2]

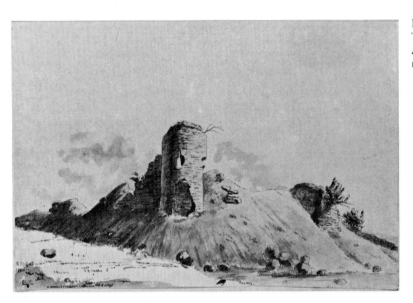

Fig 60
THOMAS COCKING
Auchencass Castle
no. 6.7

Fig 61
JOHN BROWN
Holyrood Gatehouse
no. 6.11

Here is information on the history, scenery, the port facilities and geology of an area quite unknown to the great majority of Pennant's readers.

Pennant also made use of the drawings and information that Joseph Banks had collected on his scientific expedition to Iceland in 1772. Banks was to have accompanied Captain Cook on his second voyage round the world but plans were changed at the last moment and Banks decided to sail to Iceland visiting the Hebrides on his way north and Orkney on his return. Banks was joined on Orkney by George Low and together they excavated a prehistoric burial mound on the links of Skaill and measured the circle of standing stones at Stenness (fig 59).

Francis Grose was in Scotland during the summers of 1788, 1789 and 1790 to record the castles and religious buildings of the country. Like Pennant, Grose relied on a group of fellow antiquaries who shared their knowledge and their drawings. When Grose visited his friend Robert Riddell at his home in Nithsdale in May 1790 he brought with him the drawings that Moses Griffith had made for Pennant in 1772. Tom Cocking, Grose's draughtsman and servant, copied them for Riddell. Two men who also shared Grose's antiquarian interests and helped him in his research were Captain George Hutton, who was himself working on a study of the monastic houses of Scotland and Lord Buchan, a former pupil of Sandby at the Woolwich Academy. In 1786 Buchan had bought the ruins of Dryburgh Abbey to protect them from destruction. Robert Burns, a neighbour of Riddell was a friend of Grose; *Tam O'Shanter* was first published under Grose's entry on Alloway Church.

From Friars Carse, his home in Dumfriesshire, Robert Riddell set out with his guest to record the antiquities of southern Scotland; they were fascinated by ruins (fig 60) and curious about the genealogies of the families who once lived there. They admired the modern as well as the old, as for instance at Dalquharran where Robert Adam's newly built mansion stood opposite the remains of the old house.

Grose covered southern Scotland thorough-ly but he saw surprisingly little of the country north of the Kingdom of Fife. He made one expedition in the summer of 1790 as far as Moray recording the castles and abbeys on the coast along his route. For the rest he relied on Pennant's material.

It was not only the amateurs and antiquaries who valued what was just beginning to be recognised as an important heritage. Artists too were interested in the medieval buildings amongst which they lived. John Runciman recorded the destruction of the ancient Netherbow Port on the Royal Mile and his brother Alexander and John Brown made records of the recently destroyed gatehouse at Holyrood (fig 61).

Awareness of and respect for the past grew during the last third of the eighteenth century. The publications of men like Grose and Pennant and the poetry of Ossian stimulated an interest in Scottish history that was only to be satisfied by the writings of Sir Walter Scott.

The poetry of Ossian which aroused such interest throughout the country inspired few Scottish artists. The only one who chose to illustrate Ossian was Alexander Runciman. By training Runciman was a landscape painter but the lack of visual imagery in the poetry meant that he was forced both in his etchings and in his great ceiling at Penicuik House to paint the activities of the heroes and heroines of Gaelic mythology divorced from their native landscape. It was not as if Runciman was defeated by the idea of such a combination of figures and landscape for he painted just such in an illustration to Milton's *Allegro*. If Ossian's poetry provided little subject matter for landscape painters Ossian himself could be imagined as a Gaelic Homer or Celtic river god sounding his harp on the edge of a mountain torrent (fig 62). John Clerk thought of Ossian when out walking.

'We went on Sunday with an intention to go up to the high hill called Gete Fell or the windy hill altho it was cloudy on the top,—it did not clear, but we were as highly pleased to see the dark clouds and fogs rolling in the deepest glens below us, as if we had got to the top, and you may trust

Fig 62
After CHARLES CORDINER
Cascade near Carrol
no. 6.15

Fig 63
JACOB MORE
Figures outside a cave
no. 6.17

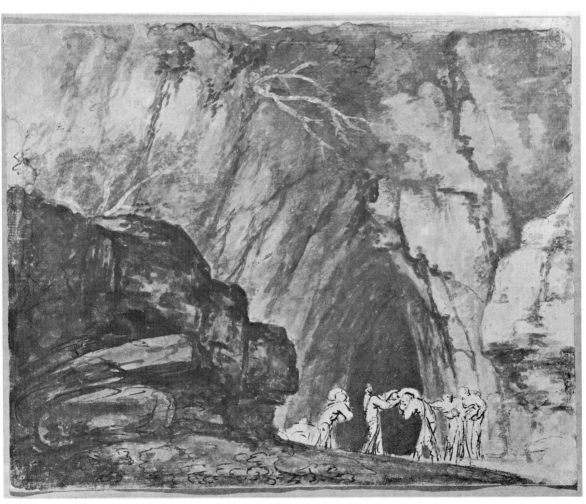

Ossian that his descriptions of these things are not exagirated, we threw or rather pushed over great stones, and were I to tell you thire size, you would not believe me, as it was darker than ordinary we saw great quantity of fire fly from ye stones as the bounded and brooke.'[3]

Not surprisingly perhaps painters looked to other artists rather than to writers for their landscape imagery. Salvator Rosa, the great

in terms of a painting by Salvator. In a poem by John Beugo, Alexander Runciman is set up to challenge the seventeenth-century artist.

'Shall Rosa's shade be known o'er Esk to fly,
and Runc'man's genius pass unheeded by?
Runc'mun, who sought where nature's grandeur lay,
Whose eye pursued, where fancy led the way.'[4]

Fancy could lead in all sorts of directions. For

Fig 64
JACOB MORE
A natural arch
no. 6.16

romantic landscape painter of the previous century, inspired the generation of artists that was painting in the 1760s and 1770s. Jacob More, John Clerk, Richard Cooper and Alexander Runciman were amongst many who painted mysterious scenes of soldiers and bandits set in either real or imaginery landscapes (fig 63). Indeed contemporary commentators could see the Scottish countryside

Jacob More it led to a type of imaginary landscape that was a fusion of his own observations and the decorative tradition in which he had been trained (fig 64). Robert Adam made watercolours of upland twilight landscapes (fig 65), always distinctively Scottish but seldom of recognizable places. His architectural designs for castles, Culzean and Seton for instance (fig 66), were romantic recreations of the past. In the watercolours of John Clerk fact and fancy often merge. The tiny figures in the foreground of his view of Castle Stalker suggest that he was drawing the

Fig 65
ROBERT ADAM
A castle on a moorland
no. 6.21

Fig 66
ROBERT ADAM
Seton Castle

Castle as it must have appeared centuries before. The same type of figures occur in his view of the Castle of Udolpho, the great Appenine fortress of Gothick fiction (pl vi). Clerk's castle with its grouped towers and machicolations could have been designed by his brother-in-law so close is it to Robert Adam's own buildings.

The last years of the eighteenth century saw the beginning of modern tourism in Scotland. A steady flow of visitors both from within the

four days and from hence yesterday to Inverary, they had been at Dunkeld and Blair. His ldp [Lordship] either from real opinion or from politeness gave the preference to Taymouth then to Dunkeld and lastly to Blair; he found greater variety of objects here, than at the others tho the extraordinary drought of this year has deprived it of some of its wild beauties by the lowness of the river and want of water in the natural cascades.'[6]

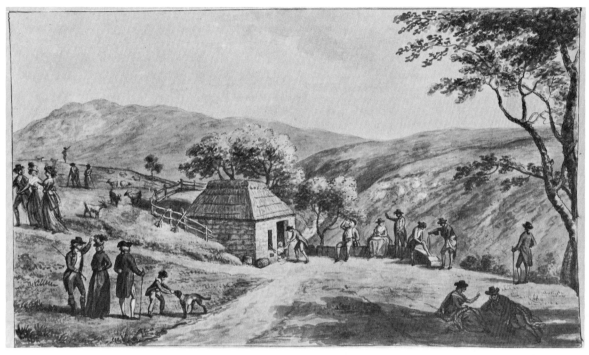

Fig 67
DAVID ALLAN
Moffat Mineral Well
no. 6.27

Fourteen years later in 1773 the increasing number of visitors was becoming a burden to the earl.

country and from south of the border wanted to see for themselves the places made famous in the books of views published by Sandby, Pennant and Grose. Lord Breadalbane noted the trend as early as 1759 when he wrote to his daughter from Taymouth

'It has been the fashion this year to travel into the highlands, many have been here this summer from England, I suppose because they can't go abroad.'[5]

'Lord Lyttleton and his son were here

'We have had a great deal of company here this summer, sixteen often at table for several days together; many of them from England, some of whom I knew before, and others recommended to me, being on a tour thro the Highlands which is becoming *Le bon ton*, but sometimes a little troublesome. Being always in a crowd is not agreeable.'[7]

Several places, particularly in southern Scotland, became established as tourist centres. Moffat with its mineral springs and baths (fig 67) was a fashionable resort as early

as the 1720s when Sir John Clerk of Penicuik went annually to take the waters. Roslin with its Gothic Chapel and Castle ruins (fig 68) situated high up above the picturesque valley of the North Esk was close enough to Edinburgh to be reached in a day's excursion. Unlike Moffat, Dunkeld (fig 69) boasted no mineral springs but claims were made for the purity of its air, the medicinal effects of its goat's whey (particularly recommended to consumptive patients), and also the power of the surround-

ing scenery to induce serenity of mind (fig 70).[8] The idea that the contemplation of landscape could be beneficial or inspirational was an idea of the greatest importance, one from which new attitudes towards landscape developed in the nineteenth century.

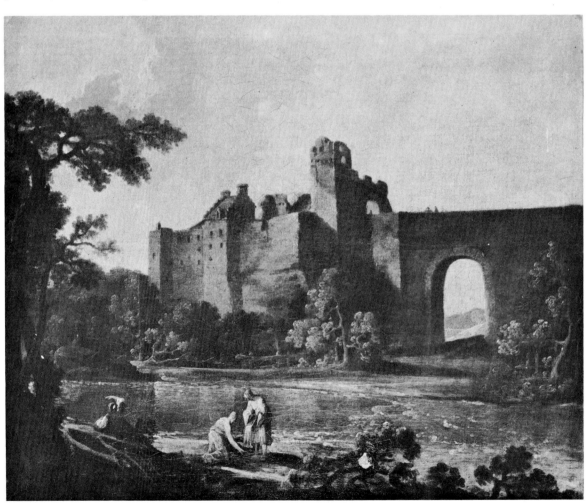

Fig 68
JACOB MORE
Roslin Castle
no. 6.29

(1) Pennant's letter to George Paton is in the National Library of Scotland MS 29.5.5(i) fol 23r + v.

(2) Thomas Pennant *A Tour in Scotland and a voyage to the Hebrides 1772* p 165 of 1774 edition.

(3) From a letter of 4/9/1763 from John Clerk to Margaret Adam. Register House GD18/5486/4/1.

(4) From John Beugo's poem *Esk Water* 1797.

(5) From a letter of 11/8/1759 from Lord Breadalbane to his daughter the Marchioness Grey. Bedford Record Office L30/9/17/23.

(6) From a letter of 1/9/1759 from Lord Breadalbane to his daughter. Bedford Record Office L30/9/17/24.

(7) From a letter of 3/9/1773 from Lord Breadalbane to his daughter. Bedford Record Office L30/9/17/192.

(8) For the beneficial effects of scenery on the mind see Dr T Garnett. *Tour in the islands* 1800 Vol II p 73.

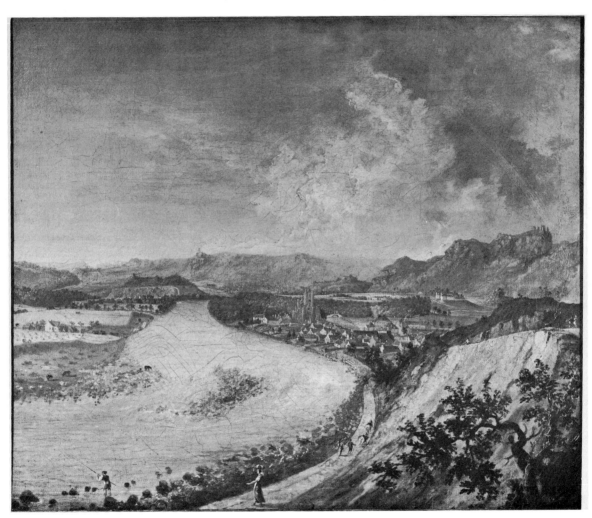

Fig 69
CHARLES STEUART
Dunkeld
no. 6.31

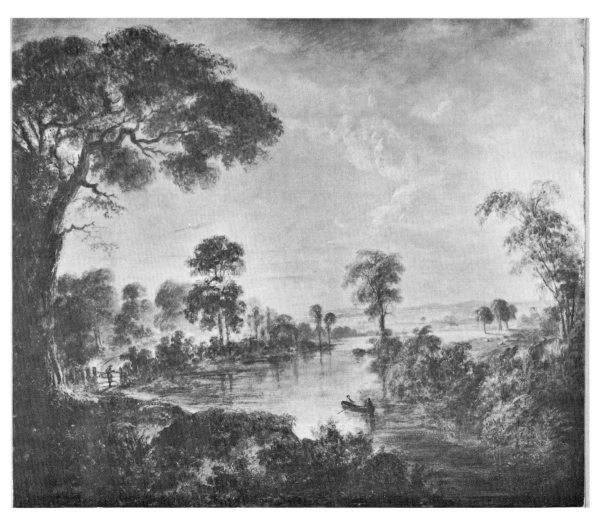

Fig 70
ALEXANDER RUNCIMAN
View on the Tay
no. 6.34

ALEXANDER NASMYTH 1758–1840
6.1 **Wallace's Tree**
Pencil. 13.9 × 13.7 cm
Inscribed by the artist *Wallace's tree at Elderslie Renfrewshire AN* and inscribed by his son James *Alex Nasmyth 1819*
National Gallery of Scotland

MOSES GRIFFITH 1747–1819
6.2 **East Loch Tarbert, Argyll** fig 58
Pen and wash. 15.5 × 24.4 cm
Inscribed: *View of Tarbat Bay*
National Gallery of Scotland

MOSES GRIFFITH
6.3 **McDonald's Inn, Ross-shire**
Grey wash. 12.3 × 18.6 cm
Inscribed: *Roderick McDonald's an inn in Rosshire*
Thomas Pennant was interested in the distinctive characteristics of Scotland whether it was her flora and fauna or, in this case, a type of building
National Gallery of Scotland

CHARLES CORDINER 1746–1794
6.4 **Rocks near Banff**
Watercolour. 18.9 × 29.7 cm
Inscribed on the verso *Rocks near Banf 1790*
Cordiner supplied Pennant with many drawings made in the North East. Some of his views of the coastal scenery of Banffshire were engraved in Pennant's 'Arctic Zoology'
National Gallery of Scotland

JOHN CLEVELEY, Jnr 1741–1786
6.5 **The burial ground at Kilarow, Islay**
Watercolour. 27.8 × 40.5 cm
Signed: *John Cleveley Junr Delin^t 1772*
Cleveley has probably depicted his patron Joseph Banks examining a carved slab
Lent by the British Library Board. Department of Manuscripts MS 15,509 f 10

JOHN F MILLER active 1768–1780
6.6 **The Stones of Stenness, Orkney** fig 59
Watercolour. 20 × 28 cm
Signed: *John Frederick Miller 1775*
The watercolour was worked up from a sketch made in 1772
Lent by The British Library Board. Department of Manuscripts MS 15,511 f 8

FRANCIS GROSE c 1731–1791
6.7 **Dalquharran, Ayrshire**
Pen and wash. 25.9 × 36.3 cm
Riddell recorded on the 2 August 1789 'Reached the new house of Dalquharran, a most elegant Pile of Building in the gothick taste, planned by Mr Robert Adams.... Captain Grose made a neat drawing of this elegant house, which is seated on a fine wooded bank, overhanging the water of Girvan, and has every advantage that wood and water can afford it.' (Library of the Society of Antiquaries of Scotland Riddell MS IX pp 200–1)
National Gallery of Scotland

THOMAS COCKING active 1783–1791
6.8 **Auchencass Castle, Dumfriesshire** fig 60
Pen and watercolour. 18.0 × 26.7 cm
Inscribed on the verso *Ackencass Castle Annandale No 2*
Robert Riddell recorded in his journal 'Next morning early [May 20 1790] Captain Grose sent his servan Tom to Auchencass Castle, who made a drawing of that once famous place.... It is now a miserable ruin.' (Library of the Society of Antiquaries of Scotland ANT MSS 586 p 284)
National Gallery of Scotland

CHARLES CATTON, Jnr 1756–1819
6.9 **Melsore Abbey, Roxburghshire**
Watercolour. 40.4 × 60.6 cm
Catton is not known to have visited Scotland. Lord Buchan sent him in London drawings of Dryburgh Abbey which Captain Hutton had made. This view of Melrose may also have been based on drawings by local antiquaries, quite possibly Hutton himself. The watercolour was engraved by Jukes in 1798
National Gallery of Scotland

JOHN RUNCIMAN 1744–1776
6.10 **The demolition of the Netherbow Port, Edinburgh**
Proof etching with pen additions. 21.4 × 16.4 cm
Inscribed: *John Runciman fecit* (The 'John' later changed to 'A')
National Gallery of Scotland

JOHN BROWN 1752–1787
6.11 **Holyrood Gatehouse, Edinburgh** fig 61
Watercolour. 25.9 × 40.0 cm
Brown's drawing is probably copied from a lost drawing made before the destruction of the gatehouse in 1753
Lent by The British Library Board. Map Library K. Top XLIX 68.1

JOB BULMAN active 1760s
6.12 **Dunsinane Hill, Perthshire**
Watercolour. 27.4 × 38.7 cm
Signed: *J. Bulman* and inscribed on the verso *Fear not 'till Birnham wood do come to Dunsinane Act 5 scene 5, Macbeth in Shakespear.*
Lent by the Trustees of the National Museum of Antiquities of Scotland

ALEXANDER RUNCIMAN 1736—1785
6.13 **The Finding of Corban Cargloss** (small version)
Etching. 16.5 × 25.4 cm
Inscribed: *A moon beam glittered on a rock in the midst stood a lovely form a form with floating locks vide Ossian Poems*
National Gallery of Scotland

ALEXANDER RUNCIMAN
6.14 **A Perthshire landscape with a scene from Milton's Allegro**
Oil on canvas. 63.5 × 76.2 cm
The city of Perth and the towers of Scone Palace can be seen on the left of the painting
Lent by The Hon Sir Steven Runciman

JAMES BASIRE after CHARLES CORDINER
6.15 **Cascade near Carrol, Sutherland** fig 62
Engraving from 'Scenery of the North of Scotland'. 11.3 × 14.8 cm
'Here, perhaps, has Carril, whose name is still preserved in these scenes, nursed his wild and desultory strains: here, "amidst the voices of rocks, and bright tumblings of waters, he might pour the sound of his trembling harp."' From *Scenery of the North of Scotland* (1780) p. 77
National Gallery of Scotland

JACOB MORE 1740–1793
6.16 **A natural arch** fig 64
Oil on canvas. 41.0 × 62.5 cm
The style of the painting suggests that it was painted before the artist left Scotland for Rome in 1773
Lent by Brinsley Ford Esq

JACOB MORE
6.17 **Figures outside a cave** fig 63
Pen and bodycolour. 26.7 × 32.9 cm
More made a number of drawings of soldiers and bandits. One is drawn on the verso of his Sketch of Stonebyers Linn (fig 51) indicating that they were made before he left Scotland
National Gallery of Scotland

JAMES CALLENDAR active 1770s
6.18 **Mountain landscape**
Green and grey wash. 19.3 × 30.6 cm
Signed: *Ja Callendar delin*
Little is known of the artist whose watercolour style is close to Alexander Runciman's
National Gallery of Scotland

RICHARD COOPER, Jnr c 1740–1814
6.19 **Mountain landscape with soldiers**
Pen. 29.8 × 40.7 cm
Signed: *R. Cooper*
National Gallery of Scotland

J. WISTGARTH active 1790s
6.20 **A Cave**
Pen and wash. 15.2 × 18.3 cm
Like James Callendar, Wistgarth was an amateur etcher and watercolour painter
National Gallery of Scotland

ROBERT ADAM 1728–1792
6.21 **A castle on a moorland** fig 65
Pen and watercolour. 24.3 × 30.4 cm
National Gallery of Scotland

ROBERT ADAM
6.22 **Landscape with a waterfall**
Watercolour. 26.6 × 32.0 cm
National Gallery of Scotland

JOHN CLERK 1728–1812
6.23 **Castle Stalker, Argyll**
Pen and watercolour. 22.7 × 29.7 cm
Clerk's view shows the castle not as it looked when he sketched it but as he imagined it must once have looked. His reconstruction was influenced by the architecture of the towers of eastern Scotland with which he would have been more familiar
Lent by Sir John Clerk of Penicuik, Bt

JOHN CLERK
6.24 **Loch Lubnaig, Perthshire**
Pen and watercolour. 23.5 × 28.8 cm
Lent by Sir John Clerk of Penicuik, Bt

JOHN CLERK
6.25 **The Castle of Udolpho** pl vi
Pen and watercolour. 16.9 × 21.3
Inscribed on the verso *Castle in the mystery of Eudolpho*;
Ann Radcliffe's novel 'The mysteries of Udolpho' was
published in 1794
Lent by Sir John Clerk of Penicuik, Bt

DAVID ALLAN 1744–1796
6.26 **Moffat, Dumfriesshire**
Watercolour. 17.4 × 29.0 cm
Inscribed: *Moffat 1795*
Lent by the Trustees of the late Mrs Magdalene Sharpe-
Erskine

DAVID ALLAN
6.27 **Moffat Mineral Well 1795** fig 67
Water colour. 23.5 × 43.4 cm
Signed: *D Allan del 1795* and inscribed *Moffat Well Aqui
pauperibus prodest, locupletibus Aqui-Horace*
Robert Riddell visited Moffat in 1790 and wrote 'Here
is a medicinal water, of the same nature, (tho' weaker)
than Harrowgate, and another called Hartfell Spar,
both much resorted to—particularly during the summer
vacation of the Court of Sessions at Edinburgh.' Library
of the Society of Antiquaries of Scotland ANT MSS 586
p 283
Lent by the Trustees of the late Mrs Magdalene Sharpe-
Erskine

WILLIAM DELACOUR died 1768
6.28 **Roslin Castle and Chapel, Midlothian,
from the south east**
Pen and watercolour. 32.7 × 74.7 cm
Signed: *De la cour delin 1761*
The precision of this drawing, quite unlike Delacour's
usual watercolour style, suggests that it and its com-
panion view from the north west were intended to be
engraved
Lent by the British Library Board. Map Library K. Top
XLIX 79 b

JACOB MORE
6.29 **Roslin Castle** fig 68
Oil on canvas. 73 × 90 cm
More exhibited a view of Roslin Castle at the Society of
Artists in 1771
Lent by The Rt Hon The Earl of Wemyss and March

JACOB MORE
6.30 **Roslin Castle**
Pen and pencil. 29.7 × 50.4 cm
This is a sketch for 6.29. A note to John Beugo's poem
'Esk water' records that 'Jacob More, the celebrated
landscape painter is known to have made his earliest
sketches on the Esk'
National Gallery of Scotland

CHARLES STEUART active 1760–1790
6.31 **Dunkeld, Perthshire from the east** fig 69
Oil on canvas. 51 × 59 cm
This is one of a set of six small views of Dunkeld and its
environs that Steuart painted for the Duke of Atholl
Lent by His Grace The Duke of Athol

CHARLES STEUART
6.32 **Waterfall**
Oil on canvas. 70 × 90 cm
Steuart painted many of the picturesque sites on the
Duke of Atholl's estates in Perthshire
Lent by the Hunterian Museum, Glasgow

JOHN CLERK
6.33 **The Tay at Dunkeld**
Pen and watercolour. 21.2 × 50.0 cm
Lent by Sir John Clerk of Penicuik, Bt

ALEXANDER RUNCIMAN
6.34 **View on the Tay** fig 70
Oil on canvas. 49.0 × 61.6 cm
Lent by The Hon Sir Steven Runciman

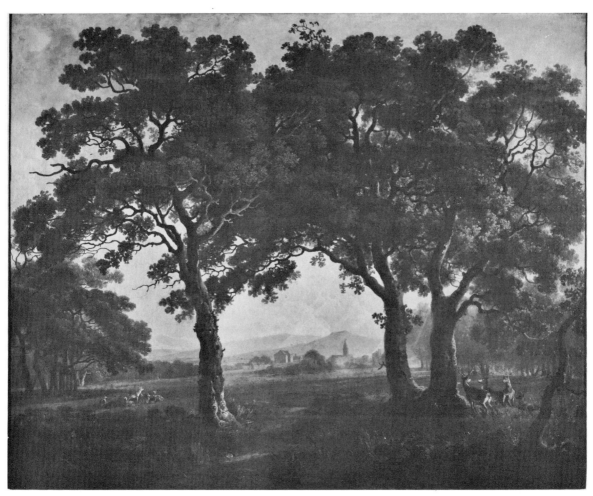

Fig 71
GEORGE BARRETT
Dalkeith Park with the House in the distance
no. 7.1

7

Provincial and Border Antiquities

The Lothians and the Esk

'Upon the whole,' wrote Scott, 'tracing the Eske from its source till it joins the sea at Musselburgh, no stream in Scotland can boast such a varied succession of the most interesting objects, as well as of the most romantic and beautiful scenery.'

'Sweet are the paths, O passing sweet,
By Eske's fair streams that run,
O'er airy steep, through copsewood deep,
Impervious to the sun;
Who knows not Melville's beechy grove
And Roslin's rocky glen,
Dalkeith which all the virtues love,
And classic Hawthornden?'

These lines from *The Grey Brother*, written while Scott was living in his cottage on the Esk near Lasswade may well, like the description of haunted Roslin in *The Lay of the Last Minstrel*, have brought the beauties of this valley to the attention of a wider public than would otherwise ever have heard of them, but the Esk was a noted beauty spot many years before Scott settled there, and he was far from being the first poet to celebrate its charm. Hardly any eighteenth or early nineteenth century tourist to Edinburgh failed to visit Roslin. Some, like John Stoddart in 1799 and the Wordsworths in 1803 were attracted by the presence of Scott, but others, Grose, Pennant, Farington, and Turner on his first visit, came independently, the first three mentioned long before Scott's residence. Allan Ramsay's poetic descriptions of the upper reaches of the Esk were probably unknown to Southern visitors, but they had heard of the sixteenth century poet Drummond, withdrawn into a melancholy and romantic seclusion at

his castle of Hawthornden, if only because the English dramatist Ben Johnson had visited him there.

'Deare Wood, and you sweet solitary Place
Where from the vulgare I estranged live'

Drummond had written, but by the second half of the eighteenth century this once secluded retreat of the Esk valley, an easy walk from the centre of Edinburgh, had turned into a popular recreational area for its jaded citizens. As such it was described by John Beugo, artist and engraver, in his 1797 poem *Esk Water*, which tells of an imaginary pilgrimage to Roslin early one morning. Less attractive as a poem than Scott's fragmentary *Grey Brother*, *Esk Water* is nevertheless of greater interest in connection with painted views of the Esk valley, because Beugo was looking at the scenery from an artistic standpoint, and applying the canons of late eighteenth century picturesque theory to what he saw. The literature dealing with the picturesque, in which the rules and theories were formulated, had been written in England, with no intended reference to specific Scottish scenes. Nevertheless, once formulated, picturesque theory proved to fit the actual scenery of the Esk like a glove. This partly explains the glen's popularity, and the droves of sketching visitors attracted there.

Beugo walked out to Roslin via Liberton, and he tells, in succession, of Roslin Castle, Roslin Chapel, Hawthornden, the rocks at Dryden, Penicuik House, Dalkeith, Melville, Mavisbank, Springfield, and the upper reaches of the Esk near Carlops. The tissue of his poem is woven out of visual observations

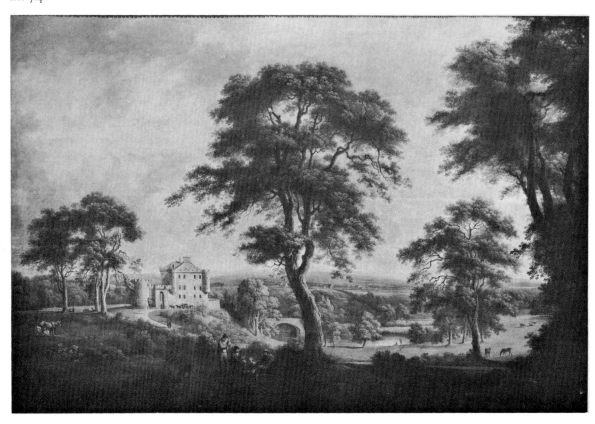

interspersed with associations, reflections, and memories of recent or distant historical events, the Esk river serving, along its length, as the thread to link the places described with each other, and the associations with the places. This mixture was to continue a familiar one in Scottish literary and pictorial treatment of rivers, re-emerging in the late nineteenth century with the illustrated river books of George Reid and D Y Cameron. 'Contrast' is the key concept in Beugo's response to the Esk.

'Sweet are the swelling banks, with verdure crown'd;
The groves delight which skirt the hill around;
Rugged the caves, where roars the th'impeded flood;
And grand the rocky wild o'erhung with wood.
Each object, singly, bears a passive part;
Contrast awakes them, and they seize the heart.
What were the scene, if only rocks were seen?
A wild fantastic, with a hateful mein.
What is the lengthen'd wood? a labour past,
Where every turn is gloomy as the last.
But, 'midst the op'ning woods, let rocks appear,
And the strong contrast works enchantment there.
Tis hence the ravish'd bosom's rapt'rous glow,
Where rocks arise and woods and waters flow.'

The artistic community in Edinburgh was a very small one, and one can safely assume familiarity with Beugo's poem amongst the local landscape painters, as well probably as acquiescence in the sentiments displayed. Conversely Beugo would have seen many of the views of the Esk recently produced, and this suggests that part of his poem, purporting to be an invocation to any reader who aspired to be an artist, may equally and indeed more accurately be read as an account of actual pictures of the Esk, known to Beugo.

'Who with his wish, can o'er his picture weave
The gleam of sun-shine, or the ruddy eve,
How may he pleas'd, DALKEITH's delights survey'd,
Combine the beauties of the wood or glade!
Bid the old oaks their hundred branches raise,
Or blend the tints the younger wood displays!
Bid op'ning vistoes wide reveal the lawn,
Where bounds the courser, or where starts the fawn!'

These lines bring to mind the work of two painters, first the views of the Esk and Dalkeith Park painted for the Buccleuch family by George Barret, pictures that closely match the description of the old oaks, spreading lawns, deer, and effects of light in Beugo's poem, second the small pair of views of the Esk in Dalkeith Park painted by Alexander Nasmyth. These last two pictures are undated, but Riddell in his 1791 annotations to Gough's *Scottish Topography*,[1] stated that Nasmyth had 'painted for the Duchess of Buccleugh three views near Dalkeith. Mr Naesmith painted for Lady Stopford two views in Dalkeith Park', and the pair of views exhibited here are very likely two out of the three recorded by Riddell. While Nasmyth's aesthetic stance would appear to have corresponded fairly closely to Beugo's as revealed in the *Esk Water* poem, the various Nasmyth pictures itemised by Riddell, together with Nasmyth's earlier surviving landscapes, make it clear that he was seldom working as a free agent, his paintings being mostly commissions. Furthermore, these, unlike the work of the antiquarian topographers Grose and Pennant or the picturesque tourists Farington and Gilpin, were closely bound up with the conception of landscape as property, agricultural land, park, and pleasure ground, adjacent to a country house. This is particularly apparent in the formal portrait of Dalhousie Castle on the South Esk. Nasmyth's Dalhousie is no dreary frontal itinerary of windows but a true landscape composition, based upon designs by Claude—possibly the *View of Delphi with a procession* that Nasmyth could have seen

in the Doria Pamphili palace in Rome, but there are other and very similar Claudes elsewhere. Dalhousie itself was an ancient building that had undergone several remodellings, and nothing better reveals the flavour of Nasmyth's own taste than the exact point in its architectural vicissitudes at which he caught the castle's likeness. Originally, according to the reconstruction of its appearance in 1790 Clark of Eldin drawing,[2] an inconvenient cluster of odd-shaped chimneys, gables and turrets, the house received its eighteenth century overhaulings in the cause of increased comfort. The castle Nasmyth painted in 1802, so regular and simple in shape, with a shallow pitched roof, cropped turrets, and a massive keep substituted for the former medley of crow-stepped gables, resembles nothing so much as a design by Robert Adam. Its classicised form was anathema to Walter Scott who, visiting the castle in 1827, declared that it had been 'mangled by a fellow calld I believe Douglas, who destroyed as far as in him lay its military and baronial character and roofd it after the fashion of a Poor's House'[3] (ie a Workhouse). By that date gothic Scotland had overtaken classical, arcadian Scotland, and Burn was busy remodelling the castle in accordance with the new requirements.

With Dalhousie, Nasmyth was faced by a ready made building for which he had had no architectural responsibility, but his 1789 design for the temple to Hygeia on the wooded banks of the Water of Leith was a deft touch of art added, in just the right spot, to convert what he would have felt as a naturally appropriate setting into a recognisable Claudian Arcadia. His reference was instantly understood by Sir John Stoddart, who visited the temple in 1799.

'Here is not the deep seclusion, or the wild horror, which banishes every idea of human operation; nor are the picturesque features of the landscape so bold, and mossy, as to preclude all association with the simple elegance and regularity of the temple. In short, a more happy union of nature and art is seldom found.... The temple seemed to be introduced, as into a picture, by

the felicitous pencil of Claude; and a company of females, issuing from it, resembled the processions, which we sometimes see, in that great painter's compositions.'[4]

Smollett had likened Loch Lomond to Arcadia,[5] and later Gilpin at Loch Lomond thought of Poussin, of Virgil, of the Elysian fields, and Academic groves. Elsewhere in Scotland he dropped automatically into quotations from Virgil, Tacitus, Sallust and Pliny.[6] Such associations were a natural outcome of the classical education common throughout Europe and Nasmyth was practising an international system of visual reference to classical architecture, Italian landscape, and the paintings of Claude that was the exact counterpart to the habit of classical literary quotation, but this Italian and classically oriented culture, by referring so much to a common central source not native to Scotland, rendered his compositions distasteful to the inbred nationalism of the nineteenth century which preferred an internally Scottish set of references. In 1821 complaints were voiced about the lack of specific national character in Nasmyth's landscapes. They might, it was felt, be of places anywhere. They were too like Italy. The trees were not identifiable as individual species, nor the rocks distinguishable as granite, sandstone, or flint.[7] Nasmyth's pictures were thus failing to satisfy two separate demands, first those of romantic nationalism and second those of the growing scientific taste for presentations that were botanically and geologically accurate—a taste that was to reach a climax in the writings of John Ruskin. Broadly speaking, therefore, it would be true to say that the phenomenal popularity of Nasmyth's work at the beginning of the century gradually waned in the same measure that a likeness to Italy or to classical landscape descriptions ceased, in Scotland, to be regarded as a proper compliment to Scottish scenery.

Not all Nasmyth's work had this formal and public character, and his drawing of the poet Robert Burns at Roslin Castle commemorates an entirely private occasion. 'Burns was so much struck with the beauty of the morning that he put his hand on my

74

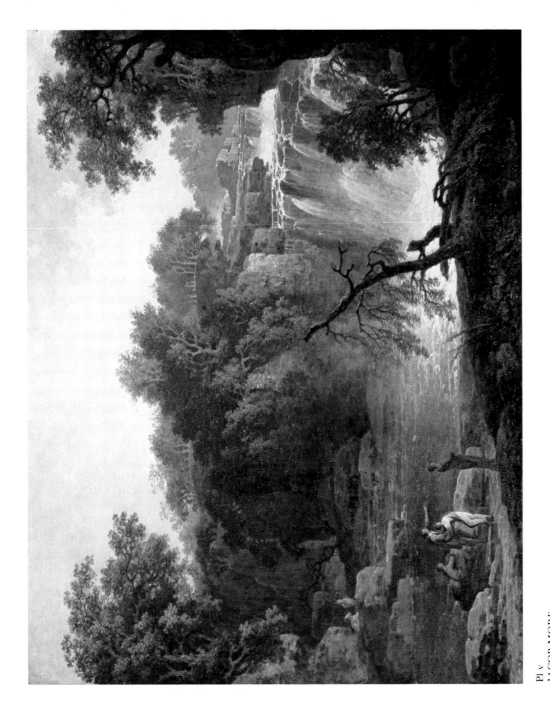

Pl v
JACOB MORE
Cora Linn
no. 5.3

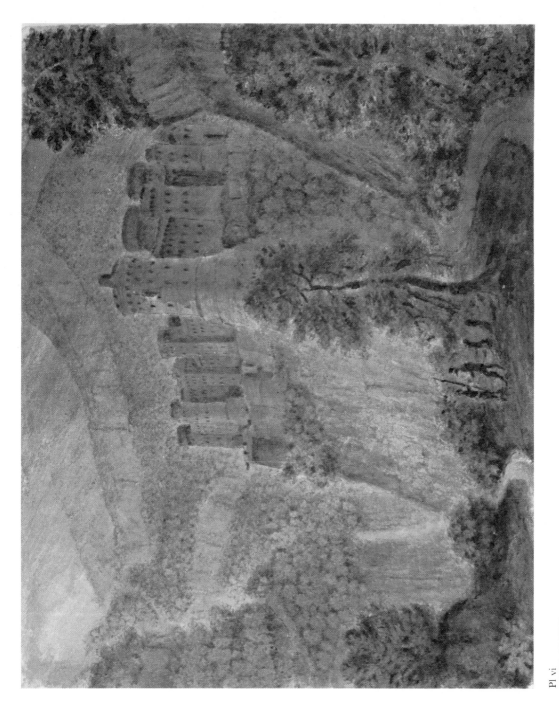

Pl vi
JOHN CLERK
The Castle of Udolpho
no. 6.25

Fig 75 (*top*)
ALEXANDER NASMYTH
Roslin Castle in 1789
no. 7.11

Fig 76 (*bottom*)
JOSEPH FARINGTON
Roslin Castle in 1789
no. 7.12

father's arm and said, . . . "Let's awa to Roslin Castle." . . . After an eight miles walk they reached the castle at Roslin. Burns went down under the great Norman arch, where he stood rapt in speechless admiration of the scene. The thought of the eternal renewal of youth and freshness of nature, contrasted with the crumbling decay of man's efforts to perpetuate his work, even when founded upon a rock, as Roslin Castle is, seemed greatly to affect him. . . . This sketch was highly treasured by

Another of Nasmyth senior's drawings of Roslin Castle, which is dated 1789, bears direct comparison with Farington's of the same year. Both artists clearly shared an interest in the picturesquely intermingled and contrasted textures of the crumbling stone walls and encroaching foliage of tree and creeper. Farington's drawing has, however, a more mannered cleverness, and one senses the application of a technical formula that reduces leafage, rock and wall into a linear

Fig 74
ALEXANDER NASMYTH
Burns and Alexander Nasmyth at Roslin Castle
no. 7.6

my father, in remembrance of what must have been one of the most memorable days of his life.'[8] So highly treasured was it indeed that the original faint pencil inscription recording the month and year of Burns' visit, together with Nasmyth's initials, has been strengthened by being traced over again. Possibly this act of pious restoration was carried out by Alexander, but one suspects the hand of his son James who sorted and inscribed many of his father's drawings, and who painted a version of the scene based on the drawing. In James' painting, the intimate shared response to the beauty of the June dawn at Roslin that gives the drawing its charm, has hardened into an iconically static memorial tribute to Nasmyth's friendship with a mighty poet dead.

pattern. When Farington was in Edinburgh in 1801 he made unfavourable comparisons between two of Nasmyth's views of Roslin which he had seen in the painter's studio, and his own recollections of the place. 'I saw two views of Rosslin Castle painted for Sir James Erskine Sinclair, the Proprietor of it. . . . On first seeing them I thought them much inferior to what I expected, being deficient in style and in colouring and executed in a puerile and feeble manner. He does not appear

to feel the points on which the effect of a picture shd. rest and which denote the master.... I cannot but think if such pictures were sent to a London Exhibition they wd. be thought very indifferent by the Professors—I was surprised at the liberty taken in one of the views of Rosslin. He had certainly exhibited all that was to be found in the place, but I am sure there is no one point from which he could see all that He has represented.'[9] As a pupil of Wilson, Farington no

doubt disliked the minuteness of Nasmyth's handling, but any disapproval he felt must have been exacerbated by hearing the chauvinistic remarks of Raeburn's servant, who called Nasmyth 'a great landscape painter, the best in Scotland and superior to any in England.' A further stimulant to Farington's jealousy was his belief, not entirely well founded, that Ibbetson had been neglected on his visit to Scotland. 'Ibbetson was at Edinburgh some time ago and re-

Fig 77
ANONYMOUS
Roslin Chapel and Castle in 1789
no. 7.13

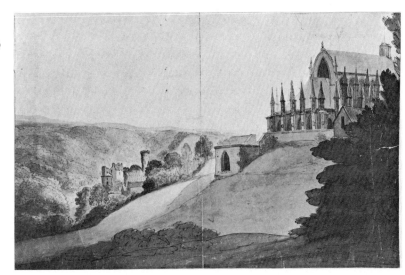

Fig 78
JOHN THOMSON
Roslin Chapel and Castle
no. 7.19

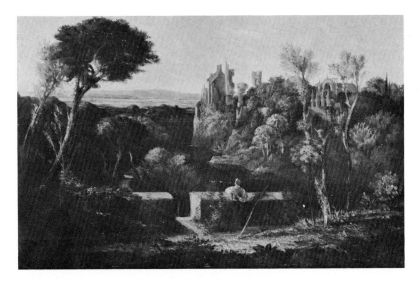

Fig 79
JOSEPH MALLORD WILLIAM TURNER
Linlithgow Palace
no. 7.15

Fig 80
HUGH WILLIAM WILLIAMS
Hawthornden
no. 7.10

mained there two years, but he could not obtain the opinion of the Scotch so as to be put in competition with Nasmyth.'[10] In fact Ibbetson was in Scotland in July of 1800, and stayed only a few months. Whilst there he was patronised by Lady Balcarres, to whose daughters he gave sketching lessons, and he received several commissions for views of the Esk valley near Roslin, to which he had withdrawn as much for the sake of peace and quiet as for the scenery. One of his landscapes, showing Roslin Castle, was admired by Hugh William Williams—who had himself painted water colour views of the castle—though Lady Balcarres complained that Ibbetson had incorrectly shown the country girls in the picture wearing shoes and stockings.[11] This was just the sort of mistake an English visitor would be most prone to make, and brings to mind Turner's later tendency to introduce tartan clad figures into lowland views, but a wilder and more fantastic deviation by Ibbetson from factual probability can be seen in his *Mermaids' Haunt*, a view of the Esk painted three years after his Scottish visit. In this strange composition, reminiscent of the work of Poelenburgh, the imaginary bevy of bathers has been given for background a portrait of the real Hawthornden Castle perched on its crag, rather than the imaginary setting one would expect. Grant (*The Old English Landscape Painters* Vol I, pp 161 and 163) claimed that each one of these nudes was a study of Ibbetson's second wife, but offered no evidence to support this claim, which indeed suggests just the kind of myth making this unusual picture would inevitably attract. Ibbetson's flight of fancy would never have occurred to any Scottish painter, for

whom the scene at Hawthornden would necessarily have had very different associations, and Scottish artists in general were not accustomed to introduce nude bathers into their landscape views. The nearest parallel amongst the Scots to Ibbetson's painting is Schetky's view of Hawthornden, engraved in 1822 for Walter Scott's *Provincial Antiquities*, amongst the rocks of which a few small bathing boys were permitted to scramble.

Despite occasional backbiting and personal disagreements, there was no fundamental aesthetic divergence on the part of the English and Scottish artists here discussed. Farington was contemptuous of Nasmyth's skill. The Scots preferred Nasmyth to Ibbetson. Ibbetson himself fantasised about Hawthornden in a way no Scot was likely to do. Nevertheless, what all these artists looked for and valued in the river, rocks and woods of the Esk valley and other similar places, were essentially the same qualities. These qualities were not uniquely Scottish but could be found to a greater or lesser degree in many other parts of Britain, and it was incidental to the painters concerned that the scenes they recorded on the Esk happened to lie in Scotland rather than Somerset, Derbyshire or Westmorland. Very large tracts of Scotland were, however, of a character that picturesque dogma could not accommodate, and it was these regions of the Borders and the Highlands which eventually led to the creation of a landscape painting designed to propagate what was uniquely and even aggressively characteristic of Scotland as a place distinct from other places.

In Beugo's *Esk Water*, the description of Dalkeith was followed by a suggestion to the

aspiring artist that he should try painting 'classic ground, the scenes of rural song' where 'RAMSAY stray'd.'

'Go paint the birchen shade, the grassy field,
The fall of water, and the rocky bield;
The neighbouring mountain, and its knolls below,
And all the charms encircling HABBIE'S HOWE.'

In a note, Beugo added 'Several places have been pointed out as that alluded to. It is, however, sufficiently ascertained to be upon the Esk, in the grounds of Newhall.' As the earlier lines in the poem seemed to refer to actually existing pictures of Dalkeith, so these too imply that Beugo was acquainted with a literary/artistic project that had been, or was perhaps at that moment being carried out. This project, completely unique until Cadell organised Turner's landscape vignettes illus-

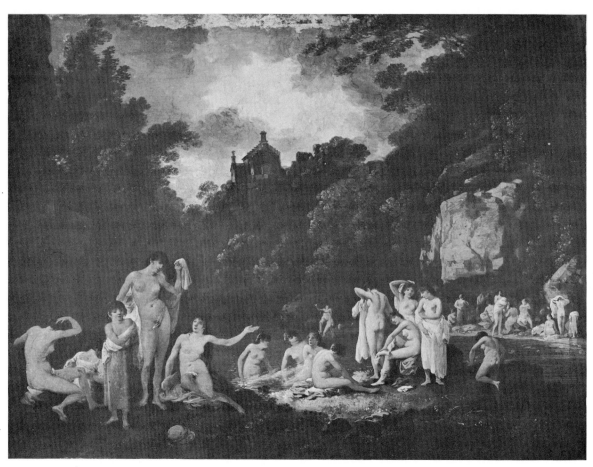

Fig 81
JULIUS CAESAR IBBETSON
The Mermaids' Haunt (Hawthornden)
no. 7.16

trating the poetry of Scott, consisted in the attempt made by Robert Brown, the owner of Newhall House, to prove, by commissioning artists to make accurate portraits of the landscape scenery round Newhall, that these had been the actual places described by Ramsay in his pastoral poem *The Gentle Shepherd*. Brown believed that it was only by grasping the nature of the landscape which had been Ramsay's model, that any attempt

could be made by the reader to understand the true character of the poem, and the commissioned views were thus not ordinary illustrations decorating the poem, but landscape surrogates for the use of those readers of Ramsay who had never seen the places described, and by means of which they could enter into the poet's mind and feelings. To this end, Brown published engravings from a number of the drawings, together with written descriptions of his own, in the *Edinburgh Magazine* in 1801, 1802, and 1803. In 1808 he republished in book form the engraved views, the descriptions, and arguments, as accompaniments to a Life of Ramsay and the text of his poem. A map of the North Esk and the area round Carlops was included, with Ramsay's fictitious place names mingled with the real ones. Brown's project was thus very different in character and intent from Sandby's earlier set of illustrations to the *Gentle Shepherd* which showed a random series of scenes in the vicinity of Edinburgh, and the kind of views which were executed by Brown's chosen artists under his supervision were also fundamentally different, at least in purpose, from the picturesque views of the Esk by Farington, Ibbetson and Nasmyth, that have already been discussed.

The map, descriptions, the lists of flora, and the engravings, add up to a remarkably complete portrait of a place that the author clearly loved, and the identity of which emerges as the sum total of present facts and past associations, and the continuity of the pastoral life which bound past to present, and which was seen as a precious state, already damaged both socially and visually by the encroachments of modern civilisation. Chief amongst these changes were the

Fig 82
WILLIAM ALLAN
Queen Victoria and the Prince Consort at Hawthornden in 1842
no. 7.21

land enclosures which altered the open face of the country and reduced its ancient pastoral character.

Robert Brown was anxious to stress the naturalness and truth of Ramsay's descriptions, and that the drawings were intended to follow suit. 'The sole object was to delineate the objects they contain with fidelity and truth, and to exhibit the scenes they represent

exactly as they were seen when the drawings were taken, without using any freedoms, or making any alterations or improvements whatever.' Even the times of day at which the various drawings were made, together with comments on the direction of the sunlight, were duly recorded by the author. His intention of illustrating exactly what Ramsay had described, led to pictures of scenery that the artist in search of the picturesque would normally have rejected. This western division

of the Pentland hills might, Brown wrote, 'with unrivalled propriety, be considered as the Arcadia of Scotland', but his notion of an Arcadia was very far from that of an artist nourished on Italian scenery and the paintings of Claude. 'The hills are smooth and swelling: The banks, and mounts, and meadows, are covered with green, unbroken sward; and spotted with sheep; ... The transitions, except as to the Peaked Craig, and the Hole Haugh Know, are all gradual, and undulating: And,

Fig 83
JAMES STEVENSON
Cascade on Monk's Burn behind Glaud's House
no. 7.22

not a tree is to be seen; but the remains of the old withered ash, appearing at a distance.' This smoothly undulating emptiness, the epitome of what the picturesque painter most disliked, was fast vanishing, and a note of great regret enters Brown's writing as he speaks of the alterations effected by villages, factories, markets, coach roads, and, above all, enclosures and the plough.

'In the days of Ramsay, ... the whole estate was open pasture; and *Habbie's Howe, Glaud's Onstead, Symon's House, Mause's Cottage*, and all the other scenes, were, with the Esk and its tributary streams the Carlops, Lin, Harbour Craig, Monk's, burns, &c. in the midst of undivided sheep-walks, of which the Pentland Hills made a part.

'The design of these *illustrations*, is, to arrest the original appearances of the objects alluded to by Ramsay, before it is too late, and they have been irrecoverably lost.'

Fig 84
JAMES STEVENSON
Monk's Burn and Glaud's House
no. 7.23

(1) Library of the Society of Antiquaries of Scotland, Edinburgh.
(2) In the collection of Sir John Clerk of Penicuik Bart.
(3) Sir Walter Scott *The Journal* ed. W E K Anderson 1972, p 403.
(4) John Stoddart *Remarks on Local Scenery and Manners in Scotland during the Years 1799 and 1800*, 1800, vol I p 97.
(5) Tobias Smollett *The Expedition of Humphrey Clinker.*
(6) William Gilpin *Observations on the Highlands of Scotland* 1789.
(7) *The Scots Magazine* 1821
(8) James Nasmyth *James Nasmyth Engineer* 1883 pp. 34–35.
(9) *The Farington Diary* ed. James Greig 1922, vol I p 323.
(10) Ibid p 327.
(11) Mary Rotha Clay *Julius Caesar Ibbetson* 1948, p 67.

GEORGE BARRETT 1732–1784

7.1 Dalkeith Park with the house in the distance
fig 71
Oil on canvas. 136 × 174 cm
Lent by His Grace the Duke of Buccleuch and
Queensberry

ALEXANDER NASMYTH 1758–1840

7.2 View in Dalkeith Park fig 72
Oil on canvas. 91.5 × 119.4 cm
Signed. *A. Nasmyth*
Lent by His Grace the Duke of Buccleuch and
Queensberry

ALEXANDER NASMYTH

7.3 View in Dalkeith Park
Oil on canvas. 90.2 × 120.7 cm
Signed: *A. Nasmyth*
The river is the Esk
Lent by His Grace the Duke of Buccleuch and
Queensberry

ALEXANDER NASMYTH

7.4 Dalhousie Castle fig 73
Oil on canvas. 114.3 × 167.6 cm
Signed: *A.N. 1802*
Dalhousie stands on the South Esk a few miles from
Roslin. The old castle had received extensive remodel-
ling in the eighteenth century
Lent anonymously

ALEXANDER NASMYTH

7.5 St Bernard's Well
Pencil. 23.0 × 33.8 cm
Inscribed by James Nasmyth: *St Bernard's Well near
Edinburgh my father Alexander Nasmyth was the architect of it.
James Nasmyth*
The foundation stone of the Temple of Hygeia, Goddess
of health was laid in 1789. The design is based on the
classical Temple of the Winds at Tivoli
National Gallery of Scotland

ALEXANDER NASMYTH

**7.6 Burns and Alexander Nasmyth at Roslin
Castle** fig 74
Pencil. 15.9 × 21.0 cm
Inscribed: *Part of Roslynn Castle. The figure is Rt Burns
1786 AN June 13*
Scottish National Portrait Gallery

JAMES NASMYTH 1808–1890

**7.7 Robert Burns and Alexander Nasmyth at
Roslin Castle**
Oil on canvas. 61.0 × 91.5 cm
Inscribed on a label on the reverse: *This picture was
painted by me from a smaller pencil sketch by my father which
he made on the spot when he and Robert Burns had walked out
to Roslin Castle on the morning of the 13th of June, 1786. My
father Alex. Nasmyth, much valued this sketch as reminding him
of a very delightful occasion. See a description of this in my
autobiography (signed) James Nasmyth.* The pencil sketch
referred to is no. 7.6
Lent by the Royal Scottish Academy

ALEXANDER NASMYTH

7.8 Springfield near Roslin
Pencil. 21.5 × 28.0 cm
Inscribed: *June 4 1824 Springfield near Roslin. Sketched
for a picture to be painted for General Leslie*
National Gallery of Scotland

HUGH WILLIAM WILLIAMS 1773–1829

7.9 Roslin Castle
Water-colour. 42.0 × 59.7
Signed and dated: *H. W. Williams 1796*
Lent by His Grace the Duke of Buccleuch and
Queensberry

HUGH WILLIAM WILLIAMS

7.10 Hawthornden fig 80
Water-colour. 43.2 × 60.4 cm
Signed and dated: *H. W. Williams 1796*
Lent by His Grace the Duke of Buccleuch and
Queensberry

ALEXANDER NASMYTH
7.11 **Roslin Castle in 1789** fig 75
Pencil. 24.5 × 42.0 cm
Inscribed by James Nasmyth: *Roslin Castle 1789 by my father Alexander Nasmyth before the fall of the great tower*
Lent by the Royal Commission on the Ancient and Historical Monuments of Scotland

JOSEPH FARINGTON 1747–1821
7.12 **Roslin Castle in 1789** fig 76
Pencil, pen and wash. 32.2 × 56.0 cm
Inscribed: *Colours bleached red and deep red—rock the same— parts most broken most red. Chapel silver grey and mossy south east view Rosslin Castle and Chapel July 24 1789*
Farington toured Scotland in 1788 and again in 1792 with the object of issuing a set of large engraved views, a project which was never completed. No evidence, apart from this drawing, has yet emerged, concerning any Scottish visit made in 1789
National Gallery of Scotland

ANONYMOUS
7.13 **Roslin Chapel and Castle in 1789** fig 77
Pen and wash. 37.0 × 56.5 cm
Inscribed on verso: *This view of the Chapel and Castle of Roslin Sketched on the spot Sept 89.* Inscribed on recto: *from North East*
This corresponds very closely to the view published by Grose in Vol. I of his book *The Antiquities of Scotland* (1789). In style it resembles the work of Grose and his servant Cocking, apart from the foreground foliage which may have been added, to complete the drawing, by another hand. It is however far larger than the drawings Grose normally made, which were related to the size of the intended engravings, and is unlikely to have been the actual drawing used for the book
National Gallery of Scotland

JOSEPH MALLORD WILLIAM TURNER
1775–1851
7.14 **Roslin Castle and Chapel**
Pencil, across two pages each measuring 11.1 × 8.1 cm in the Scotch Antiquities Sketchbook of 1818
This sketchbook contains the studies Turner made in preparation for his illustrations to Scott's *Provincial Antiquities.* Already, on his earlier visit of 1801, he had made numerous sketches of Roslin and the Esk
Lent by the Trustees of the British Museum

JOSEPH MALLORD WILLIAM TURNER
7.15 **Linlithgow Palace** fig 79
Oil on canvas. 91.4 × 122.0 cm
Exhibited in Turner's own gallery in 1810. Turner had made a number of drawings of Linlithgow on his 1801 visit to Scotland. He later drew a view of Linlithgow Palace from the other side for Scott's *Provincial Antiquities* 1819–26
Lent by the Walker Art Gallery, Liverpool

JULIUS CAESAR IBBESTON 1759–1817
7.16 **The Mermaid's Haunt** fig 81
Oil on panel. 37.5 × 48.2 cm
A view of Hawthornden. Ibbetson visited Scotland and stayed near Roslin in 1800. Grant in his *Old English Landscape Painters* claims that this was a sketch for a larger picture dated 1803
Lent by the Victoria and Albert Museum

After JOHN CHRISTIAN SCHETKY 1778–1874
7.17 **Hawthornden**
Engraving
After the painting by Schetky published in Scott's *Provincial Antiquities and Picturesque Scenery of Scotland* (Vol II 1827). The first proof of the engraving is dated 1822.
National Gallery of Scotland

JOHN THOMSON 1778–1840
7.18 **Edinburgh from Corstorphine**
Oil on canvas. 34.9 × 48.3 cm
Engraved for Scott's *Provincial Antiquities and Picturesque Scenery of Scotland*
National Gallery of Scotland

JOHN THOMSON
7.19 Roslin Chapel and Castle fig 78
Oil on panel. 31 × 46 cm
Lent by the Fine Art Society

SAMUEL DUKINFIELD SWARBRECK
7.20 Rosslyn Castle and Glen
Lithograph
Inscribed: *Rosslyn Castle and Glen J. D. Swarbreck
May 1837*
Published in *Sketches in Scotland* (1839), dedicated to the
Earl of Rosslyn. The figure seated on a rock in the
foreground holds Scott's *Lay of the Last Minstrel* in which
Roslin is described
National Gallery of Scotland

WILLIAM ALLAN 1782–1850
**7.21 Queen Victoria and the Prince Consort
at Hawthornden in 1842** fig 82
Oil on canvas. 162.6 × 124.0 cm
A label on the back is inscribed: *Royal visit 14 Sept 1842.
Painted for the late Sir Walker Drummond Bart.
William Allan 72 Great King St*
The Queen visited Hawthornden during the absence of
the owner Sir Walker Drummond, for whom this picture
was painted, presumably as a record of the event he was
unable to see
Scottish National Portrait Gallery

JAMES STEVENSON died 1844
**7.22 Cascade on Monk's Burn behind
Glaud's House** fig 83
Watercolour. 33.0 × 48.2 cm
Commissioned by Robert Brown, owner of Newhall
House, and engraved for *The Gentle Shepherd with illus-
trations of the Scenery* (1808).
Lent anonymously

JAMES STEVENSON
**7.23 Monk's Burn and Glaud's House
(from the south-east)** fig 84
Watercolour. 33.0 × 48.2 cm
Commissioned by Robert Brown, owner of Newhall
House, and engraved for *The Gentle Shepherd with illus-
trations of the Scenery* (1808)
Lent anonymously

After ALEXANDER CARSE died 1843
**7.24 Harbour Craig near the Craigy Bield
from the N.**
Engraving
After a drawing by Carse commissioned by Robert
Brown, and published in *The Gentle Shepherd with illus-
trations of the Scenery* (Vol I 1808)
Lent anonymously

After ROBERT BROWN
7.25 The Fore Spital of New-Hall from the S.W.
Engraving
After a drawing by Robert Brown, owner of Newhall
House, published in *The Gentle Shepherd with illus-
trations of the Scenery* (Vol II 1808)
Lent anonymously

8

Provincial and Border Antiquities

The Borders and Tweed

On July 19 1792, the painter Farington who was staying with Mr Riddell of Friar's Carse, the friend of Nasmyth and Burns and the companion of Francis Grose, was taken 'to Crickup Lyn & to see a waterfall called the grey mare's tail... The waterfall is 80 or 90 feet, and the form of it is picturesque but it wants accompanyments of wood etc.' Six days later he was standing looking at another fall, the popular and well wooded Cora Lynn, which elicited a very different reaction. 'More cannot be said than that it is so perfect a composition to speak the language of art, as to leave no room for proposing an alteration in any of the accompaniments.'[1] To Farington, with a taste formed on picturesque principles, much of Scotland presented a diet of visual starvation. The empty moorland spaces bored and repelled him, 'barren of strong Hedge-row the great ornament of most English Landscape'. 'I recollect in no part of the world such a length of country witht objects to engage notice.' 'a continuation of barrenness and drearyness'. His heart sank as he traversed the 'sullen & Heather headed Hills . . . in the rudest state covered with black purple Heather.' Conversely he cheered up whenever his eye met with cultivation and plantations. 'Well wooded' is a term of high commendation. 'Dreary' signifies the opposite quality, and 'Finished', in Farington's vocabulary invariably signifies the abundant presence of trees. Thus Loch Ard, Blair Drummond and a waterfall near Buchanan were all described as 'finished' with woodland, while poor Ferguson of Raith who had set plantations on his own land, was 'not much obliged to his neighbours for any decorations like his own, to finish his prospect. The

Country swells & sinks, but it is an undulating surface, . . . without woods and with but very few trees.' Finished is a highly expressive word, suggestive of the final touches given by a painter to his picture after the main features and underlying structure have been laid in.

Farington was not an agriculturalist interested in the economy of timber planting. He was solely concerned with the effect of woodland upon the eye. An identical attitude, expressed in slightly different language, can be found in Gilpin's *Observations on the Highlands of Scotland*. In Selkirkshire Gilpin observed that 'In general the mountains formed beautiful lines; but as in history-painting, figures without drapery, and other appendages, make but an indifferent group; so in scenery, naked mountains form a poor composition. They require the drapery of a little wood to break the simplicity of their shapes, to produce contrasts, to connect one part with another; and to give that richness in landscape, which is one of its greatest ornaments.'[2] Farington and Gilpin were not acquainted, but Gilpin knew enough of Farington's work, and of his project for publishing a volume of large Scottish engravings, to feel that these illustrations would prove sympathetic, even complementary to his own writing on picturesque Scotland.

In justice to Farington, it must be noted that his aesthetic stance was very closely and correctly matched to the capacities of his water colour technique. In a bare and rolling country, devoid of hedges, woods and buildings, a compensating richness of pattern is provided by the play of light and shadow across the ground as clouds travel across the sky. However, Farington's emphatic linear treat-

Fig 85
WILLIAM SIMSON
The Grey Mare's Tail
no. 8.1

Fig 86
THOMAS GIRTIN
The Eildon Hills and the Tweed near Melrose
no. 8.2

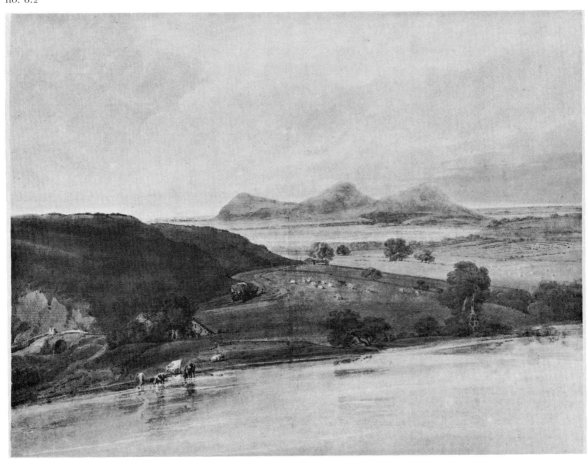

ment supplemented by pallid washes—a treatment common to many of the early water colourists, and well suited to a country of great textural contrasts and lavish vegetation—was not really capable of conveying these nuances of light change. A stronger freer use of tone such as Girtin employed, and a greater understanding of internal modelling such as Turner displayed, were required before the artist could take into account this contrast and flow of shadows. Faced therefore with a waterfall as barren and exposed as the Grey Mare's Tail, Farington saw a work of art which nature had somehow failed to complete and had left in an unsatisfactory state.

This failure to supply a picture was not felt by William Simson who, thirty six years later, chalked in the fall of the Grey Mare's tail with obvious zest at the naked and savage face of the hill down which the cataract came tumbling. This change of attitude was not simply the result of a development in drawing technique. Between Farington's and Simson's visits to the waterfall stands that made by Walter Scott in, or shortly after 1805. With Skene of Rubislaw he climbed up to Loch Skene from which the fall issues, one misty day, and bogged, bruised and several times lost on the way up, eventually reached the top. Out of this experience came the imagery for his powerful descriptive passage on the Grey Mare's Tail published in *Marmion* in 1808.

'Rises the fog-smoke white as snow,
Thunders the viewless stream below,
Diving, as if condemn'd to lave
Some demon's subterranean cave
. . .

Where, deep deep down, and far within,
Toils with the rocks the roaring linn;
Then, issuing forth one foamy wave,
And wheeling round the Giant's Grave,
White as the snowy charger's tail,
Drives down the pass of Moffatdale.'

Thereafter, those who saw the fall, saw it through Scott's description. Even Lord Cockburn who visited it in 1839 and found it 'fully powdered and frizzled', ruminated on the influence of Scott as he travlled up.(3)

The Border region from Moffat to Kelso,

including the Ettrick forest and the vales of the Yarrow, the Teviot and the Tweed, was pre-eminently Scott's own countryside. There, at Smailholm Tower and later at Kelso, he spent some of the crucial years of his childhood, and from 1804 until 1812 he lived at Ashesteil on the Tweed, shifting then to Abbotsford, which remained his home until his death in 1832. *The Minstrelsy of the Scottish Border* which he collected and edited was published in 1802 and 1803. These mainly traditional ballads, accompanied by Scott's detailed notes and some poems of his own, were followed by the wholly original *Lay of the Last Minstrel* early in 1805. The Border setting of this poem overlapped with that of the *Minstrelsy*, Yarrow, Teviot and Tweed, Newark Castle and Melrose Abbey. *Marmion*, following in 1808, covered a wider area, including, besides the Scottish borders, Northumberland, Linlithgow, Edinburgh and the East coast. In subsequent poems Scott moved further north to the Highlands and Islands, returning to the Borders in some of the novels, especially *Guy Mannering* (1815). The extent to which Scott affected the public as a poet of landscape can best be gauged by comparing the early, discarded plan to employ Flaxman, the illustrator of Homer and Dante, to draw figurative designs for the 1805 *Lay*, with Cadell's 1831 commission to Turner to illustrate Scott's poetry with landscape drawings only.

Since all visitors to Scotland who travelled by land had necessarily to pass through the Borders, it was here they received their first taste of the country, and here that their reactions to it can be tested. William Scrope, friend of Scott, amateur artist, and author of books on salmon fishing and deer stalking, has described what the first impression was upon visitors who came before the publication of Scott's poems.

'My first visit to the Tweed was before the Minstrel of the Forth had sung those strains which enchanted the world, and attracted people of all ranks to this land of romance. The scenery therefore at that time, unassisted by story, lost its chief interest; yet was it all lovely in its native charms. What

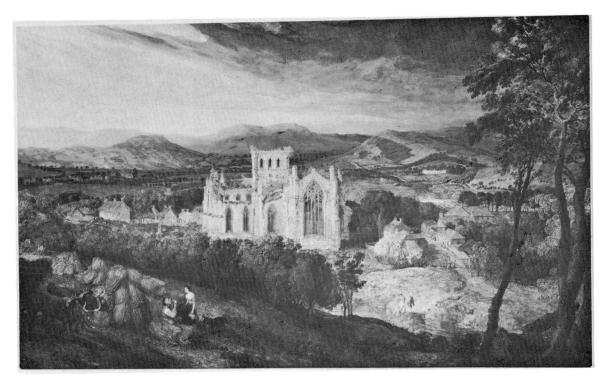

Fig 87
JAMES WARD
Melrose Abbey, The Pavilion in the distance
no. 8.3

Fig 88
JAMES WARD
The Eildon Hills and the Tweed with Littledean Tower
no. 8.4

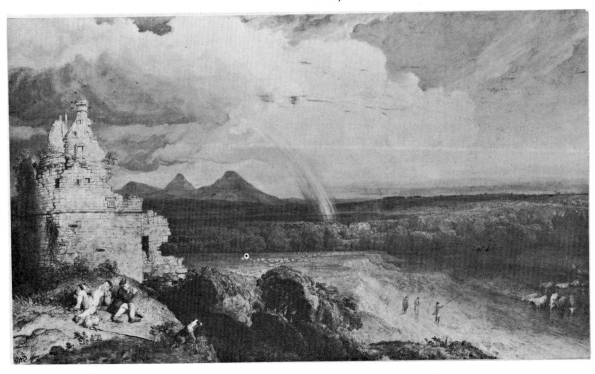

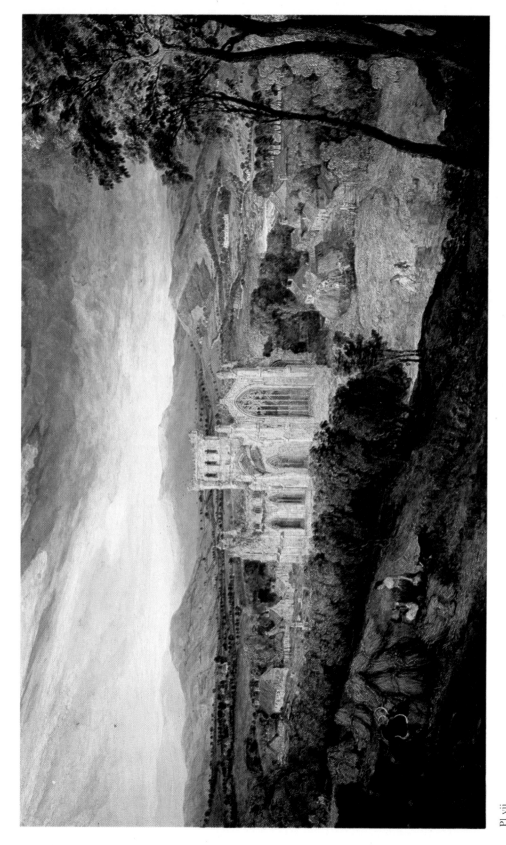

Pl vii
JAMES WARD
Melrose Abbey
no. 8.3

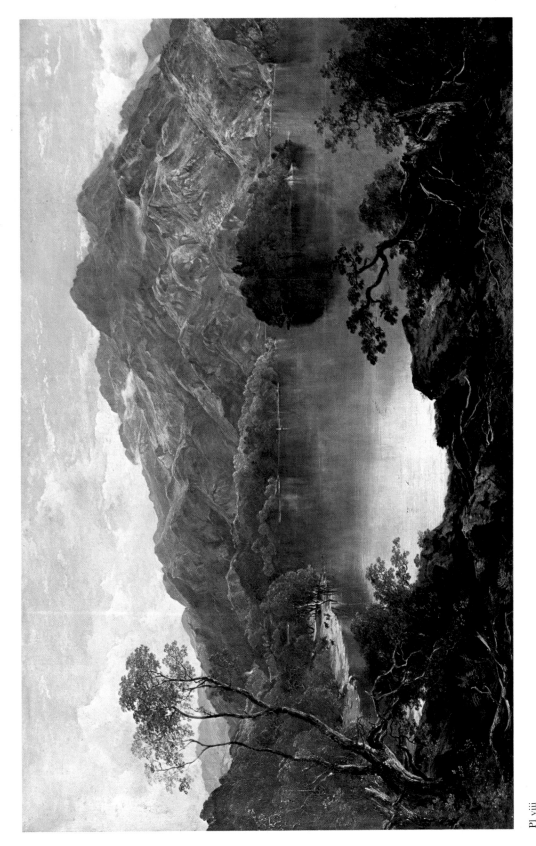

Pl viii
HORATIO McCULLOCH
Loch Katrine
no. 9.14

stranger just emerging from the angular enclosures of the South, scored and subdued by tillage, would not feel his heart expand at the first sight of the heathery mountains, swelling out into vast proportions over which man has no dominion?... The stranger might wander in the quiet vale (of the Tweed), and, far below the blue summits, he might see the shaggy flock grouped upon some sunny knoll,... and, lower down on the haugh, his eye perchance might rest awhile on some cattle standing on a tongue of land by the margin of the river, with their dark and rich brown forms opposed to the brightness of the waters. All these outward pictures he might see and feel; but he could see no further: The lore had not spread its witchery over the scene.'[4]

Gilpin had noticed exactly what Scrope describes, vast tracts of land unmarked by boun-

Fig 89
JAMES WARD
Study for Melrose Abbey
no. 8.5

Fig 90
JAMES WARD
Study for the Eildon Hills with Littledean Tower
no. 8.6

dary walls, 'intirely in a state of nature',[5] but his heart had not expanded. Girtin too, who visited the Tweed in 1800, before the publication of the *Minstrelsy* or *The Lay* and thus looked with the eyes of the innocent tourist postulated by Scrope, saw and painted a sweeping, bare river, wading cattle, and austere unenclosed expanses of rolling hill. We have no record of what Girtin felt about the scenery, but his was an image quite unprecedented in its melancholy starkness. No

public was a change of heart. The barren hills remained the same, but his readers were taught to place a value upon those very aspects in the landscape which had once appeared matters of shame. This change of heart was effected largely through the power of historical association. Scott himself readily admitted that he did not look at landscape quite as a painter would do, but that he was attracted more by places 'distinguished by historical events' than by places merely re-

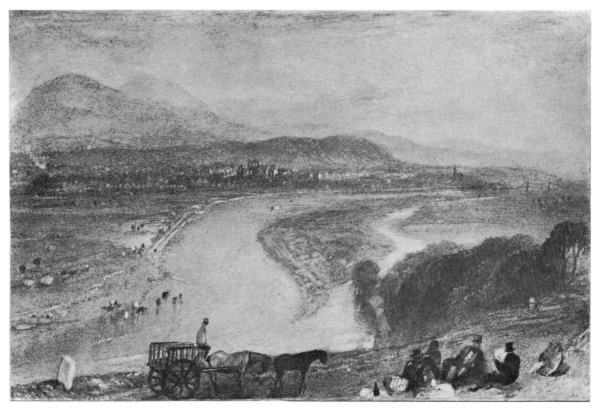

Fig 91
JOSEPH MALLORD WILLIAM TURNER
Melrose Abbey
National Gallery of Scotland. Vaughan Bequest of Turner watercolours

nowned for beauty. When in 1817 he brought Washington Irving to his favourite view the latter was extremely disappointed.

Scottish artist of that date would have admitted pictorially to quite such bleakness. It was not merely that Scottish landscape painting was more backward and provincial than the English, but that national pride, stung by a succession of visitors' taunts concerning treeless, hedgeless hills, at first retarded before it accelerated, the acceptance of this wild, uncultivated portrait. What Scott gave the general

'I beheld a mere succession of grey waving hills, line beyond line, ... monotonous in their aspect, and so destitute of trees, that one could almost see a stout fly walking along their profile; and the far-famed Tweed appeared a naked stream, flowing between bare hills, without a tree or thicket on its banks.'

Scott protested at this reaction of his guest. 'I like the very nakedness of the land; it has something bold, and stern, and solitary about it.'[6] He imparted this enthusiasm for the solitary and stern to an extraordinary diversity of people. A child, Elizabeth Grant, travelling home to the Highlands in 1812 with *The Lay*, *Marmion*, and *The Lady of the Lake* amongst the family luggage, remembered passing through the Borders, 'starting up in the carriage in ecstasies, flinging ourselves half out at the sides each time these familiar names excited us.... It was not so much the scenery, it was the "classic ground" of all the Border country.'[7] Years later, Lord Cockburn, as he travelled along the Yarrow to St Mary's Loch, reflected that, 'It is when the trees begin to fail, when the hard-wood keeps back, and lets the fir go on, and when . . . the very fir gives up to the grass, and we are left to the solitude of the hills, that the real peculiarity and interest of the range begins.... The bareness, openness, and sameness of the valley might seem to preclude its being interesting, but these are the very things that aid the old associations, and impart that feeling of pleasing melancholy which belongs to the region.' He felt the old stories, ballads, and the 'genius of Scott lingering in every valley.'[8]

Amongst the earliest visitors to succumb to Scott's vision of the Borders were Dorothy and William Wordsworth, on their Scottish visit of 1803. The *Minstrelsy* was published, and stanzas of the unfinished *Lay* were repeated to them by Scott himself. Both Wordsworths responded to the 'pensive' melancholy of the Tweed valley, and Dorothy, who admired the flowing lines of the hills, considered that here at least the picturesque traveller should not regret the absence of trees. The three poems that Wordsworth wrote to the Yarrow reflect very strongly the influence of Scott's obsessions. The first, *Yarrow Unvisited*, was written whilst touring the Borders under Scott's guidance on this first visit of 1803. The last, *Yarrow Revisited*, commemorates the expedition made to Newark with Scott shortly before his death. The theme common to all three poems is the relation and interaction between simple perception of scenery, and the colouring given by poetic and historical association. Alternate arguments for the simple and for the associative types of perception are advanced— 'What's Yarrow but a river bare,/That glides the dark hills under?' (*Yarrow Unvisited*)—'I see—but not by sight alone,/Loved Yarrow, have I won thee' (*Yarrow Visited*)—'Ah no! the visions of the past/Sustain the heart in feeling/Life as she is—' (*Yarrow Revisited*).

As writers, Wordworth and Scott could juggle with time, backwards and forwards, and Scott always saw with a double (and sometimes treble) vision, Melrose in its pride, and ruined Melrose, Teviot echoing to the clash of armour, and Teviot in pastoral peace, Blackford sprinkled with tents before the battle of Flodden, and Blackford yellow with nineteenth century oats, but for the painter things were not so easy. He had to choose between, and adhere, either to the ancient or to the modern Melrose, and in general he opted for the modern setting, leaving the spectator's imagination free rein. Scott's immediate influence on artists thus operated mainly in the consecration of certain sites about which he had written, and, this gift of double vision having been imparted through the poem, the artist could rest assured that the public would know what his picture of Melrose, St Mary's Loch, or the Grey Mare's Tail, meant.

Five years after Girtin's trip, Ward visited Scotland. He stayed with Lord Somerville at the Pavilion on the Tweed, and was taken to see Scott at Ashesteil where he was impressed by the poet's reading. *The Lay* had been published earlier that year and had already brought a steady stream of pilgrims to the Borders. Ward's visit must have followed the storm and heavy flooding of mid August for crossing the Tweed at the Ashesteil ford the carriage floor was awash with river water. In Ward's two large canvases of 1807 past and present are hustled pell-mell together. Ruined Melrose is thrust between the cottages of a thriving village, and beside Littledean tower, in the other picture, two shepherd lads and their dogs gaze across the peaceful Tweed valley where a salmon fisher wades and cattle come down to drink. This second picture in particular picks up something of Scott's mood

in the invocation to the Teviot, of *The Lay*.

'No longer mail clad warriors ride
Along thy wild and willowed shore
As if thy waves since time was born
Since first they rolled upon the Tweed
Had only heard the shepherd's reed
Nor answered to the bugle horn.'

It is hard to determine how far this rather generalised echo of Scott is accidental. Lord not been taken to Scotland merely to produce pieces of standard country house portraiture. The country he shows is not conceived primarily as private estate, but is a landscape emancipated by the wider appeal of its legends and memories, a property common to any who could read Scott's poems. Shortly before his trip to Scotland, Ward had encountered Rubens' *Chateau de Steen*, and had been fired with a spirit of emulation. It was from Rubens that he learnt how to bring a

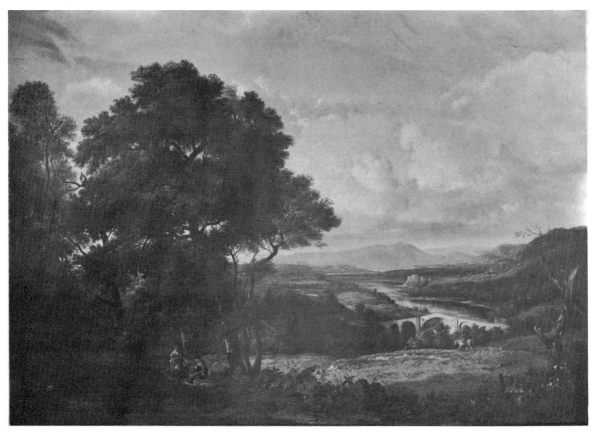

Fig 92
PATRICK NASMYTH
The River Tweed with Melrose Abbey in the distance
no. 8.7

Somerville, who brought Ward to the Borders, was Scott's near neighbour at Ashesteil and his regular sporting companion. Though Mertoun appears in one picture, and Lord Somerville's house, the Pavilion, in the other, both houses are small incidental patches in the landscape, and it is clear that Ward had vigorous individual personality to life in a landscape, and this sense of positive force and energy may have appeared to Lord Somerville as the proper pictorial counterpart to the descriptive passages of Scott.

Both the wish and the ability to suggest such positive, independent natural energy are absent in the productions of Nasmyth and his children, in whose landscapes, by contrast, a passive and gracious compliance of all natural growth to human convenience and taste—a nature obliging and arranged—is

the most pronounced characteristic. The serenity of the Nasmyth family Arcadia was impervious to invasion by Scott's 'Gothic Borderers . . . the iron race of Salvator.' Its components had been assembled in the previous century, under very different conceptions of the relationship between man and nature, and despite the fact that Patrick Nasmyth's view of the Tweed with Melrose in the distance may have been painted as late as 1819, it would have been the same had Scott never written a line. The style is strongly influenced by Alexander's work, and nothing could be more unlike contemporary accounts of the bare Tweed than this lush valley with its repoussoir of mature and lofty trees. It is unlikely that there was any intention on Nasmyth's part of giving an alien or falsified character to the Tweed valley. Probably he quite genuinely admired its beauty, but felt, as Gilpin and Farington would have felt at an earlier date, that it was incomplete, and the full development of its potential required the finish or dressing of woodland. That these woods had only been planted in Nasmyth's mind we can be fairly certain, for Turner's water colour of Melrose and the Tweed, painted after his visit to Abbotsford in 1831, shows the vale as still bare and open.

The matching of Turner the illustrator to Scott the poet undertaken by Cadell—a choice dictated mainly by financial motives—nevertheless succeeded in producing, now and then amongst the illustrations, a real match of outlook and vision. Turner's Tweed, a great vista of empty space transformed by a radiance of evening light that glints on the distant ruins, is a true equivalent to the 'unconfined', 'irregular' and 'romantic' vision of landscape that Scott upheld as being like the desultory, wandering character of his own unclassical rhyming.

> 'Yet pleased, our eye pursues the trace
> Of Light and Shade's inconstant race;
> Pleased, views the rivulet afar,
> Weaving its maze irregular;"
> Then, wild as cloud, or stream, or gale,
> Flow on, flow unconfined, my Tale!'
> (*Marmion*, introduction to Canto 3)[9]

The Nasmyths' eyes had been trained on the pattern of an older style of landscape painting, and Turner was an outsider whose talent, by chance, bore some resemblance to Scott's, but upon some of the younger Scottish artists the poet's influence was direct and indisputable. William Simson, whose *Grey Mare's Tail* displays in a general way the characteristics of Scott's description, also painted three versions of salmon leistering on the Tweed, which seem to derive from Scott's account of this sport given in *Guy Mannering*. The hero of this novel does not join with the men spearing salmon but observes the scene from the river bank, admiring its pictorial qualities.

> 'Often he thought of his friend Dudley the artist, when he observed the effect produced by the strong red glare on the romantic banks under which the boat glided. . . . Then it (the torch) advanced nearer, brightening and enlarging as it again approached, till the broad flickering flame rendered bank, and rock, and tree, visible as it passed, tinging them with its own red glare of dusky light, and resigning them gradually to darkness, or to pale moonlight, as it receded. By this light also were seen the figures in the boat, now holding high their weapons, now stooping to strike, now standing upright, bronzed, by the same red glare, into a colour which might have befitted the regions of pandemonium.'

Scott's contribution to painting here was rather an enlargement of the repertoire of sporting scenes in landscape than the introduction of a new point of view. A contrast between warm fire or torchlight, and cold moonlight, was a relatively common artistic device which Scott merely transferred from pictures already seen into a new context where no painter had hitherto observed it. His greatest success in moulding the basic nature of an artist's outlook was achieved with Thomson of Duddingston. This artist, who is now inseparably linked with the imagery of savage Scottish romanticism, surprisingly possessed, before he fell under the influence of Scott, no clear personal style or individual viewpoint. In a sense he never came to possess one, but adopted Scott's as his own. In 1815, a writer

complained to *The Scots Magazine*, 'Mr Thomson's grand error seems to consist in his not adopting some decided manner, and painting in it straightforward.... His *manners* are almost as various as his *pictures*.' From 1818 Thomson was working on illustrations for Scott's *Provincial Antiquities*. Many of these, especially the views of Edinburgh, Craigmillar, and Innerwick, were gentle and contemplative in mood, lush with rich foreground plants and thickly growing trees, but,

with Fast Castle. Thomson was suddenly forced against imagery of an utterly different kind. 'Imagination can scarce form a scene more striking, yet more appalling, than this rugged and ruinous stronghold . . . overhanging the raging ocean,' wrote Scott in the text accompanying Thomson's plate. In 1814, Nasmyth had made a pencil drawing—probably from a ship—of distant Fast Castle,[10] but Scott seems to have been correct in believing that the place had never

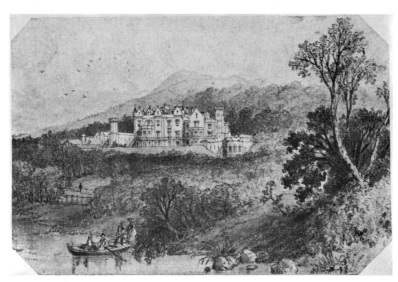

Fig 93
JOHN W EWBANK
Abbotsford
no. 8.9

Fig 94
After LOUIS HAGHE
Salmon fishers on the Tweed
no. 8.13

been engraved. It was therefore his own pictorial discovery which he transmitted to Thomson. The painter obliged with, over a period of years, at least eleven *Fast Castles*, from above, from below, from the South, and from the North, in weather conditions of ever increasing ferocity. One of the earliest was painted in 1823 for Scott himself. Writing to Alexander Nasmyth's son-in-law, Daniel Terry, Scott called this picture 'a true Scottish scene. It seems to me that many of our painters shun the sublime of our country by labouring to introduce trees where doubtless by search they might be found, but where certainly they make no conspicuous part of the landscape.' Despite the use of the plural, it is not hard to guess at whom this shaft was aimed. It was believed by most people including Thomson, and virtually admitted by Scott, that Fast Castle was the model for the imaginary castle of Wolf's Crag in *The Bride of Lammermoor* (1819). The description of Wolf's Crag in a storm (Chapter IX) gives a very good idea of the extent to which Scott's conception of the place came to dominate Thomson's vision in the painting of number 8.15.

'At this moment the cloud which had long lowered above the height on which Wolf's Crag is situated, and which now, as it advanced, spread itself in darker and denser folds both over land and sea, hiding the distant objects and obscuring those which were nearer, turning the sea to a leaden complexion, and the heath to a darker brown, began now, by one or two distant peals, to announce the thunders with which it was fraught; while two flashes of lightning, following each other very closely, showed in the distance the grey turrets of Wolf's Crag, and, more nearly, the rolling billows of the ocean, crested suddenly with red and dazzling light.'

Whereas in 1815 Thomson's work appeared to have no marked character, by 1825 it already typified, at least amongst the circle of Scott's acquaintance, the awesome power of nature at its wildest and most inhospitable. Christopher North makes The Shepherd (Scott's friend, the shepherd poet Hogg) refer to Thomson in the *Noctes Ambrosianae*.

'Gang into an exhibition, and only look at a crowd o' Cockneys . . . a' glowering perhaps at a picture o' ane o' Nature's maist fearfu' or magnificent warks! . . . Is't a picture o' a lang lang endless glen, wi' miles on miles o' dreary mosses, and hags, and lochs . . . mountain above mountain far and near, some o' them illuminated wi'

Fig 95
JOHN THOMSON
Newark Castle
no. 8.14

a' their woods till the verra pine-trees seem made o' heaven's sunshine, and ithers, wi' a weight o' shadows that drown the sight o' a' their precipices, and gar the michty mass o' earth gloom like thunderclouds, wi' nae leeving thing in the solitude but your plaided self, and the eagle like a mote in the firmament—siccan a scene as Tamson o' Duddingston wad trummel as he daured to paint it,—What, I ask, could a Princes Street maister or missy ken o' sic a wark mair than a red-deer wad ken o' the inside o' George's Street Assembly Rooms?'[11]

Fig 96
JOHN THOMSON
Fast Castle from below
no. 8.15

In Thomson's *Glen Altrive* one senses an artist with a conventional apparatus for landscape design, including the usual side screens of trees, being pushed towards imagery of a stark and grandiose nature which his skill and even his temperament could not quite compass. Altrive was Hogg's own setting, and Thomson's painting in some slight degree lives up to Hogg's rhapsodic verbal painting, but only in some degree, for the description is a piece of wild exaggeration, an excursion into wishful thinking, more a demand by Hogg (or Professor Wilson/Christopher North) for the satisfaction of romantic extremism, than an account of any picture that had yet been painted. It was not here in the Borders, but in the Highlands, and not by the amateur Thomson, but by men such as Landseer and McCulloch, that Scott's 'Land of the mountain and the flood' was to be given true pictorial form.

Fig 97
JOHN THOMSON
Glen Altrive
no. 8.17

(1) All the Farington quotations in this section are taken from the manuscript journals relating to his Scottish tours of 1788 and 1792, in the possession of Edinburgh City Libraries.

(2) William Gilpin *Observations on the Highlands of Scotland* 1789, p 50.

(3) Lord Cockburn *Circuit Journeys* 1888, p 56.

(4) William Scrope *Days and Nights of Salmon Fishing in the Tweed* 1843, p 103.

(5) William Gilpin *Observations on the Highlands of Scotland* 1789, p 111.

(6) J G Lockhart *The Life of Sir Walter Scott* new edition of 1893, pp 353–354.

(7) Elizabeth Grant *Memoirs of a Highland Lady*, first published 1898. Edition of 1950, pp 112–113.

(8) Lord Cockburn *Circuit Journeys* 1888, pp 55–56.

(9) Turner's vignette represents the aspect of Melrose at the time of his own visit, and was thus not intended to illustrate any particular descriptive passage in *The Lay of the Last Minstrel*. The likeness between Turner's work and the lines quoted from *Marmion* is therefore one of general attitude merely.

(10) In the National Gallery of Scotland, D 3727/69.

(11) John Wilson (Christopher North) *Notes Ambrosianae* Dec 1825.

WILLIAM SIMSON 1800–1847
8.1 **The Grey Mare's Tail** fig 85
Black chalk heightened with white on grey paper. 13.9
× 21.2 cm
Inscribed: *Grey Mare's Tail May 1828*
The Grey Mare's Tail is a waterfall descending from
Loch Skene near Moffat. It was described by Scott in
his poem *Marmion*.
National Gallery of Scotland

THOMAS GIRTIN 1775–1802
8.2 **The Eildon Hills and the Tweed near Melrose** fig 86
Water colour. 48.5 × 64.1 cm
Signed: *Girtin 1800*
Lent by the Syndics of the Fitzwilliam Museum,
Cambridge

JAMES WARD 1769–1859
8.3 **Melrose Abbey, the Pavilion in the distance** Pl vii, fig 87
Oil on panel. 103 × 173 cm
Signed: *J. Ward*
This picture and no. 8.4, its pair, were commissioned by
Lord Somerville for whom Ward also painted a pair of
pictures showing Fitzhead in Somerset. The pair of
Scottish views was exhibited at the RA in 1807
National Gallery of Scotland

JAMES WARD
8.4 **The Eildon Hills and the Tweed with Littledean Tower** fig 88
Oil on panel. 103 × 173 cm
Signed in monogram and dated: *J. WARD 1807*
The pair to no. 8.3 above
National Gallery of Scotland

JAMES WARD
8.5 **Melrose Abbey**
Chalk. 24.2 × 35.0 cm
Signed in monogram and inscribed: *Melrose Abbey J.
WARD RA*
Ward first visited Scotland in 1805 when he was taken
by Lord Somerville to stay at the Pavilion on the
Tweed, and to visit Scott. This drawing was the study
for no. 8.3, above. Melrose Abbey was described by
Scott in *The Lay of the Last Minstrel*
Lent anonymously

JAMES **WARD**
8.6 **The Eildon Hills and the Tweed with Littledean Tower** fig 90
Pencil and wash. 27 × 33 cm
Signed: *JWD RA*
This is a study for no. 8.4, above
Lent by the Visitors of the Ashmolean Museum, Oxford

PATRICK NASMYTH 1787–1831
8.7 **The River Tweed with Melrose Abbey in the distance** fig 92
Oil on canvas. 80 × 113 cm
This is very close in style to the work of Patrick
Nasmyth's father, Alexander. Patrick Nasmyth exhibited
a *View on the River Tweed in the neighbourhood of Melrose
Abbey* at the RA in 1819
National Gallery of Scotland

After JOSEPH MALLORD WILLIAM TURNER
1775–1851
8.8 **Melrose Abbey**
Engraving
After the water colour by Turner (in the Vaughan
Bequest of Turner Water Colours, National Gallery of
Scotland) commissioned by Cadell to illustrate *The
Poetical Works of Sir Walter Scott* (1833–34). Turner stayed
with Scott at Abbotsford in 1831 and was shown the
surrounding countryside by Scott himself. The figures
seated on the grass in the foreground include Cadell and
Turner. The sketchbook Turner used on this visit is in
the British Museum.
Lent by the Trustees of the National Library of
Scotland

JOHN W EWBANK 1799–1847
8.9 Six vignettes of Abbotsford and the neighbouring countryside
All pencil and wash
a. **Abbotsford** fig 93
7.2 × 11.1 cm
b. **Distant view of Melrose and the Tweed**
7.3 × 10.9 cm
c. **Huntly Burn**
13.6 × 10.1 cm
Inscribed: *Huntly burn. Glen. Abbotsford*
d. **Abbotsford and the Tweed**
13.6 × 10.0 cm
e. **Abbotsford library**
13.6 × 10.0 cm
f. **Distant view of Melrose and the Tweed**
7.5 × 12.0 cm
This is closely based on Turner's vignette for *The Poetical Works of Sir Walter Scott*, see no. 8.8
National Gallery of Scotland

SAMUEL DUKINFIELD SWARBRECK
8.10 **Abbotsford and the Vale of the Tweed**
Lithograph
Published in *Sketches in Scotland* (1839)
Lent by the Trustees of the National Library of Scotland

WILLIAM SIMSON
8.11 **Salmon leistering by moonlight on the River Tweed, the Eildon Hills in the distance**
Oil on canvas 127.0 × 94.3 cm
The sport of salmon leistering (spearing) by torchlight sometimes called burning the water, was practised by Scott and was described by him in the novel *Guy Mannering*. It was later explained from a more technical viewpoint by Scott's friend William Scrope in *Days and Nights of Salmon Fishing in the Tweed* (1843). This painting by Simson is probably rather earlier in date than his other versions of the same subject engraved for Scrope's book (see no. 8.12)
Lent anonymously

After WILLIAM SIMSON
8.12 **Burning the water**
Lithograph
After the painting by Simson published in William Scrope, *Days and Nights of Salmon Fishing in the Tweed* (1843)
Lent by the Trustees of the National Library of Scotland

After LOUIS HAGHE 1806–1885
8.13 **Salmon fishers on the Tweed** fig 94
Hand coloured lithographic proof with pencil drawings in the margin. Published in William Scrope, *Days and Nights of Salmon Fishing in the Tweed* (1843)
National Gallery of Scotland

JOHN THOMSON 1778–1840
8.14 **Newark Castle** fig 95
Oil on canvas. 83.8 × 73.7 cm
Newark Castle on the River Yarrow, an ancient stronghold of the Buccleuchs, was used by Scott for the setting of his *Lay of the Last Minstrel*. Thomson's picture, painted for the Duke of Buccleuch, was exhibited in Edinburgh at the Royal Institution, in 1829
Lent by his Grace the Duke of Buccleuch and Queensberry

JOHN THOMSON
8.15 **Fast Castle from below** fig 96
Oil on canvas. 76.2 × 105.4
Fast Castle on the Berwickshire coast was generally held to be Scott's model for the castle of Wolf's Crag in *The Bride of Lammermoor*. Thomson provided the illustration of Fast Castle seen from the opposite (South) side, engraved for Scott's *Provincial Antiquities and Picturesque Scenery of Scotland* (Vol II 1826), see no. 8.16. In 1823, Thomson presented Scott with a view of Fast Castle from above, and in 1824 he exhibited at the Royal Institution a pair of views of Fast Castle seen from below, one looking North and the other South. No. 8.15, shown here, was originally paired with another view from above, so that it seems unlikely that it was one of Thomson's 1824 exhibits. On stylistic grounds too it has the appearance of being rather later in date.
National Gallery of Scotland

After JOHN THOMSON
8.16 **Fast Castle**
Engraving
After the painting by Thomson published in Scott's *Provincial Antiquities and Picturesque Scenery of Scotland* (Vol II 1826)
Lent by the Trustees of the National Library of Scotland

JOHN THOMSON
8.17 **Glen Altrive, Selkirkshire** fig 97
Oil on canvas. 44.5 × 59.7
Altrive was the home, after 1817, of Scott's friend James Hogg, the shepherd poet. This picture is traditionally supposed to have been painted by Thomson when visiting Hogg at his Altrive farm
National Gallery of Scotland

Fig 98
WILLIAM DANIELL
Bonar Bridge
no. 9.1

Fig 99
JAMES GILES
Old Balmoral Castle
no. 9.7

Reproduced by gracious permission
of Her Majesty The Queen.

9

The Mountain and the Flood

'By a happy combination of steamboat, railway, and pedestrian journeys, we managed to see Loch Lomond and Loch Long...in one day' wrote Waagen the German art critic, who visited Scotland in 1850. He added, 'Never before had I witnessed scenery which bore so strongly the impress of a grand melancholy. In those mists which never dispersed during the whole day, and veiled more or less the forms of the hills, I could well imagine the presence of those Ossianic spirits which pervade Macpherson's poems. Many parts also brought Walter Scott's "Lady of the Lake" vividly before me.'[1] Waagen's discrepant experience, the incongruity of which he seems not to have noticed, was matched by that of thousands of other nineteenth century tourists who were enabled by the newly engineered communications systems to reach in easy journeys the most remote of Highland lochs and glens, but who, their goal attained, blotted the presence of steamboat, coach, and train from their vision, and looked only for Ossian and Scott.

At the start of the century it took four days to travel from Edinburgh to Inverness. There were no public coaches or post horses available. Sea lochs or firths were crossed by badly equipped ferries whose rudders were liable to fall off in mid stream. The Wordsworths, in 1803, were compelled at each such ferry, either to swim their horse behind the boat, or to force him to stand on board and risk the chance of his capsizing it in his terror, and at the Dornoch firth, before Bonar Bridge was erected, Joseph Mitchell's father once saw ninety nine travellers drown when the ferry overturned. In 1809, however, a stage coach was introduced between Inverness and Perth which initially covered the distance in three days, a time that was eventually shortened to eleven hours. In the 1840s coaching reached its zenith of efficiency, but the ten to twelve miles an hour that the drivers maintained was no match for the speed of a train, and gradually the railways superseded the coaches, so that, by 1883, Mitchell could speak of coaching as a thing of the past. In 1844 Lord Cockburn was grumbling that 'from Edinburgh to Inverness the...country is an asylum of railway lunatics... And anyone who puts in a word for the preservation of scenery, or relics, or sacred haunts, is put down as a beast, hostile to the "poor man's rights", "modern improvement", and the "march of intellect".' As far as Lord Cockburn could see the railways annihilated the scenic beauty they were designed to render available. 'Tay! thou art doomed!' he lamented in 1846. 'We passed the surveyors flags—the scientific upas,—twice this forenoon.' And he grieved, 'I never see a scene of Scotch beauty without being thankful that I have beheld it before it has been breathed over by the angel of mechanical destruction'.[2] Scott talked of his as an age when 'every London citizen makes Loch Lomond his washpot, and throws his shoe over Ben Nevis.'[3] He was writing in 1810, shortly after the publication of *The Lady of the Lake*. Years later, Alexander Fraser, the landscape painter, described a 'summer tide of tourists' pouring through the Highlands with the object of escaping from 'the prose of life to something of its poetry, in the land of the mountain and the flood.'[4] Fraser looked back on the date of the publication of *The Lady of the Lake* as marking a new era in literary and artistic

history, and it was against this background of the developing tourist industry in the Highlands that he attempted to place McCulloch's paintings. For the army of summer migrants described by Fraser, serviced by modern road, railroad, and steamer, the 'poetry of life' for which they were searching did not include the machinery of transport. No steamer breaks the surface of McCulloch's *Loch Katrine*, nor stagecoach trundles through his *Glencoe*, although Lord Cockburn wrote in

1843 that the coach horn had been heard in Glencoe all summer. 'Spirits of Fingal and Rob Roy! What say ye to this?'

There is something theatrical and illusory about the experience of Scottish scenery as it was rendered available by modern travel. Every effort was made to provide the visitor with a rapid succession of scenic alterations which ran before his eyes while he sat in stationary comfort in the theatre of his coach or railway carriage, regarding an unrolling series of vistas

Fig 100
EDWIN LANDSEER
Loch Avon
no. 9.3

that did not include, as a scenic addition that he could see, his modern everyday self. This applies as much to the Glasgow crowds of 1850, shuttled by rail from Bowling to Balloch, and then dispatched by steamer all over Loch Lomond, as it does to Queen Victoria, whose journey through Perthshire in 1842 was stage-managed so 'that the greatest possible amount of rich scenery might come within the range of the royal vision—that landscapes of the most various character, and severally amongst the best of their order, might pass rapidly before the view, and melt into one another like the hues of the rainbow—and that no intrusion of equipage and ceremoniousness should occur to disturb the royal mind's banqueting on beauty.'[5] These efforts were highly successful, and the Queen 'really appeared to feel as if affected by the silent exulting gloriousness of Scottish landscape quite as sensibly as by the enthusiastic welcomes of her people.' This was

Fig 101
EDWIN LANDSEER
The Monarch of the Glen
no. 9.4

intended for praise, not censure, but how George IV, twenty years earlier, would have stared had it been implied that he ought to be as pleased to see a mountain as a loyal Scottish subject.

The Queen's short visits to the Scottish Highlands in 1842, 44, and 47, left her with a longing for a much closer involvement with the landscape that could only be satisfied by a house of her own. In September 1848 she spent her first holiday at Balmoral, an old house which she thought pretty, and which Lord Cockburn in 1841 called 'beautiful... I do not recollect where I have seen any place that struck me more than Balmoral.' The Queen instantly responded to the surrounding scenery with delight. 'It was so calm so solitary, it did one good as one gazed around' she wrote of that first afternoon. 'All seemed to breathe freedom and peace, and to make one forget the world and its sad turmoils'[6] and the solitude was the chief benefit she

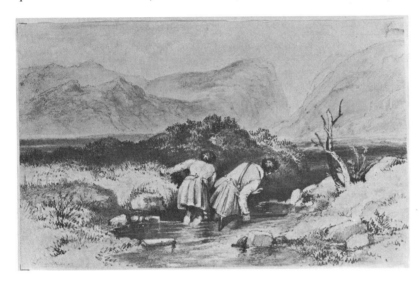

Fig 102
WILLIAM SCROPE and
CHARLES LANDSEER
Stalking for a quiet spot
no. 9.5

MR. BRIGGS'S ADVENTURES IN THE HIGHLANDS.

No. IV.

TO-DAY HE GOES OUT FOR A STALK, AND DONALD SHOWS MR. BRIGGS THE WAY.

Fig 103
After JOHN LEECH
Mr Briggs's Adventures in the Highlands No. IV
no. 9.6

always stressed whenever a place moved her deeply. 'So wild and solitary—no one but ourselves and our little party there'—'truly sublime and impressive; such solitude'—'the solitude, the complete solitude very impressive.' When in the Highlands, the Queen crossed lochs in rowing boats, took two hour mountain walks, or made day and two day pony expeditions, getting off to walk down places so steep that she fell, and scrambling up 'almost perpendicular' slopes. She forded rivers, picnicked on mountain tops, and sketched constantly, wishing very much that Landseer was present to record the scene. While she walked and rode, the Prince Consort stalked deer, returning sometimes late in the evening. Their experience and occupations, endeavours to participate in and respond to the scenery, recording it in words and sketches, were typical of those of many middle class families who took houses in the Highlands for a summer season.

Even stalking could become a method of self involvement in the landscape. In Scott's *Lady of the Lake*, it is, as at the opening of many celtic fairy tales, a stag that leads the King into the unknown country of the Trossachs, and one attraction of deer stalking as a sport was that it did, in actual fact, carry the stalker into places where no man made roads or even paths existed. Christopher North rhapsodised—with a touch of irony— on the joys of direct uninhibited contact with wild nature. 'The delight of the Highlands is in the Highland-feeling. That feeling is entirely destroyed by stages and regular progression... It is tedious in the extreme, to be drenched to the skin along high-roads—the rattle of wheels blends meanly with thunder— and lightning is contemptible, seen from the window of a glass coach. To enjoy mist, you must be in the heart of it as a solitary hunter, shooter, or angler.'[7] William Scrope, who provided some of the illustrational material for his own book, *The Art of Deerstalking*, was another observer who rated very highly amongst the pleasures of stalking the entry it provided to unknown tracts of natural beauty. 'And now what do you think of this wild region?' he demands of his sporting companion. 'Do you not almost feel as if you were

wandering in a new world? Here, everything bears the original impress of nature untouched by the hand of man since its creation. That vast moor spread out below you; this mass of huge mountains heaving up their crests around you; and those peaks in the distance, faint almost as the sky itself, give the appearance of an extent boundless and sublime as the ocean.'[8] Stalking was an exacting sport. Not only was the stalker quite unprotected from the weather, and unaccommodated with roads or level going, he was also required to crouch, wade, crawl and hide for hours on end, looking at the terrain through the mind of the animal he was following. The loneliness and hours of watching fostered a different attitude towards the countryside from that evinced by the English fox hunting artist for whom it was merely fenced ground crossed at a gallop by swarms of men in scarlet. The vast unfenced Highland landscape swallowed and absorbed the human stalker. It seemed not to belong to man at all, but to animals—or so at least Landseer appears sometimes to have felt, for though his earliest Highland pictures are sporting triumphs, in the 1840s, he began to produce, at irregular intervals, paintings of Highland landscape occupied by deer who are its sole possessors and observers. These paintings—as distinct from their titles—are not anthropomorphic, sentimental or fabulous in character, but serious efforts to envisage the natural environment as standing in some other possible relation than to man and his needs.[9]

The Queen, as we saw, believed that the scenery did her good. Her belief was moderate in comparison with that of Susan Ferrier, the Scottish novelist, in whose three books appreciation of Highland landscape is treated as a spiritual acid test or barometer, revealing the exact moral levels of her characters. Those who wish that the mountains were flat, or who look on straths as sheep pasture and lochs as sources of herring, or who, worst of all, consider that the arrival of a weekly steamer embellishes the view, are morally and spiritually debased. One may well ask how it was that the Highlands which so depressed Farington in the eighteenth century had come to be accepted as bestowing spiritual beni-

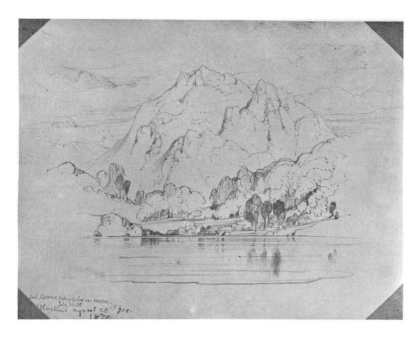

Fig 104
JOHN RUSKIN
Loch Katrine
no. 9.13

Fig 105
HORATIO McCULLOCH
Loch Katrine
no. 9.14

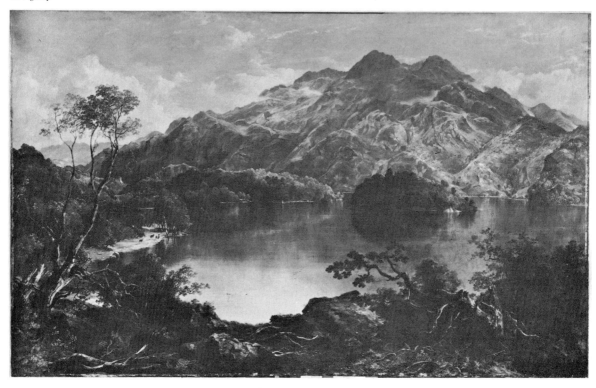

ficence on the right minded observer. A range of indirect explanations might be given, citing such influences as the pantheism of Wordsworth, but all direct enquiries lead straight to one place—the defile of the Trossachs into which the King follows the stag at the beginning of *The Lady of the Lake*.

From its first appearance, it was accepted that Scott had shown a remarkable pictorial sense in his treatment of Loch Katrine and the Trossachs. 'He sees everything with a painter's eye' wrote Jeffrey in the *Edinburgh Review* (No XVI for 1810). 'Whatever he represents has a character of individuality and is drawn with an accuracy and minuteness of discrimination, which we are not accustomed to expect from verbal description.... The rocks, the ravines, and the torrents, which he exhibits, are not the imperfect sketches of a hurried traveller, but the finished studies of a resident artist, deliberately drawn from different points of view.' All this is very true, but it does not explain the spell cast by the poem, not merely over the region described, but, by extension, over much of the rest of the Highlands as well. Scott's characterisation of Katrine, in this poem, is as an inviolate sanctuary of peaceful beauty, a self contained 'enchanted land' protected from the real outer world by 'sentinel' mountains, and penetrable, with difficulty, by the near secret pass of the Trossachs whose fantastic beauty, 'the scenery of a fairy dream', prepares the traveller for the new world he will encounter. This world has become the retreat of the exiled Douglas and his daughter Ellen, who live an idyllic, innocent and simple life, in close contact with the natural beauty that surrounds their island home—a life that is the antithesis of the Douglas' former existence at court. In this idyll the rules of ordinary life are suspended, and real identities disguised or shed. Ellen's Isle has several parallels with the enchanted island of Shakespeare's *Tempest*, not least in being a place where ancient enemies are brought harmlessly together and through which their quarrel is eventually healed.

What Scott's poem held out to the crowds of tourists whose visits to the loch are reputed to have raised post-horse duty to such an extraordinary degree, was not simply the offer of great scenic beauty, but the promise, if only for a brief holiday period, of a different way of life. Ellen and her father were the dream prototypes of all holiday visitors who stayed in hotels or rented houses, and picnicked, walked, boated, and lived simply, having temporarily shed their professional and social identities for the sake of the spiritually restorative effects of natural beauty. Even the Queen made her long pony expeditions incognito, and, whilst being rowed by moonlight on Loch Muich, felt herself to be in one of the descriptive passages of the poem.

Turner's vignette provides a view corresponding to that of the hunting king in the poem, as he first sees Loch Katrine and her islands, with Benvenue in the south. Its establishment of this as one of the best viewing points was clearly an influence on Horatio McCulloch, whose enormous and elaborate painting of Loch Katrine is an inflated version of the Turner. Curiously enough Ruskin, who visited the Loch in 1838, and drew Benvenue from a point rather closer to it, betrays— though he must have known Turner's vignette—no hint of Turner's influence. His drawing style at this juncture, based on the picturesque architectural studies of Prout, has a certain piquancy when its mannered curves are applied to the weathered irregularities of old buildings, but rather loses its point when used on Scott's 'crags, knolls, and mounds, confusedly hurl'd', forms in which irregularity is an essence, not a picturesque deviation.

Horatio McCulloch's debt to Turner over Loch Katrine was not noticed or acknowledged in his own day. For a time he occupied, in Scottish landscape painting, a peculiar, almost messianic position, with John Thomson as his forerunner. As early as 1847 the *Art Union* observed that his subjects were 'purely national', and though at that date he still appeared to be hesitating between the Lowlands and the Highlands, by 1860 his Highland role was clearly established. 'He is a poet-painter', wrote the self-styled 'Iconoclast' who raised his idol to McCulloch amidst the smashed reputations of all other Scottish landscapists. 'He can make you feel through his art the loneliness of mountain sides and great glens, and inspire you, if you will but open

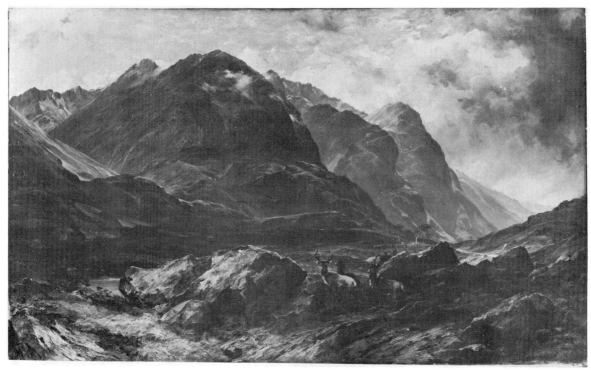

Fig 106
HORATIO McCULLOCH
Glencoe
no. 9.19

Fig 107
HUGH WILLIAM WILLIAMS
Glencoe
no. 9.18

your mind to receive the impression, with the feeling of religion and wonder, which, growing out of the sense of that loneliness, has imbued his own spirit.'[10] Two years later another anonymous pamphleteer, 'L'Inconnu', elevated McCulloch's pedestal another few feet. 'He is as strictly a national painter as our English Constable. He delights in hills as Constable in valleys. He catches the bold bluff of a craggy steep as faithfully as Constable seized the gentle curves and ami-

The unquestioning identification of Scotland with the Highlands, and hence with mountains, the whole with the part, would have startled Runciman, More, and Nasmyth, in the previous century.

In the third volume of *Modern Painters*, Ruskin, writing of nineteenth century appreciation of mountains, claimed that, 'The charm of romantic association can only be felt by the modern European child...it depends for its force on the existence of ruins and

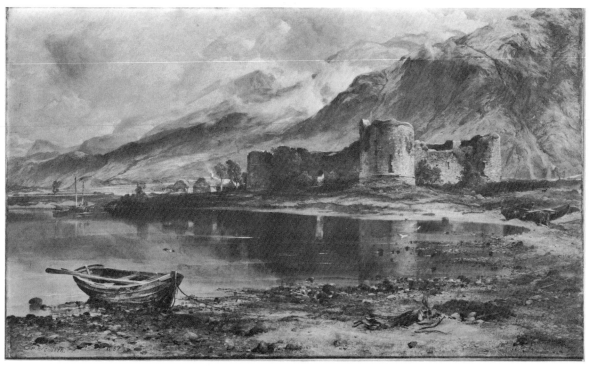

Fig 108
HORATIO McCULLOCH
Inverlochy Castle
no. 9.11

able windings of homely English landscape. And in colour and handling he surpasses Constable.'[11] After McCulloch's death one of his obituarists put some finishing touches to his diadem. 'He was the Christopher North of the canvas, and as he could write and speak so variously...so McCulloch painted; now the mountain corry, "its echoes repeating the roar of the cataract and the scream of the eagle"; and again the quiet vale, asleep in the morning light of its own loveliness...they were in a very true sense, kindred spirits.'[12]

traditions, on the remains of architecture, the traces of battlefields, and the precursorship of eventful history.' The truth of this statement in relation to Loch Katrine or Glencoe is indisputable, but Ruskin does not mention—at least here—a perverse and contradictory, but powerful sort of landscape association—that is, the conviction that a place is quite without any human associations. Again and again one hears, on the lips of travellers in remote parts of the Highlands, echoes of the Ancient Mariner's astonished cry, 'We were the first that ever burst into that silent sea.' That the value of a place should reside in its complete rebuttal of all human values, its total innocence of human contact, is strange,

but in the century of spoliation by mail coach, railway, and steamer, understandable. The appearance of much high romantic Scottish landscape painting, especially certain works by Landseer and McCulloch, may be seen as an attempt to sustain a myth of uncontamination that became less true with every year that passed, Even so, places hard of access did of course remain, whose seeming nature was of so hostile a character that the feeling of being the first discoverer continued

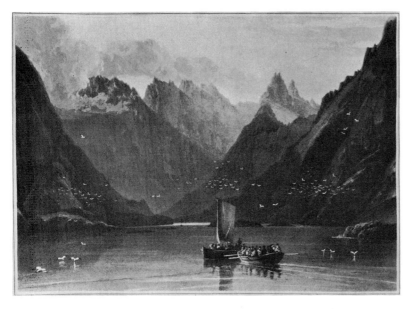

Fig 109
WILLIAM DANIELL
Loch Coruisg near Loch Scavig
no. 9.20

the Isles, took such complete verbal possession of scenes that they were never later released from his hold. His account of Coruisk mesmerised subsequent visitors, but the place itself mesmerised them more strongly, and one feels Lord Cockburn struggling to put Scott aside, and then succumbing to the same impressions. 'Every prospect and every object is excluded, except what are held within that short and narrow valley; and within there is nothing except the little loch, towered over by the

a perpetual part of the experience of visiting them. Such a place was Loch Coruisk on the Isle of Skye. If Loch Katrine was an earthly paradise, and Glencoe a perfect agreement between natural sublimity and a history of human terror, Coruisk seemed to exist merely to show what the world would have been without human occupants. As Lord Cockburn neatly put it, 'An inn, or even a house, or perhaps even a sheep, would extinguish Coruisk', and as he left Loch Scavaig and looked back on the Cuillins, he compared them with the Firth of Clyde. 'How much does Clyde owe to human association, to culture, to seats, to villages, to towns, to vessels! The peculiarity of the interest in Scavaig arose from the total absence of all human interference, the scene would have been the same had man not existed.'[13]

Scott, who described Coruisk in *The Lord of*

high and grisly forms of these storm-defying and man-despising mountains... Each of the hills seems to consist of one stone.' (North Circuit 1841).[14] He noticed also that the hills seemed to curve inwards over the loch but doubted whether this was in actuality the case.

John MacCulloch the geologist who published his description of the Western Isles in 1819, observed how dark the far end of, the loch always looked. 'The effect of simplicity and proportion in diminishing the magnitude of objects is here distinctly felt, as it is in the greater efforts of architecture: Those who have seen the interior of York Cathedral will understand the allusion.' Because of this visual deception, 'He who would paint Coruisk must combine with the powers of the landscape-painter those of the poet. It is to the imagination, not to the eye that his efforts must be

directed.'[15] Daniell, in his aquatint of 1819, failed, despite the height, darkness, and saw-toothed edges of his hills, in conveying the effect of complete seclusion and self contained unity which visitors usually felt, or in expressing the curvilinear character of the mountain ridge. Turner, on the other hand, who must have climbed to the highest point at the south east end of the Loch, and climbed still higher yet in his mind, gives a powerfully effective equivalent to all the sensations travellers normally described, a portrait that is imaginatively, though it may not be factually true. Although the views of Melrose and the other Border scenes Turner drew for Scott's *Poetical Works* do not illustrate particular passages in the poems, this is not the case with Turner's views of Loch Katrine and Loch Coruisk. In the Borders Scott was on his own ground. He knew the sites from every side, and of course took Turner to the best viewpoints, even though these were not the spots from which his fictitious characters had gazed in the poems. In the Highlands however Scott had not this intimate acquaintance with places, and he described sites as the visitor would naturally arrive in front of them. His Coruisk and Turner's are thus the same, and for the same reason. Turner's Coruisk, however, does exhibit a closer adherence to Scott's verse than this. The rosy light and curling mists of the vignette are exactly what Bruce and his followers saw when they left Loch Scavaig and climbed to the vantage point later occupied by Turner.

'The evening mists, with ceaseless change,
Now clothed the mountains' lofty range,
Now left their foreheads bare,

And round the skirts their mantle furl'd,
Or on the sable waters curl'd,
Or on the eddying breezes whirl'd,
Dispersed in middle air.'

This too was the descriptive point which Ruskin seized when writing about the engraved vignette after Turner's *Coriskin* (*Modern Painters Vol I; Of Truth of Clouds*) giving his interpretation a characteristically scientific twist, for on mountains bare of vegetation rain quickly evaporates into mist. 'Now this effect has evidently been especially chosen by Turner for Loch Coriskin, not only because it enabled him to relieve the jagged forms with veiling vapour, but to tell the tale which no pencilling could, the story of its utter absolute barrenness of unlichened, dead, desolated rock.' Another aspect of Scott's description that surely attracted Ruskin's attention, was the allusion to the primeval pre-history visible in the present day structure of the Cuillins' rocks.

'Seems that primeval earthquake's sway
Hath rent a strange and shatter'd way
Through the rude bosom of the hill,
And that each naked precipice,
Sable ravine, and dark abyss,
Tells of the outrage still.'

In discussing mountain forms (*Modern Painters Vol II; Of the Inferior Mountains*) Ruskin declared that he would prefer Turner's *Coriskin* to a geological drawing as a means of explaining structure, and in the fourth volume of *Modern Painters* he returned to the engraving of *Coriskin*, even copying it in outline himself, to demonstrate its merits. 'Note...the way in which Turner leans on the *centre* and body of

the hill, not on its edge; marking its strata stone by stone, just as a good figure painter, drawing a limb, marks the fall and rise of the jointly,' and yet once more, in the *Elements of Drawing*, Ruskin urged his readers to copy and learn from the engraving of Turner's *Coriskin*. These passages, with their vivid descriptions and dogmatic exhortations, did not fail to exert an effect on artists. The work of Horatio McCulloch, for example, does seem, in its grasp of the intricately seamed faces of

Fig 110
JOSEPH MALLORD WILLIAM TURNER
Loch Coriskin (Coruisk)
National Gallery of Scotland, Vaughan Bequest of
Turner Water colours

rocks and hills, and its superiority in this respect to the shapeless, lumpy slabs painted by Thomson of Duddingston, to betray the influence of Turner, and these formal properties were of course just what an engraving could most satisfactorily transmit. Ruskin thus acted as a filter on Turner and Scott, for what had begun, in *The Lord of the Isles*, as a half fanciful method of heightening the effect of Coruisk's savage power, a romantic intuition, reached the artists of the 1850s and 60s, who studied *Modern Painters*, as a correct way of reading nature, guided by geological text-book knowledge. What a painter directly influenced by Ruskin made of the Cuillins can be seen in the ensuing section.

Fig 111
JOHN THOMSON
Loch Scavaig and the Cuillins, Skye
no. 9.22

(1) Waagen *Treasures of Art in Great Britain* 1854, vol III, p 291.

(2) Lord Cockburn *Circuit Journeys* 1888 pp 268, 302, 308.

(3) J G Lockhart *The Life of Sir Walter Scott* new edition of 1893, p 190.

(4) Alexander Fraser *The Life and Works of Horatio McCulloch RSA* 1872, p 9.

(5) *Perthshire Illustrated: a series of select views.* 1844 p LXXXVIII.

(6) Queen Victoria *Leaves from the Journal of our Life in the Highlands from 1848–1861*, 1868 p 65–66.

(7) John Wilson (Christopher North) *Noctes Ambrosianae* October 1825.

(8) William Scrope *The Art of Deerstalking* first pub 1838, edition of 1897 p 42.

(9) For example, (RA 1844) *Coming Events cast their shadows before them*; (RA 1851) *The Monarch of the Glen*; (RA 1853) *Night*, and *Morning* and *Children of the Mist*; (RA 1861) *Fatal Duel*.

(10) Iconoclast *Scottish Art and Artists in 1860*, 1860, p 25.

(11) L'Inconnu *Landscape and Historical Art in the Royal Scottish Academy of 1862.*

(12) William Glen *Art Journal* 1867, p 188.

(13) Lord Cockburn *Circuit Journeys* 1888, p 126.

(14) Ibid p 123–124.

(15) John MacCulloch *A Description of the Western Islands of Scotland 1819*, vol I, p 284.

WILLIAM DANIELL 1769–1837
9.1 **Bonar Bridge** fig 98
Aquatint
Published 1821 in the series *The Coast of Great Britain*
Bonar Bridge crossed the Dornoch Firth in Sutherland.
The bridge was designed by Telford in 1811 and had an
iron arch with a span of 150 feet. Its construction
followed a major ferry disaster in 1809
National Gallery of Scotland

DAVID OCTAVIUS HILL 1802–1870
9.2 **Pass of Killiecrankie**
Lithograph
Published in *Sketches of scenery in Perthshire drawn from
Nature and on stone by D O Hill, 1821*
Lent by the Royal Scottish Academy

EDWIN LANDSEER 1802–1873
9.3 **Loch Avon** fig 100
Oil on panel. 35.2 × 44.5 cm
Loch Avon is a small lake high in the Cairngorm
mountains. This sketch may have been painted at the
same time as the view by Landseer of Loch Avon (in a
private collection, on loan to the National Museum of
Wales) which is dated *September 9 1833*
Lent by the Trustees of the Tate Gallery

EDWIN LANDSEER
9.4 **The Monarch of the Glen** fig 101
Oil on canvas. 63.8 × 68.9 cm
Exhibited at the Royal Academy in 1851 with the lines
 'When first the day star's clear cool light,
 Chasing night's shadows grey,
 With silver touched each rocky height
 That girded wild Glen-strae
 Uprose the Monarch of the Glen
 Majestic from his lair,
 Surveyed the scene with piercing ken,
 And snuffed the fragrant air.'
A remarkable similar descriptive passage occurs in
Scott's *Lady of the Lake* where the stag is called 'The
antler'd monarch of the waste'
 'The dew drops from his flank he shook;
 Like crested leader proud and high,
 Toss'd his beam'd frontlet to the sky.'
The painting was originally intended to hang in the
Refreshment Room of the House of Lords as one of a
group of four illustrating The Chase
Lent by John Dewar and Sons

WILLIAM SCROPE 1772–1852 and CHARLES
LANDSEER 1799–1879
9.5 **Stalking for a quiet spot** fig 102
Pencil and wash heightened with white. 11.9 × 19.1 cm
Inscribed: *E. Landseer*
Reproduced in William Scrope's *The Art of Deerstalking
1838*. The plate reproduced is inscribed 'T. Landseer
and W. Scrope' but the author, in his preface, claims
that the figures and animals in his illustrations were
drawn by Charles Landseer and the landscapes by
himself
National Gallery of Scotland

After JOHN LEECH 1817–1864
9.6 **Mr Briggs's adventures in the Highlands
 No IV and V** fig 103
Engravings
Reprinted from *Punch* (1861). IV is captioned: *Today he
goes out for a stalk, and Donald shows Mr Briggs the way.* V
is captioned: *With extraordinary perseverance they come within
shot of 'The finest hart'. Mr B is out of breath, afraid of
slipping, and wants to blow his nose (quite out of the question).
Otherwise he is tolerably comfortable*
Mr Briggs was a London business man who regularly
appeared in Leech's cartoons. The backgrounds were
drawn from studies made in the Forest of Atholl
Lent anonymously

JAMES GILES 1801–1870
9.7 **Old Balmoral Castle** fig 99
Oil on panel. 55.0 × 81.6 cm
This view, one of a pair, was painted in 1848. Queen
Victoria stayed for the first time at Balmoral on 8
September 1848. She described the house as a 'pretty
little castle in the old Scottish style', but it was not large
enough, and was replaced by the present castle, begun
in 1853 and completed in 1856. The old castle was
demolished as the new one was built
Lent by Her Majesty the Queen

After CARL HAAG 1820–1915
9.8 Luncheon at Cairn Lochan
Engraving
After the view commissioned by Queen Victoria. Published in *Leaves from the Journal of our Life in the Highlands* (1868). The Queen picnicked at Cairn Lochan on 16 October 1861. She admired the lights on the mountains 'like the bloom on a plum', and made some 'hasty sketches'
Lent anonymously

CARL HAAG
9.9 Queen Victoria fording the Poll Tarff
Chromolithograph and watercolour. 60.4 × 127.0 cm
Carl Haag was recommended to the Queen by the Duke of Saxe-Coburg and Gotha, and stayed at Balmoral in 1853 in order to paint scenes of stag hunting. This composition was one of four engraved for Queen Victoria's *Leaves from the Journal of our Life in the Highlands* (1868). The fording of the Tarff took place on the Queen's 'Third Great Exhibition—To Glen Fishie, Dalwhinnie, and Blair Athole' in October 1861. The expedition lasted two days, the 8 and 9 October. Sixty-nine miles were covered on the first day and sixty on the second. The figure leading the way across the river, was, according to the Queen's *Journal*, Sandy McAra, the guide, and leading her pony were John Brown and the Duke of Atholl. Prince Albert and Princess Alice appear following behind the Queen
Lent by Her Majesty the Queen

HORATIO McCULLOCH 1805–1867
9.10 My Heart's in the Highlands
Watercolour. 40.6 × 56.0 cm
A study for the oil painting of 1860 now in Glasgow City Art Gallery. This does not show an actual view but is an imaginative amalgam of typically Highland scenic features
Lent by Paisley Museum and Art Gallery

HORATIO McCULLOCH
9.11 Inverlochy Castle fig 108
Oil on canvas. 90.2 × 151.0 cm
Signed: *H. McCulloch 1857*
Inverlochy Castle stands below Ben Nevis, part of which appears in the background. The painting was based on a sketch made by the artist on the spot
National Gallery of Scotland

After JOSEPH MALLORD WILLIAM TURNER 1775–1851
9.12 Loch Katrine
Engraving
After the watercolour by Turner, published in *The Poetical Works of Walter Scott* ed. Cadell (1833–34) as an illustration to *The Lady of the Lake*. Turner visited Loch Katrine in the late summer of 1831 with the specific purpose of making studies for this illustration. Ellen's Isle appears in the centre
Lent by the National Library of Scotland

JOHN RUSKIN 1819–1900
9.13 Loch Katrine fig 104
Pencil
Inscribed: *Loch Katrine looking to Coir nan Uriskin July 28.38. J. Ruskin Signed 28th Dec. 1879*
In the summer of 1838 Ruskin toured Scotland with his parents
Lent by the Ruskin Gallery, Bembridge

HORATIO McCULLOCH
9.14 Loch Katrine pl viii fig 105
Oil on canvas. 104 × 183 cm
Dated: *1866*
Ellen's Isle, so named from Scott's *Lady of the Lake* appears in the centre, with Benvenue behind it
Lent by Perth City Art Gallery and Museum

After ROBERT HERDMAN 1829–1888
9.15 The Lady of the Lake
Engraving
Published by the Royal Association for the Promotion of the Fine Arts in Scotland in *Six Engravings in illustration of The Lady of the Lake* (1868). This shows Ellen, the heroine of the poem, with Ellen's Isle, Loch Katrine and part of the slope of Benvenue behind her
National Gallery of Scotland

ANONYMOUS
9.16 (a) The Boat House—Loch Katrine
 (b) The Path by the Lake—Loch Katrine
Chromolithographs
Published in *Souvenir of Scotland*, T Nelson and Sons (1889)
National Gallery of Scotland

PATRICK NASMYTH 1786–1831
9.17 Glencoe
Watercolour. 17.2 × 25.5 cm
Signed: *P. Nasmyth*
Lent by Glasgow City Museum and Art Gallery

HUGH WILLIAM WILLIAMS 1773–1829
9.18 Glencoe fig 107
Watercolour. 26.2 × 35.0 cm
National Gallery of Scotland

HORATIO McCULLOCH
9.19 Glencoe fig 106
Oil on canvas. 110.5 × 182.9 cm
Signed: *H. McCulloch, 1864*
Lent by Glasgow City Museum and Art Gallery

WILLIAM DANIELL
9.20 Loch Coruisg near Loch Scavig fig 109
Aquatint
Published 1819 as part of the series *The Coast of Great Britain*
National Gallery of Scotland

After JOSEPH MALLORD WILLIAM TURNER
9.21 Loch Coriskin (Loch Coruisk)
Engraving
After the watercolour by Turner (Vaughan Bequest of Turner watercolours, National Gallery of Scotland), published in *The Poetical Works of Walter Scott* ed. Cadell (1833–34), as an illustration to *The Lord of the Isles*. Turner visited Loch Coruisk in 1831 after visiting Loch Katrine and the Clyde
Lent by the National Library of Scotland

JOHN THOMSON 1778–1840
9.22 Loch Scavaig and the Cuillins, Skye fig 111
Oil on canvas. 106.0 × 213.3 cm
Thomson probably visited Skye in 1836. He painted at least three views of Scavaig, besides views of Loch Coruisk. The peaks in the left background are those depicted by William Daniell and by Turner (see nos 9.20 and 9.21)
Lent by the New Club, Edinburgh

After JOHN RUSKIN
9.23 Copy of Turner's Loch Coriskin
Engraving
After a drawing by Ruskin published in *Modern Painters* Vol IV (1856) as an example of Turner's grasp of rock structure in mountain crests. The outline drawing above it on the same page was copied from Claude and unfavourably compared by Ruskin with the Turner
Lent anonymously

10
Truth of Foreground

On 10th July 1847, Elizabeth Rigby, later to become Lady Eastlake, wife of the Director of the National Gallery, London, visited Loch Lomond, where instead of admiring the panoramic prospect of water, islands and mountains she admired the 'foregrounds—lumps of rock finely outlined on the shore.' 'I want,' she wrote, 'a different standard of the picturesque; our standard is chiefly what a favourite artist has made. I should like to choose a totally different class of pictures, more formal and truthful—the Holbeins of landscape—and break the public in to admire those.' On 2nd August, she returned to her theme. 'I don't care for these lochs in full view; little shore-bits of them are delicious... and I love every inch of a burn, with ferns hanging over it and every stone, round which it ripples, rich in colour... Nothing looks large or interesting of which you see the whole. I doubt whether what the world calls fine scenery ever looks well in a picture; there is no idea given by it.'[1]

It is ironical that Lady Eastlake's revised standard of truthful foreground painting should have come into actual existence through the agency of Ruskin whom, despite their common interest in early art, and common admiration for Turner, she detested, and whose *Modern Painters* she reviewed with hostility. She did not, however, detest Millais, the other main agent in the revision of Scottish picturesque, and it was partly through her encouragement that Effie Ruskin was ennabled to obtain annulment of her marriage and to remarry with Millais, after the disastrous holiday of 1853 when the new Scottish picturesque had taken shape in Millais' portrait of Ruskin at Glenfinlas. The progress of this

work, and of the relationship between the painter and the critic, has been charted in such detail by Mary Lutyens (*Millais and the Ruskins*, London 1967) that it would be superfluous to repeat it here. Two points however do need to be raised. The first concerns the locality that Millais painted. At Brig o Turk he was on the very doorstep of the Trossachs, in Scott's country of *The Lady of the Lake*, a situation in which a view of Ellen's Isle or Loch Katrine had become for most artists almost a religious obligation, but Millais, though he alluded to Scott's poem in a letter and actually visited Loch Katrine, did not paint either it or Benvenue. The other point requiring some consideration is Ruskin's own attitude towards the scenery, and, incidentally, towards Scott's description of it, for he went on from Brig o Turk to lecture at Edinburgh where he used Scott quotations, including one from *The Lady of the Lake*.[2] The unprecedented stress laid by Ruskin on precision and understanding in depicting the plants and pebbles of a foreground demanded a quality of vision that he thought was discernable in marked degree in the poetry of Walter Scott. It is curious that Scott's poetry should normally have operated as encouragement towards an inflated pictorial romanticism, and that only Ruskin really noticed, extracted and stressed what, for want of a better word one may call the Pre-Raphaelite elements in Scott's vision of landscape. The accuracy and minuteness of Scott's descriptive verse had, as we saw, been briefly adverted to by Lord Jeffrey, in his review of *The Lady of the Lake*, but for Ruskin the precision of Scott's natural detail was a matter of crucial importance indicating a parallel sensibility to

Fig 112
JOHN WILLIAM INCHBOLD
The Cuillin Ridge, Skye
no. 10.7

Fig 113
JOHN MILNE DONALD
A Highland Stream, Glenfruin
no. 10.8

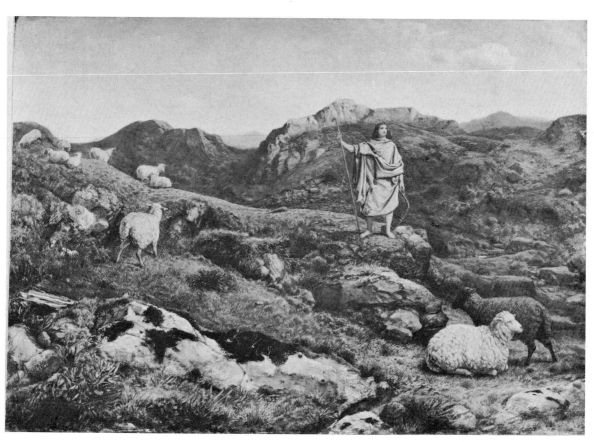

Fig 114
WILLIAM DYCE
David in the Wilderness
no. 10.12

that of Turner, and, although Ruskin does not say so, to his own way of looking. When talking of the modern conception of landscape (*Modern Painters* vol III)[3] Ruskin illustrated his points by quotations from *The Lady of the Lake* and by an extended quotation from *Rokeby* to demonstrate Scott's colour sense in painting foreground plants;

'...he laid him down
Where purple heath profusely strown,
And throatwort, with its azure bell,
And moss and thyme his cushion swell'
in the movement of running water;
'Beneath her banks, now eddying dun,
Now brightly gleaming to the sun,
As, dancing over rock and stone,
In yellow light her currents shone.'
and the overgrown surface of rocks;
'One, prominent above the rest,
Reared to the sun its pale grey breast;
A thousand varied lichens dyed
Its waste and weatherbeaten side.'

'Note', Ruskin commented, 'what is indeed manifest throughout Scott's landscape as hardly to need pointing out—the love of rocks, and true understanding of their colours and characters.' His own writing about rocks is a miracle of exact and sensitive observation. 'The dark sides of fractured stone receive brilliant reflexes from the lighted surfaces, on which the shadows are marked with the most exquisite precision, especially because, owing to the parallelism of cleavage the surfaces lie usually in directions nearly parallel. Hence every crack and fissure has its shadow and reflected light separated with the most delicious distinctness, and the organisation and solid form of all parts are told with a decision of language, which, to be followed with anything like fidelity, requires the most transparent colour, and the most delicate and scientific drawing.' (*Modern Painters* vol II, 1846).

He pointed out how the eroding action of violent eddies in a torrent hollows out the convex sides of its rocky bed so as to produce a series of alternating curves, whose surfaces, as depicted by Turner, 'seem to palpitate from the fine touch of the waves, and every part of them is rising or falling, in soft swell or gentle depression, though the eye can scarcely trace the fine shadows on which this chiselling of the surface depends.' Later, he was to praise in Titian (*Modern Painters* vol IV, 1856) the writhing lines of stones in the bed of a torrent, following the undulating grain of the crystalline structure, and the undercutting of the water.

The common failure in the painting of falling or strongly running water arose, Ruskin thought, from its 'being too interrupted, the forms flung hither and thither, and broken up and covered with bright touches, instead of being wrought out in their real unities of curvature...to indicate the varied and sweeping forms of a crystalline and polished substance, requires far more skill and patience than most artists possess. In some respects it is impossible.... Many tricks of scratching and dashing will bring out a deceptive resemblance; the determined and laborious rendering of contour alone secures sublimity' (*Modern Painters* vol II, 1846). Later, in the *Elements of Drawing*, Ruskin was to warn young practitioners against the subject of falling water, and to suggest that they first measured their skill upon a heap of broken bottle glass which presented the same interplay of reflections, but was at least static. Ruskin's sense, that structures of crystalline precision—forms that even the camera could not then act fast enough to trap—underlay the blurred, deceptive flurry of spray, was matched by his sense of movement—flexion of grain, splintering, aquatic erosion, and plant growth—in the rocks. Crystalline fixity in the water, life and change in the rocks—neither the impressions ordinarily developed out of a casual or superficial glance—are forcibly conveyed in Millais' extraordinary painting. Ruskin watched with something like amazement as the lichens appeared on Millais' rocks, 'gleaming like frosted silver', and the torrent itself, 'truly such as was never painted before.' (Mary Lutyens, *Millais and the Ruskins* p 93.) New indeed, for what Ruskin was seeing were his own words made visible! It would be far overstating the case to claim that Ruskin played here the role of Svengali, mesmerising from Millais art that he had not

Pl ix
JOHN EVERETT MILLAIS
Ruskin at Glenfinlas
no. 10.1

Pl x
JAMES GUTHRIE
The Hind's Daughter
no. 11.13

the ability to produce himself. Nevertheless, the power of his ideas and visual preoccupations exerted their greatest hold over Millais at this juncture, and even the following year when Millais, half estranged, returned to Glenfinlas without Ruskin, the spell of the latter's writing still held, and Millais forced his friends Luard and Collins to listen to readings from Ruskin's lectures. That the influence was reciprocal, so that Ruskin modified his own drawing style, bringing it closer

similar to Millais' Glenfinlas rocks, the effect of which was due to 'the white spots of silvery lichen...and to the flowing lines in which the darker mosses, growing in the cranny, have arranged themselves beyond.'

On several occasions in *Modern Painters* Ruskin, as we have seen, commended the engraving of Turner's *Loch Coriskin* with its view of the Cuillin hills as a valuable object of study to a young artist. By a curious coincidence, Inchbold's picture of the Cuillins from

Fig 115
WILLIAM DYCE
The Man of Sorrows
no. 10.13

to that of Millais, has been suggested by Paul Walton. (*The Drawings of John Ruskin*, Oxford 1972, p 81) and it would seem also that the effect of Millais' lichens was deeply impressed upon Ruskin's visual memory, for, in the fourth volume of *Modern Painters*, he reproduced a daguerreotype of a rocky slab rather

Sligachan was exhibited slightly later in the same year as the appearance of the fourth volume of *Modern Painters* with Ruskin's own outline copy of the Turner engraving. Inchbold's picture betrays so strongly the joint influence of Millais' Glenfinlas portrait and Ruskin's writings that it is tempting to wonder whether in fact Ruskin had not been discussing these mountains with Inchbold in the previous autumn, even perhaps urged him to try his hand at painting them. Inchbold's

Fig 116
JOSEPH NOEL PATON
The Bluidie Tryste
no. 10.14

view of the Cuillins, not from Loch Coruisk, but from the northern side of the range, is now common in photographic views, but seems, in 1856, to have been unattempted. It presents an interesting case of a new view of a place being made accessible to artists simply as a result of a revolution in painterly style. In 1819, MacCulloch the geologist, had complained about the interior of Skye, 'There is little . . . to attract the attention of the painter. If the distant outline is often grand or picturesque, the want of objects in the middle ground leaves the landscape barren, naked, and meagre: The artist searches in vain amid the wearisome repetition of brown, smooth, undulating moor, for the dark wood, the bushy ravine, the rocky torrent, or the intricacy of broken hills, to contrast with the distance and to fill his picture.'[4] In short, the landscape did not resemble a Nasmyth or even a Thomson of Duddingston. Inchbold made no search for these missing features. Instead, by the simple device of removing attention from the middle distance to the extreme foreground, he obtained all the variation of texture and breakage of surface that could be wished, together with an astonishing interplay between the ground under foot and the far distant peaks whose cruel edges are diminished by the fractured rocks and water of the burn.

After his marriage in 1855 Millais settled at Bowerswell in Perthshire. In 1857 he received a commission from the publishers Dalziel to produce thirty designs for a projected volume of engraved illustrations to the Parables. Although initially he was enthusiastic, Millais' interest gradually waned, and he only completed twenty illustrations. In 1863 twelve of the engravings appeared in *Good Words*. In 1864 the full twenty were published in book form alongside the appropriate texts. In commissioning Millais the Dalziels had wished to avoid the 'conventional style' of biblical illustration, and their belief that Millais would adopt an unusual approach was justified by the finished designs in which he gave all those parables that required outdoor settings, landscape backgrounds copied from the local Perthshire countryside. To appreciate the originality and boldness of this step, it must be remembered that Millais' friend Holman Hunt had only recently returned from visiting the Holy Land, and had, in 1856 exhibited his *Scapegoat* with its stridently detailed desert setting. If Millais had wished to place his *Parables* in authentic Eastern surroundings he could surely have obtained from his friend enough visual material to do so. Those Parables in which the Scottish setting is most obvious are *The Sower* with a foreground of shingly pebbles and reeds, and distant pine trees, *The Good Samaritan* with distant hills and woods of mixed deciduous and pine trees, *The Lost Sheep* with a craggy hill slope, a pine tree and an eagle, *The Ten Virgins* with moorland and pine, and, lastly, *The Good Shepherd* with its foreground of thistles. In each of these cases the figures are dressed in a conventional biblical style of costume, only the landscape is Scottish. That landscape is used, in every case, to exemplify a specific biblical image— that of the wilderness, waste or desert place, the very antithesis of good and fertile ground. The thorns and stony scree where the Sower wasted his seed, the desolate place between Jerusalem and Jericho where the Traveller fell amongst thieves, the wilderness where the Lost Sheep went astray, the stormy night into which the Foolish Virgins were locked out, and the moorland where the Good Shepherd was slaughtered in defence of his flock—all these have adopted a Scottish face.

One can only guess that Millais may have chosen these settings to give the stories a wider application and more of a home thrust than they would have possessed with Oriental settings. He may, in his own fashion, have been protesting against the literal fidelity of Hunt's *Scapegoat*, for many years later he pointed out how little a British public could be expected to empathise with foreign-featured child models used to illustrate the biblical text 'Suffer the little children'.[5] It is worth observing, however, that the opportunity to convert the Eastern environment into a Scottish one came from the scope and wide connotations of the 'wilderness' used by the Authorised Version to express the biblical desert. Having once identified his wilderness as part of Scotland Millais was to return on several occasions—but without the biblical

Fig 117
WILLIAM FETTES DOUGLAS
**The Recusant's Concealment
Discovered: Persecution in
Scotland**
no. 10.16

trappings—to this image of desolation, in his large landscapes of the 1870s and 80s.

Millais had not a literary nor a logically consistent mind and his approach to the components of a design seems to have been largely intuitive and impulsive. Passing through Glencoe for instance, in 1854, he seized on the idea of making it the setting for a picture of St George and the dragon, a picture that we never hear of again for it passed from Millais' mind as easily as it darted in. It was left therefore for Dyce in his more conscious and deliberate fashion, to carry Millais' hybrid type of religious painting one stage further. His two small paintings, *The Man of Sorrows* of 1860, and its companion, *David in the Wilderness* are instantly recognisable examples of Millais' combination of costumed figure and Scottish scenery. Although the Dalziel engravings had not yet been published it is most likely that Dyce would have known what Millais was about, and would have seen the earlier of the Parable designs. When *The Man of Sorrows* was exhibited at the Academy of 1860, *The Art Journal* (pp 164–165) reviewed it as follows. 'It will be understood that the Saviour is here represented in the wilderness... The conditions of the figure having been determined, the painting of it, with all its energy of finish, was a trifle, in comparison with the landscape in which it is circumstanced, every visible blade of herbage, and every idle pebble, being duly registered. But the wilderness is not a wilderness of the Holy Land. It is a Scottish waste, such as there are many at the bases of the "slopes" in the shires of Inverness and Aberdeen. Mr Dyce paints locality with a truth that is loud in pronouncing the whereabouts.'

The reviewer's lack of curiosity as to why Dyce, so truthful in one respect, should have used so blatantly Scottish a setting, is surprising in view of the presence, in the same exhibition, of Goodall's *Early Morning in the Wilderness of Shur*, showing Ayoun Mousa, the Wells of Moses, the traditional spot where the Israelites had crossed the Dead Sea, and Moses had struck the rock. Dyce's two pictures belong to a phase of his career when he seems to have been trying out landscape backgrounds as forms of visual parallel to the

mental state of the human observers within them, and in *The Man of Sorrows* as in the Walker Gallery's *Gethsemane*, the Scottish wilderness discovered by Millais becomes, under Dyce's hand, an analogue of the spiritual loneliness and desolation experienced by Christ in foreseeing His death. In the *David*, on the contrary, the landscape turns, with the complete reversal of mood in the central figure, into an expression of freedom, mental expansion and untamed potential. No ac-

Fig 118
JOHN FAED
Death of Burd Ellen
no. 10.17

curately delineated desert could have been put to exactly this same double use. Whereas the East generally carried, in Europe, connotations of a certain glamour, sadness and melancholy brooding were the properties of Ossian's Highlands, energy and liberty from the restraints of civilisation the characteristics of Walter Scott's. The Scottish Highlands

Fig 119
WILLIAM BELL SCOTT **The Border Widow** no. 10.19

128

Fig 120
WILLIAM BELL SCOTT
Silver Birch trunk
no. 10.21

possessed, by the mid nineteenth century, two well understood alternative meanings, and Dyce employed both. At one extreme they were experienced as mentally and spiritually restorative—the post-Scott attitude—at the other, mentally and spiritually repelling and destructive—the eighteenth century view—the stuff of life, or of death. In Dyce's pictures the transition from one extreme to the other is effected without expressionistic distortion of the scenery, mainly by the central observer's mental attitude, for the rocks and heath remain intransigeantly constant to their own characteristic features.

In these deeply and subtly considered religious paintings Dyce occupies an isolated position. The majority of other Scottish artists who were influenced by pre-Raphaelitism accepted, in a far simpler manner, Ruskin's theories of truth to specific fact, and were swayed into temporary or permanent imitation of Millais and the other pre-Raphaelites' dazzling achievements with rocks, foliage and running water. A certain initial resistance among the Scots to the new style is apparent from Ruskin's attack upon the critics of Waller Paton's 1858 *Wild Water, Inveruglas.*

'If you Scotch people don't know a bit of your own country when you see it, who is to help you to know it? If, in that mighty wise town of Edinburgh, everybody still likes flourishes of brush better than ferns, and dots of paint better than birch leaves, surely there is nothing for it but to leave them in quietude of devotion to dot and faith in flourish.'[6]

By 1869 however Ruskin's theories, in however elementary or distorted a form, seem to have been taken for granted in the *Daily*

Fig 121
WILLIAM BELL SCOTT
Foreground Study
no. 10.22

Review's pious declaration concerning the engraving of McCulloch's *Lowland River*. 'The geological perfection of the rocks is worthy of all praise. Artists now have two courses open to them: either to paint carefully from nature, or to study geology. A combination of both courses would seem to be the best in these times.'[7] On another occasion McCulloch's geology was criticised as inadequate, but the remarkable thing is that any need was felt to comment on this aspect of his work at all. In one way the Scots did divert pre-Raphaelite landscape to a characteristic use. The veracity of the English pre-Raphaelite backgrounds, painted as was well known, on the spot, offered the Scots a new opportunity for putting into practice their inveterate native habit of associating particular places with old and tragic events. Pre-Raphaelitism in Scotland produced a number of pictures illustrating

Fig 122
WILLIAM BELL SCOTT
The Rustic Bridge
no. 10.25

themes of love and death from medieval legend, the *Minstrelsy of the Scottish Border*, or Scott's own original writing, with figure and landscape being assigned equal parts and carrying equal expressive weight. Even Millais contributed to this body of work with his 1878 picture of the doomed Ravenswood and Lucy Ashton plighting their fatal troth beside a waterfall. (*Bride of Lammermoor.*)

The most notable of these romantic tragedies in a landscape was also the earliest, Noel Paton's 1855 *Bluidie Tryste*. Millais was writing to Paton from Glenfinlas while finishing the portrait of Ruskin in 1854,[8] and Paton must have seen the picture at some stage, but when or how is not known. Ruskin reviewed *The Bluidie Tryste* with very qualified praise.

'I regret the prevailing gloom which at present characterises this artist's work; art may face horror but should not dwell on it. ... there was no need, as far as I can see, or feel, for the defilement of this sweet dell with guilt ... the hue of the leafage round him (the dead knight) should have had, it seems to me, the deep sympathy through all its innocent life which is felt in those words of Keats

"Saying, moreover, 'Isabel, my sweet
Red whortle-berries droop above my head,
And a large flint stone weighs upon my
 feet;
Around me beeches and high chestnuts
 shed
Their leaves and prickly nuts ...'"'

Ruskin added, 'This foreground is, of course, painted with intensest care and perfect draughtsmanship; there is more natural history in it than in most others in the rooms.'[9]

Ruskin's criticism, together with the possibilities implied in his quotation from Keats, would seem to have been taken to heart by William Bell Scott when, in 1860, he came to paint his *Border Widow*, a subject in which the open grave, the kneeling girl, and the murdered man, bear the strongest resemblance to the situation of Keats' Isabel and Lorenzo. Following Keats, Scott took an autumnal setting with bare branches and withering foreground leaves, but substituted, for Keats'

whortleberries, the more significant berries of the deadly nightshade, growing beside the murdered Knight's head. The composition of the two figures bears a close resemblance to Paton's design for the ballad of the *Dowie Dens of Yarrow*, and suggests that Scott had been influenced by Paton as well as by Ruskin's criticism of Paton. The ballad of *The Border Widow* is, like that of *The Dowie Dens*, amongst the most poignant of the poems in *The Minstrelsy of the Scottish Border*, but Scott's dated background studies were in fact carried out at Newcastle on Tyne where he was then living. The identification of notable Scottish beauty spots such as Thomson, Landseer or McCulloch painted, depends mainly on recognising the characteristic silhouettes of particular mountains, and the ground plan of lochs. Pre-Raphaelite concentration on the ground underfoot gave a new anonymity to the landscape—an escape from the tyranny of the recognisable view—and allowed the artist to make his studies anywhere. In the autumn of 1860 Scott was coming to the end of his set of murals on scenes from English Border history, and had recently met and visited Alice Boyd at her Ayrshire castle of Penkill that was to become his eventual home. Alice herself posed for the figure of the widow, and it is clear that Scott's thoughts were moving back across the Border to Scottish subjects and places.

That summer of 1860, and for every subsequent summer until he settled there, Scott painted at Penkill. His work there is as difficult to assess from an ordinary artistic viewpoint as the record of a private diary can be from a literary one. Views of the coast with Ailsa Craig, views of the castle inside and out, of the young jackdaws nesting in the turret window, of the Penwhapple stream in the glen below, all share rather touching qualities of amateurism, of intimacy, and an attachment to the details of place that comes from constant daily association. These drawings and paintings are the small fragmentary leftovers of private life, never intended for public exhibition.

The Penwhapple stream was the first object that attracted Scott's attention, 'reviving', as he said, 'my ancient landscape proclivities'. It

Fig 123
WILLIAM BELL SCOTT
The Stream
Private Collection, Scotland

The Stream.

Beneath those butressed walls so old and gray,
 Below the slope of trees whose noontide shade
 Lies on the stones with darkness velvetted,
The Stream leaps like a living thing in play,
In haste it seems, it cannot, cannot stay:
 The great trees listen there from year to year,
 And these great walls that change not, ever hear
The burden of the rivulet, "Passing away."

 But some time surely that strong oak no more
Will keep the winds in check, his breadth of beam
 Will go to rib some ship for some far shore,
These walls will all have fal'n, while that small stream
 Will still be whispering whisp'ring night and day
 These choral words, nor ever Past away.

also revived the tendency towards mysticism that he had perhaps derived from too much admiration of his elder brother David, but whereas Bell Scott's juvenile designs were, in imitation of David's, obscurely symbolic and entirely imaginary, he now endeavoured to bring together and unite his thoughts about time and human life with the particular details of the rocks and plants in the glen below Penkill. In the paintings of the stream the struggle involved in putting down the colour of the boulders in the water and the light on the leaves obscures any other intentions, but the cycles of poems written at Penkill act to some extent as a commentary on the paintings and make Scott's train of thought much clearer.

'Oneness of All (Pebbles in the stream)

Over our shadows its melodious talk
The stream continues, while oft-times a
 stray
Dry leaf drops down where these bright
 waters play
In endless eddies, through whose clear
 brown deep
The gorgeous pebbles quiver in their sleep;
The stream still flows but cannot flow
 away.'

Another poem, on the same stream, would have been called *The Stream's Secret*, had not Rossetti, then on a visit to Penkill, appropriated the title for verses of his own.

The most successful of all his Penkill designs in conveying Scott's unlikely entanglement of mysticism and fact, is the little etching, *Studies from Nature*, which contains a miniature world of clover leaves, daisies, and a bumble bee—a tiny pre-Raphaelite foreground such as Ruskin told his readers they could see if they would only lie down and look into the herbage on a grassy bank—entered by a single, huge, anonymous human finger that gently points to or touches the leaves.

(1) Lady Eastlake *Journals and Correspondence*, 1895, vol I, p 209 and p 210.

(2) *Edinburgh Lectures no 1, Architecture*. 'Each purple peak, each flinty spire was bathed in floods of living fire.'

(3) Since volume 3 of *Modern Painters* was published in 1856, Ruskin's comments on Scott do post-date Millais' picture. There is however no reason to believe that Ruskin had, since 1853, substantially altered his attitude towards Scott's poetry, for the stanzas from *Rokeby* that he quoted in *Modern Painters vol 3* are similar in kind to the passage he selected from *The Lady of the Lake* and quoted in *Modern Painters vol 2*—a description of rock forms overgrown with wild plants and creepers.

(4) John MacCulloch *A Description of the Western Islands of Scotland*, 1819, vol I, p 269.

(5) *Sir J E Millais, Art Annual* 1885, p 25. Millais had recently considered whether he could 'translate' a painted biblical scene to England, but had decided, 'the public is too critical to bear this kind of thing now.'

(6) John Ruskin, in a letter to *Witness*, Edinburgh, 27 March 1858, reprinted in the *Library Edition* of the works of Ruskin, by Cook and Wedderburn, vol xiv, p 329.

(7) Quoted by the Committee of Management of the Royal Association for the Promotion of the Fine Arts in Scotland, in its *Report* of 1869–70.

(8) M H Noel-Paton *Tales of a Grand-Daughter* 1970, pp 20–21.

(9) *Academy Notes* reprinted in the *Library Edition* of the works of Ruskin, by Cook and Wedderburn, vol xiv, pp 155–157.

JOHN EVERETT MILLAIS 1829–1896
10.1 **Ruskin at Glenfinlas** pl ix
Oil on canvas. 78.7 × 68.0 cm
Signed in monogram and dated: *JEM 1854*
The landscape setting was painted between July and
October 1853 when Millais was staying with the Ruskins
at Brig o Turk and was completed in May and June the
following year when Millais returned to the site without
Ruskin
Lent anonymously

JOHN RUSKIN 1819–1900
10.2 **Gneiss rock in Glenfinlas**
Pen, wash and body colour. 47.6 × 32.7 cm
This was drawn by Ruskin in 1853 whilst Millais was
painting the background of his portrait, and includes
part of the same rock face. Ruskin appears to have been
looking from a slightly higher level, upstream from
where Millais was working
Lent by the Visitors of the Ashmolean Museum, Oxford

After JOHN EVERETT MILLAIS
10.3 **A valuable hint to sketchers from nature**
Engraving
After a drawing by Millais, published in *Punch* (1853 p
198)
Millais made this drawing while staying with the
Ruskins at Glenfinlas and sent it to John Leech the
illustrator who arranged for its insertion in *Punch*
Lent by the Trustees of the National Library of
Scotland

ANONYMOUS
10.4 **Waterfall**
Scottish calotype print circa 1850
Scottish National Portrait Gallery

ANONYMOUS
10.5 **Rocks and a pool**
Scottish calotype print circa 1850
Scottish National Portrait Gallery

ANONYMOUS
10.6 **Rocks and falling water**
Scottish calotype print circa 1850
Scottish National Portrait Gallery

JOHN WILLIAM INCHBOLD 1830–1888
10.7 **The Cuillin Ridge, Skye** fig 112
Oil on canvas. 51.1 × 69.0 cm
Almost certainly the picture exhibited at the RA in 1856
as *The Burn, November—The Cucullen Hills*. It shows Sgurr
nan Gillean with the Sligachan burn in the foreground
Lent by the Visitors of the Ashmolean Museum, Oxford

JOHN MILNE DONALD 1819–1866
10.8 **A Highland stream, Glenfruin** fig 113
Oil on canvas. 64.8 × 89.9 cm
Signed: *J. Milne Donald 1861*
Glenfruin lies between Loch Lomond and Gare Loch
National Gallery of Scotland

WALLER H PATON 1828–1895
10.9 **Burn in a wooded glen**
Watercolour heightened with body colour. 57.0 × 35.3
cm (sight size)
Signed: *Waller Paton RSA July 1869*
The scene may be Glen Devon
Lent anonymously

After JOHN EVERETT MILLAIS
10.10 **The Lost Sheep**
Wood engraving
After a drawing by Millais published by Dalziel Bros. in
The Parables of our Lord Jesus Christ (1864)
The backgrounds for the Parables were drawn from the
countryside near Bowerswell, Perthshire, where Millais
was living
Lent by the Trustees of the National Library of
Scotland

After JOHN EVERETT MILLAIS
10.11 **The Sower**
Wood engraving
After a drawing by Millais published by Dalziel Bros. in
Good Words (1863) and in *The Parables of our Lord Jesus
Christ* (1864)
Lent by the Trustees of the National Library of
Scotland

WILLIAM DYCE 1806–1864
10.12 **David in the Wilderness** fig 114
Oil on panel. 34.3 × 49.5 cm
The combination of Scottish landscape with a biblical
figure in this and the following picture may have been
suggested to Dyce by Millais' illustrations to the
Parables, which had been begun in 1857
Lent anonymously

WILLIAM DYCE
10.13 **The Man of Sorrows** fig 115
Oil on panel. 34.3 × 49.5 cm
This was exhibited at the RA in 1860 with a quotation
from the Tractarian poet Keble, descriptive of Christ in
the wilderness
　　'As, when upon His drooping head
　　His Father's light was poured from heaven,
　　What time, unsheltered and unfed,
　　Far in the wild His steps were driven . . .' etc
Lent anonymously

JOSEPH NOEL PATON 1821–1901
10.14 **The Bluidie Tryste** fig 116
Oil on canvas. 73.0 × 65.2 cm
Signed and dated: *18JNP 55*
The woman has killed her lover believing him to be
unfaithful. The story comes from *The Hart and the Hynde*.
The landscape was painted at Glen Monadhmor, Arran
Lent by Glasgow City Museum and Art Gallery

After JOSEPH NOEL PATON
10.15 **The Dowie Dens o' Yarrow**
Engraving
After a painting by Paton commissioned by the Royal
Association for the Promotion of the Fine Arts in
Scotland. Published by the Royal Association for the
Promotion of the Fine Arts in Scotland in an illustrated
edition of the ballad, *The Dowie Dens o' Yarrow* (1860).
The ballad comes from Scott's *Minstrelsy of the Scottish
Border*
　　'She's taen him in her armis twa
　　And gien him kisses thorough;
　　And wi her tears she has washed his wounds,
　　on the dowie howms on Yarrow.'
National Gallery of Scotland

WILLIAM FETTES DOUGLAS 1822–1891
10.16 **The Recusant's Concealment Discovered:
　　　　Persecution in Scotland** fig 117
Oil on canvas. 101.2 × 50.5 cm
Signed with monogram and dated: *59*
Exhibited at the RSA in 1859. The recusant was a
seventeenth century Covenanter
Lent by Glasgow City Museum and Art Gallery

JOHN FAED 1820–1902
10.17 **Death of Burd Ellen** fig 118
Oil on canvas. 29.2 × 21.6 cm
Signed: *J. Faed*
This illustrates *Fair Helen of Kirconnell* a tragic ballad in
Scott's *Minstrelsy of the Scottish Border*
　　'Curst be the heart that thought the thought,
　　And curst the hand that fired the shot,
　　When in my arms burd Helen dropt,
　　And died to succour me.'
The painting is probably one of two both called
Kirkconnel Lee, painted 1860, and mentioned in an MS
picture list compiled by the artist
Lent by Glasgow City Museum and Art Gallery

After PETER GRAHAM 1836–1921
10.18 **Baron Bradwardine in hiding**
Engraving
Published by the Royal Association for the Promotion of
the Fine Arts in Scotland in a set of eight engraved
illustrations to Scott's *Waverley* (1865). Baron
Bradwardine was a Jacobite who was forced to hide in a
hillside cave to escape arrest after the Rebellion of 1745
National Gallery of Scotland

WILLIAM BELL SCOTT 1811–1890
10.19 **The Border Widow** fig 119
Oil on canvas. 74.3 × 55.3 cm
Signed: *W B Scott*
This illustrates a tragic ballad *The Border Widow* in
Scott's *Minstrelsy of the Scottish Border*
　　'I took his body on my back,
　　And whiles I gaed, and whiles I sat;
　　I digg'd a grave, and laid him in,
　　And happ'd him with the sod sae green.'
Lent by Aberdeen City Art Gallery and Museums

WILLIAM BELL SCOTT
10.20 **Deadly nightshade**
Pencil and watercolour on cream paper. 31.2 × 23.4 cm
Inscribed: *19 October Deadly Nightshade*
A study for the foreground of the painting *The Border Widow*
National Gallery of Scotland

WILLIAM BELL SCOTT
10.21 **Silver birch trunk** fig 120
Watercolour on cream paper. 32.4 × 10.6 cm
Dated: *18 October*
A study for *The Border Widow*
National Gallery of Scotland

WILLIAM BELL SCOTT
10.22 **Foreground study** fig 121
Oil on prepared paper. 7.6 × 25.3 cm
Dated: *20 October 1861*. This date is probably a mistake for 1860
A study for *The Border Widow*
National Gallery of Scotland

WILLIAM BELL SCOTT
10.23 **Ivy on a stone wall**
Pencil and wash. 14.1 × 21.5 cm
Dated: *April 1846*
National Gallery of Scotland

WILLIAM BELL SCOTT
10.24 **Snailshells in an elm tree**
Pencil and wash
Inscribed: *Edinb 17 April 1846*
National Gallery of Scotland

WILLIAM BELL SCOTT
10.25 **The rustic bridge** (Penwhapple stream) fig 122
Oil on canvas. 61.0 × 45.7 cm
The Penwhapple stream runs below Penkill Castle, Ayrshire, which appears through the trees. Scott first visited Penkill in 1860, returned annually, and from 1885 lived there permanently
Lent by Daniel Shackleton

WILLIAM BELL SCOTT
10.26 **Penwhapple stream**
Watercolour heightened with body colour. 22.6 × 31.6 cm
Scott made numerous studies of the stream, and wrote two poems on it
National Gallery of Scotland

WILLIAM BELL SCOTT
10.27 **Iona**
Oil on canvas. 56.0 × 73.7 cm
Signed and inscribed: *W. B. Scott 1887. Port na Curachan Iona landing place of St. Columba AD 563*
Scott was working on this at the end of his life, and left it slightly unfinished. It was based on a monochromatic watercolour sketch made when he visited Iona in September 1830
National Gallery of Scotland

11
Village, Kailyard and Pastoral

When, in 1825, James Hogg, the Ettrick shepherd, dismissed the Edinburgh 'maisters and missies' he had seen at the Royal Institution exhibition, 'glowering perhaps at a picture o' ane o' Nature's maist fearfu or magnificent works', as 'Mowdie warts' who 'micht as well look at the new-harled gable-end o' a barn',[1] he could hardly have anticipated a time to come when any group of Scottish painters would actually prefer the bathos of the harled gable to the sublimity of the mountain glen. William McTaggart, whose own rather different paintings were nevertheless much admired by the Glasgow school artists, was asked, in 1905, why he thought the pictures by this group looked so foreign, reminding the spectator of France, Holland, and Japan, but not at all of Loch Lomond, the Kyles of Bute, or Whistlefield.

'Is it because these artists were afraid of painting "views"?' his interlocutor suggested. 'That may be', he replied, 'After all, it is not grand scenery that makes a fine landscape. You don't find the best artists working in the Alps. It's the heart that's the thing. You want to express something that appeals to common humanity, not something extraordinary.... Of course you can understand the older Scottish landscape painters going to the Highlands in the footsteps of Sir Walter Scott, but humanity's the thing!'[2]

These are the words of a man who had been through a pre-Raphaelite phase in his own painting, and was consciously rejecting the mountain-based aesthetic of Ruskin's writings on Turner, as well as McCulloch's Highland romanticism with its literary foundation. In the earlier part of the century McTaggart's words would have been regarded as rank heresy. The fear of 'views' suggested as the explanation for Glasgow School taste in landscape, seems, despite McTaggart's ready acceptance of it, too passive and negative an emotion for artists who could, on occasion, rake the view-painting Royal Scottish Academician with just as much derision as ever Hogg reserved for the 'cockney' exhibition goer. The article *How I became an RSA* which appeared anonymously in the *Scottish Art Review* for November 1889, but which may have been written by James Paterson,[3] is an ironical account of an artist's road to financial success and artistic ruin. The typical landscapist of the RSA is scorned as a 'painter intended by the gods to manufacture panoramas to piano accompaniments, but who splashed great canvases with hills like dumplings and rocks like bonnet-boxes.' No names, of course, are mentioned, but it seems obvious that painters like McCulloch and perhaps McWhirter are intended. Whether however prompted by fear or by scorn, it was in reaction to the panoramic mountain tradition, the literary associations of Walter Scott, and the nomadic touring habits of the aptly named 'bedouin of the brush' that the Glasgow school and one or two other like-minded artists turned round to the duck pond, the barn, and the cabbage garden, ordinary anonymous village scenes that few tourists would bother to visit and which indeed leave the strongest impression of being landscapes for residents only, painted by residents from their own environment, and containing residents who go out, work, and return home. Landscape as thus conceived is no delectation of grandeur and waste spread before the eyes of a gasping tourist in a mail coach, steam

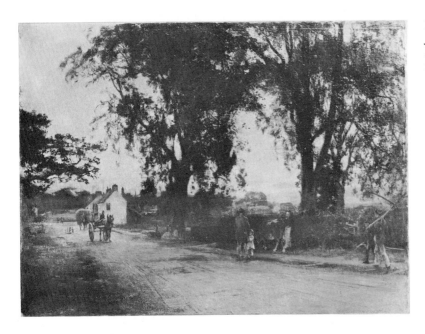

Fig 124
JAMES LAWTON WINGATE
A Summer's Evening
no. 11.5

Fig 125
WILLIAM YORK MACGREGOR
The Duck Pond
no. 11.1

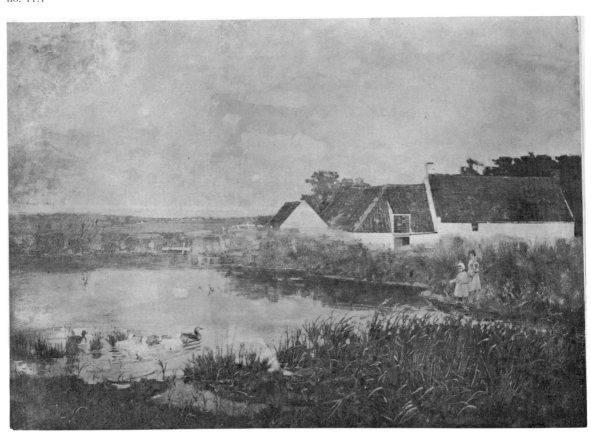

Pl xi
WILLIAM McTAGGART
Harvest Moon Broomieknowe
no. 12.6

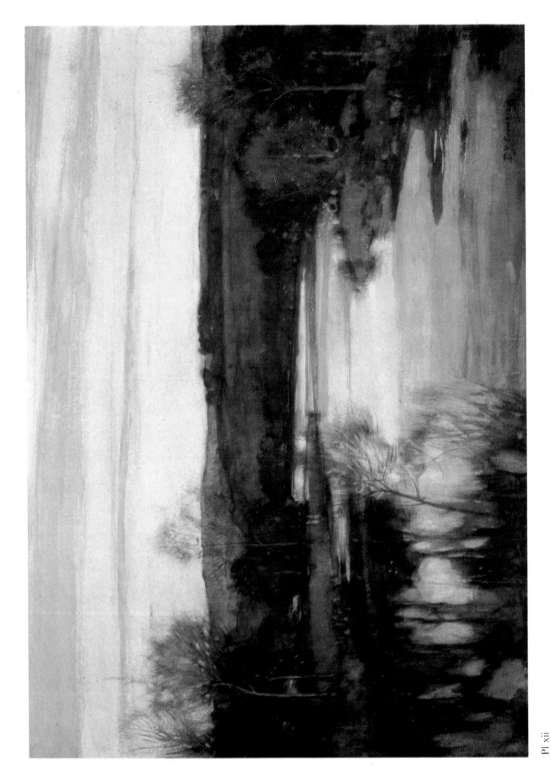

Pl xii
DAVID YOUNG CAMERON
The Waning Light
no. 12.18

boat or train, but earth to be dug, sowed and cropped in a round of daily tasks. There was, increasingly, a feeling, even if it was never formulated in words, that the proper habitat for a landscape painter was a village.

Sam Bough had lived in Malta Terrace, Edinburgh, but his exhibited pictures show him as constantly on the move, from Iona, Mull, and Skye in the West, to Berwick on Tweed in the South, Kirkwall, Orkney, in the North, and Aberdour in the East. D O Hill

not a member of the Glasgow school, but whose subject matter showed a considerable overlap with that of the Glasgow artists—had pictorial interests which closely followed the agricultural year, with seasonal activities often providing the titles for his works—for example, *Seedtime* (RSA 1878), *Field Working in Spring* (RSA 1878), *Haytime in Upper Annandale* (RSA 1880), *Sheep Shearing* (RSA 1882), *Harvest* (RSA 1870), *A Harvest Twilight* (RSA 1891), *An Autumn Pastoral* (RSA 1896), *Cattle*

Fig 126
GEORGE HENRY
Barr, Ayrshire
no. 11.6

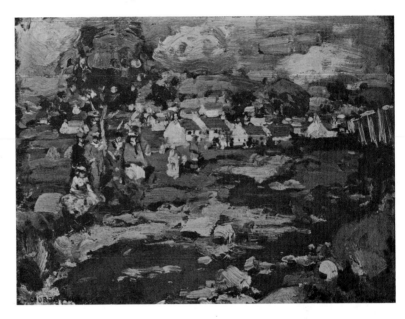

and Horatio McCulloch likewise had their bases in Edinburgh, but travelled extensively sketching in the Highlands in the summer months. This pattern of the city centre and regular expeditions to collect material at picturesque Highland sites broke down towards the end of the nineteenth century, and a new pattern began to emerge, with John Faed living, after 1881 at his birthplace of Gatehouse of Fleet, Wingate between 1881 and 1887 at Muthill, Perthshire, McTaggart from 1889 at Broomieknowe, Hornel at Kirkcudbright, Paterson from 1884 at Moniave, Tom Scott at Selkirk, and William Darling McKay in his early years at Gifford, to name a few. Guthrie's residence at Cockburnspath, short as it was, might also be added to the list. William Darling McKay— to consider, for a moment an artist who was

Feeding early Winter (RSA 1894), *Turnip-shawing, Winter Morning* (RSA 1882), and *Spring Ploughing in Galloway* (RSA 1895). Wingate's Muthill pictures were very similar in content, with ploughing, the return home of cattle, the building of hayricks, and lambing providing his subject matter. Whereas the romantic nomad had inclined towards the remarkable and outstanding, the painter of his own locality preferred the regular and the commonplace. The nature he admired was not that of the primeval and man defying rocks of Coruisk, but a nature thoroughly shaped and altered by human occupation and cultivation. This comes over as clearly in McKay's *Field Workers in Spring*, shown at the Glasgow Institute in 1879, and described in the catalogue as 'A group of farm servants, in bright costume, digging potatoes under the

superintendence of a burly overseer', as it does in MacGeorge's *Galloway Peat Moss* shown at the RSA in 1888. In both pictures the very ground itself is being, or has been, cut, pitched, piled, and carted.

Considering the intensely local nature of such subjects, it is somewhat surprising to find, on every hand, accusations of foreignness being hurled at the Glasgow artists. McTaggart's interviewer had been reminded of France, Holland, and Japan, and William

Darling McKay who covers, in his *Scottish School of Painting*, the final decades of the century which had fallen within his own experience as a painter, makes, at greater length, the same point. He writes of the French discovery of the theory or principal of tonal 'values' in 'plein air' painting as 'the complement of the recognition of perspective', adding, 'All the world went to Paris to learn a method which assimilated all schools.... Paris was everywhere; the variety which had

Fig 127
WILLIAM STEWART MACGEORGE
A Galloway Peat Moss
no. 11.11

Fig 128
WILLIAM DARLING McKAY
Field Working in Spring: At the Potato Pits
no. 11.10

characterised the art of different peoples seemed doomed; ... even outlying Scotland and conservative England were feeling its influence.' Of the Glasgow School artists he said that 'at home their style was regarded as foreign; for some years the division was marked.' With these painters of the Glasgow School one feels the extent to which the national and historical associations of landscape—a source of kindling vitality to the generation of Scott—had become a burden. They found it necessary to turn their backs and cut their minds off completely from all this aspect of landscape painting, and the intolerable weight of the burden is momentarily revealed in Paterson's defensive handling of the question of *Nationality in Art* in his essay for *Scottish Art Review*.[4] Paterson was advocating a Parisian atelier training for the artist, and behind his words one senses a pressure of insatiable public demand that every Scottish painter should continue to reinterpret the familiar theme of nationality revealed in place. The Glasgow School's exorcism of Scott was at first very thorough. Mountains, glens, all memorable and historically resonant views were rejected, along with sunsets, storms, and burns in spate. Out of the purge they rescued and elevated the idea of a picture as an entity in its own right, a structure built out of dabs of paint, tone, and colour.

These dabs of paint, so characteristically square in the early work of Macgregor and Guthrie, are the feature which really distinguish the Glasgow agricultural landscapes from those of the Edinburgh painters, McKay, McTaggart, and Wingate. The square brushstroke—usually combined with a square signature—was the hallmark of painters who had been influenced by the French plein air painter, Bastien Lepage. It was also rural in its essence, a metaphor for honesty and a sense of reality, suggestive of ground dug with a straight edged spade. The kind of value the Glasgow artists put upon Lepage can be seen in George Clausen's article on *Bastien Lepage and Modern Realism* in *Scottish Art Review* for September 1888. Of course Clausen was not himself a Scot, but his aims and style were extremely similar to those of Glasgow painters such as Guthrie. Clausen stressed that Lepage placed his figures before the spectator 'without comment, as far as is possible, on the author's part. He stressed the daylight or plein air effects, and the fact that in painting at his home village of Damvillers, 'a small village, not more picturesque or paintable than any other French, or many an English village', and in painting his own 'home-life' Lepage conveyed a new sense of close involvement with place. 'One feels in his work a deeper penetration, and a greater intimacy with his subject than in the work of other men.' Residence—whether temporary or permanent—in a village, with the object of getting to know the landscape as intimately as possible, was a French habit. Lepage at Damvillers was living where he had been born, but the French had also developed what the Scots had not, the idea of the artists' colony in a rural area. Barbizon, where Diaz, Daubigny, Millet and Corot had worked, Pont Aven, which was an artistic centre before Gauguin and his fraternity went there, and Grez where Lavery and Arthur Melville, the Glasgow artists, and Robert Louis Stevenson had stayed, are all typical examples of such colonies. Dorothy Sayers, in her novel *Five Red Herrings* describes just such a colony of landscape painters living and working in Kirkcudbright and Gatehouse of Fleet. Her novel, which is based on reality, was published in 1931, and by that date the artists' colony was a hangover from the past. None of her painters are really top class whatever their real life prototypes may have been.

It is at Cockburnspath, a 'small village', to reapply Clausen's words, 'not more picturesque or paintable than any other French, or many an English village', that one finds, centred round Guthrie, in the early 1880s, one of the earliest examples of a Scottish colony along the pattern of the French. Guthrie's Cockburnspath masterpiece, *The Hind's Daughter*, is a typical example of the stolid, static, earth-coloured painting deriving from Lepage. If however its style is foreign, its iconography is intensely Scottish. From the eighteenth century kail had been the staple diet of the Scots cottager. The word could even be used as a synonym for dinner, and it

Fig 130
JAMES GUTHRIE
A Hind's Daughter
no. 11.13

Fig 129
ARTHUR MELVILLE
The Cabbage Garden
no. 11.12

is to this extremely native subject that the square, foreign brush stroke has been applied. Behind Guthrie's picture lies Melville's earlier work, *The Cabbage Garden*, shown at the RA in 1878, and painted before he went to study in France. A combination of this and Melville's *Gardener's Daughter* (RSA 1878) seems to have given Guthrie his ingredients, the cabbages that fill the foreground with vigorous green shapes, and the standing girl amongst the vegetables, her head thrown into strong relief

against the sky to create a pattern of dark shapes linked with the boughs of trees. In Melville's work too, Guthrie would have seen pictures structured by tonal values and by the direction and thickness of brushstrokes, though these are not, in *The Cabbage Garden*, yet square. In 1882, Wingate exhibited at the RSA *Winter Twilight*, painted at Muthill. 'It shows a foreground of cabbage-garden, in which an old cottager is standing, pausing in her work to chat to a neighbour, who passes

Fig 131
JOHN Q PRINGLE
Poultry Yard, Gartcosh
no. 11.15

144

on the road behind a beech hedge. Above is a clear and lovely sunset sky, seen through the drooping, leafless boughs of a great tree. It is a homely scene.'[5] This picture is now lost, and there is no way of telling how far it may have resembled Melville's 1877, or Guthrie's 1883 cabbage gardens. Its contents, in the sense of physical objects, were certainly much the same. Guthrie passed on to George Henry the image he had inherited, but whilst Henry's watercolour clearly derives from

adapted for suggestions of activity, movement and change, either in the weather, the vegetation, or amongst the human and animal occupants of the landscape. Ambiguity was beyond it, and so too was empty space. Guthrie's Cockburnspath sketchbook of 1886 contains a rough drawing labelled 'Copath Village'. No painting was made from this but the possibility of making such a painting must have entered Guthrie's mind, for the drawing is framed by a rectangle of pencil lines as if

Fig 132
WILLIAM McTAGGART
Harvest at Broomieknowe
no. 11.21

the composition were being adjusted to a potential canvas format. Cottages, a cart propped on its shafts, a winding street, and the figure of a woman passing along it, are all the drawing contains, and the woman's figure is sketched lightly, in quick movement, on top of the lines of the road and cottages, as if Guthrie drew her at the very moment in which she swung into his field of vision. Hitherto, Guthrie's pictures had tended to possess a posed quality, but from 1885 his interest seems to have been drifting away from the substantial fixities of *The Hind's Daughter*

Guthrie, the cabbages, which Melville and Guthrie used to establish the planar surface of the earth in contrast to the vertical figures, are used by Henry primarily for their fantastic decorative, flattened effects.

The square brush method, though admirably suited to uncompromising statements about stationary material facts, was not well

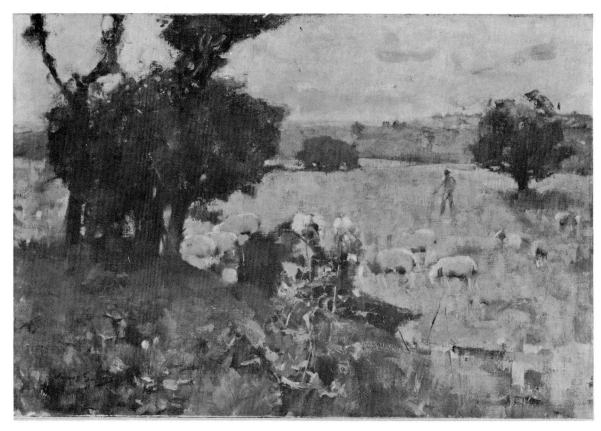

Fig 133
JAMES GUTHRIE
Pastoral
no. 11.17

Fig 134
JAMES GUTHRIE
Sheep in a meadow
no. 11.18

towards space and air, and the ambiguity of movement half glimpsed on the periphery of vision. *The Pastoral* was painted at Cockburnspath in 1885. To render the subject, which is space rather than substance, Guthrie modified his heavy, square brush loads of sticky paint to a lighter, more fluid and adaptable technique, in a very faint degree reminiscent of Whistler. The uncertain, flickering movement of the shepherd, and the slight advances of the sheep cropping the grass are conveyed by the brushing of the pigment for figures and animals lightly across the wet paint of the meadow behind them, so that they half merge, half detach themselves from the ground, with a hint of the blurred focus produced by sudden spasmodic movement. The sheep are rendered with a minimal number of strongly characteristic brush marks, sharply defined at one edge, melting away at the other, each mark taking its due place amongst the touches that define weeds,

Fig 135
EDWARD ARTHUR WALTON
Studies of sheep in a meadow
no. 11.19

grasses, sky, and trees, as if the abstract arrangement of his paint were simultaneously presenting Guthrie with a problem of as much moment as recreating a likeness of reality.

The movement of animals, sheep and cattle, through a meadow, set a pictorial problem that intrigued other painters of the Glasgow School besides Guthrie, whose pencil scribble of sheep in a meadow can be compared to E A Walton's sketch of a similar subject. The aspect of the subject that chiefly occupied these painters was technical, the finding of the least number of effective paint or pencil marks in which to convey the visual sensation of the occupation of the meadow space by a flock that was at once part of the scene, yet detached by mobility, constantly shifting ground and attitudes. To this extent, Guthrie's pictorial preoccupations resembled those of McTaggart, in whose pictures evoking changes of light, and the living occupation of a landscape without disturbing its spacial

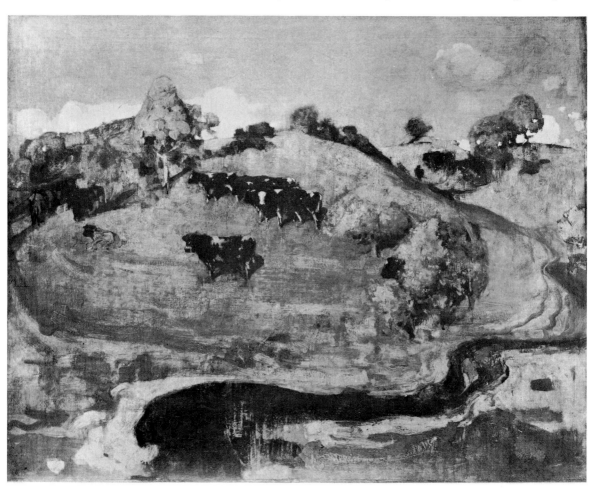

Fig 136
GEORGE HENRY
A Galloway Landscape
no. 11.22

unity, was a concern of great importance, but whereas McTaggart shaped his brush marks to wild expressive flicks, dashes, and whirls, leaving always enough of bare open space between the touches to prevent too finite an image forming, Guthrie covered his whole surface with paint, and let its qualities of fluidity and blending stand for the shifting of the physical forms he was painting. Such a method obviously owed a good deal to Melville's watercolour technique.

Like that of the cabbage garden, the theme of the meadow was resumed, after Guthrie had dealt with it, by George Henry who had frequently stayed with Guthrie and his friends at Cockburnspath. In the *Galloway Landscape* black and white cattle have been substituted for Guthrie's sheep. This substitution, so slight in itself, is one amongst a group of alterations all alike tending towards the elimination of the naturalistic, plein air aspects of the landscape and the hardening of its elements into a pattern where the curving silhouettes of hills, clouds, trees, and animals all play a decorative part. The contrasted black and white patches on the cows cut their forms up as neatly as a jig saw. They themselves stand out in clear profile against the steep upward gradient of the hill, where Guthrie's sheep had glided imperceptibly and at random amongst the grass, sharing the tonality and the very green and grey colours of the meadow. Where Guthrie's meadow merged indistinctly with the haze of distant sea and sky, Henry's meadow is sharply lopped off into two hills, their crests decorated with trees as densely massed as if their foliage had been trimmed with topiary shears. Even the clouds share the dense and lumpy character of the hills and trees. This is not the earlier solidity of Guthrie's *Hind's Daughter*, the compelling firmness of flat earth and gravity, but something new and arbitrary, having more to do with the artist's feelings than the facts of the outside world. The arbitrary reversal of experience in the hardening of the soft—clouds and trees—and flattening out of what one expects to see complete and solid—foreground and river bed—produces an effect of a dream landscape or one composed of children's toys, a storybook illustration. Hartrick the painter

claimed to know the meadow from which Henry made his picture and maintained that it had no intrinsic interest as a place. The burn that winds in such assertive loops across the base had been, Hartrick said, invented by the artist.[6] Despite its arbitrary abstracting character, the sense of place in the *Galloway Landscape* is intense. Anyone travelling through South West Scotland can find its like in a dozen hillside meadows. It is precisely this sense of place that is missing in MacGeorge's student-like *Galloway Peat Moss* with its dictatorial insistence that we should regard the sons and daughters of the soil at their labour. It was, surely, such a painting as the *Galloway Landscape* that Muirhead Bone had in his mind's eye when he grumbled that the Glasgow painters did not paint Glasgow.[7] Enduring, secure, and timeless, grand and yet snug in its evocation of pastoral Scotland, this picture suggests that no changes had, or ever could come over the Scottish landscape. This, of course, was far from being the case.

(1) John Wilson (Christopher North) *Noctes Ambrosianae* Dec 1825.

(2) J M Gibbon in *Black and White* 30 September 1905.

(3) The National Library of Scotland contains two manuscript letters from James Paterson to Blackwood, dated 20 Feb 1888 and 9 March 1888, offering a short story for publication, *Episodes in the Life of a Painter*. This story was rejected, but it is possible that either in the same form, or in a rewritten version, it may have been retitled *How I Became an RSA* and used by Paterson for *Scottish Art Review*, in 1889.

(4) *Scottish Art Review* Sept 1888 p 89.

(5) Catalogue of the *Exhibition of sixty paintings by J Lawton Wingate, March 1894* (Aitken Dott and Sons) p 15.

(6) *A Painter's Pilgrimage through fifty years* 1939 p 61.

(7) Muirhead Bone *From Glasgow to London*, pub in *Art Work* Autumn 1929 p 146.

WILLIAM YORK MACGREGOR 1855–1921
11.1 **The Duck Pond** fig 125
Oil on canvas. 89 × 122 cm
Signed: *W. Y. MACGREGOR 1882*
This is probably the picture exhibited at the Glasgow
Institute in 1883 as *The Mill Pond, Dunottar*. Dunottar is
near Stonehaven, Kincardineshire
Lent by Perth City Art Gallery and Museum

TOM SCOTT 1854–1927
11.2 **Selkirk**
Watercolour pasted in an album. 18.0 × 25.5 cm
Signed: *T. Scott 82 Selkirk*
Tom Scott was born in Selkirk where he returned to live
after 1901. This watercolour, together with others pasted
into the same album, were commissioned by T. Craig
Brown to illustrate his *History of Selkirkshire* (Edinburgh
1886) in which many were reproduced in monochrome
Lent by the Royal Scottish Academy

JAMES PATERSON 1854–1932
11.3 **Moniaive**
Oil on canvas. 35.5 × 53.3 cm
Signed: *James Paterson 1882*
Paterson settled at Moniaive in 1884
Lent anonymously

JOHN FAED 1819–1902
11.4 **Gatehouse of Fleet**
Oil on canvas. 32 × 36 cm
Signed: *J. Faed 1888*
Faed was born near Gatehouse, Kirkcudbrightshire and
returned to live there again in 1881. In 1887 he
exhibited an autumnal view of Gatehouse from the same
spot with precisely the same cloud formations in the sky.
This picture appears to be a reworking of the earlier
autumnal composition but in a different colour key. It
may be the *Village in Galloway* exhibited at the Royal
Scottish Academy in 1888
Lent by Colin Kilpatrick, Esq

JAMES LAWTON WINGATE 1846–1924
11.5 **A Summer's Evening** fig 124
Oil on canvas. 54.5 × 74.3 cm
Signed: *Wingate 88*
A view of the village of Muthill in Perthshire where
Wingate lived from 1881 until 1887
National Gallery of Scotland

GEORGE HENRY 1858–1943
11.6 **Barr, Ayrshire** fig 126
Oil on panel. 22.5 × 30.5 cm
Signed: *GEORGE HENRY*
Inscribed on the back: *Barr Ayrshire*
Henry was born in Ayrshire
National Gallery of Scotland

JOHN LAVERY 1856–1941
11.7 **Waterfall, the Glen, Paisley**
Oil on canvas. 66.0 × 50.8 cm
Lavery was living in Glasgow from 1884–1897. During
this period he had close contacts with the Fulton family
of The Glen, Paisley
Lent by Paisley Museum and Art Galleries

WILLIAM DARLING McKAY 1844–1923
11.8 **Pencaitland from the bridge**
Pencil on blue grey paper. 17.5 × 23.3 cm
Inscribed: *Pencaitland from the Bridge W.D.M. 18 June
1909*
Lent by the Royal Scottish Academy

WILLIAM DARLING McKAY
11.9 **Pencaitland**
Pencil. 22.8 × 19.4 cm
Signed and dated: *W.D.M. May 1910*
Lent by the Royal Scottish Academy

WILLIAM DARLING McKAY
11.10 **Field Working in Spring: At the Potato Pits**
fig 128
Oil on canvas. 64.2 × 97.5 cm
Signed: *W. D. McKay*
This was exhibited at the Royal Scottish Academy in
1878
National Gallery of Scotland

WILLIAM STEWART MACGEORGE 1861–1931
11.11 **A Galloway Peat Moss** fig 127
Oil on canvas mounted on panel. 81.2 × 134.6 cm
Signed: *W. S. MACGEORGE 88*
MacGeorge was born in Castle Douglas,
Kirkcudbrightshire
National Gallery of Scotland

ARTHUR MELVILLE 1855–1904
11.12 **The cabbage garden** fig 129
Oil on canvas. 45.1 × 30.5 cm
Signed: *A. Melville 1877*
Lent by Andrew McIntosh Patrick, Esq

JAMES GUTHRIE 1859–1930
11.13 **A Hind's Daughter** pl x, fig 130
Oil on canvas. 91.5 × 76.2 cm
Signed: *JAMES GUTHRIE/DECEMBER 83*
Painted at Cockburnspath, Berwickshire, where Guthrie
was living
National Gallery of Scotland

GEORGE HENRY
11.14 **Girl in a cabbage garden**
Watercolour heightened with body colour. 29.3 × 44.5
cm (sight size)
Signed: *George Henry 85*
Lent by the Trustees of Broughton House Museum,
Kirkcudbright

JOHN Q PRINGLE 1864–1925
11.15 **Poultry Yard, Gartcosh** fig 131
Oil on canvas. 63.5 × 78.8 cm
Painted in 1906. Gartcosh is a suburb of Glasgow
Scottish National Gallery of Modern Art

JAMES GUTHRIE
11.16 **Co'path Village**
Pencil sketch in Guthrie's Cockburnspath sketchbook.
Size of page 18.9 × 26.4 cm
Late in 1885 Guthrie left Cockburnspath (on the coast
road between Dunbar and St Abbs) where his house
had provided a centre for Glasgow School artists from
1883
National Gallery of Scotland

JAMES GUTHRIE
11.17 **Pastoral** fig 133
Oil on canvas. 64.7 × 95.3 cm
Signed: *James Guthrie*
Painted at Cockburnspath in 1885
National Gallery of Scotland

JAMES GUTHRIE
11.18 **Sheep in a meadow** fig 134
Pencil. 14.8 × 23.7 cm
Probably drawn at Cockburnspath
National Gallery of Scotland

EDWARD ARTHUR WALTON 1860–1922
11.19 **Studies of sheep in a meadow** fig 135
Pencil. 23.7 × 14.8 cm
National Gallery of Scotland

EDWARD ARTHUR WALTON
11.20 **A pastoral**
Lithograph
Signed: *E A Walton*
Published in *Black and white sketches by the members of the
Glasgow Art Club*, Glasgow 1881
National Gallery of Scotland

WILLIAM McTAGGART 1835–1910
11.21 **Harvest at Broomieknowe** fig 132
Oil on canvas. 87.3 × 130.0 cm
Signed: *W. McTaggart 1896*
McTaggart lived at Broomieknowe, Lasswade, near
Dalkeith, from 1889 until his death
National Gallery of Scotland

GEORGE HENRY
11.22 **A Galloway Landscape** fig 136
Oil on canvas. 121.9 × 152.4 cm
Signed: *George Henry 1889*
Lent by Glasgow City Museums and Art Gallery

Fig 137
PETER GRAHAM
A Spate in the Highlands
no. 12.1

12
Change and Decay

In 1887, Robert Louis Stevenson published, in a collection of poems (*Underwoods*), *The House Beautiful*, an account of the way in which an unprepossessing 'naked house' and 'naked moor' could be transformed by changing light, weather, and seasons.

'Yet shall your ragged moor receive
The incomparable pomp of eve,
And the cold glories of the dawn
Behind your shivering trees be drawn;
. . .
Your garden gloom and gleam again,
With leaping sun, with glancing rain.
Here shall the wizard moon ascend
The heavens, in the crimson end
Of day's declining splendour; here
The army of the stars appear.
. . .
When daisies go, shall winter time
Silver the simple grass with rime;
Autumnal frosts enchant the pool
And make the cart-ruts beautiful;
And when snow-bright the moor expands,
How shall your children clap their hands!'

This poem provides an extremely accurate, if unintentional, description of what certain Scottish painters were doing with landscape at that very moment. Its exposition of a method of seeing momentary changes and vibrations of atmosphere while disregarding the permanent unalterable facts of place, together with the child-like sense of wonder conveyed in the last line, is closely paralleled, in particular, by the work of McTaggart. The very titles of so many of the landscapes shown at the RSA during the last three decades of the century bear witness to the way emphasis had been shifted from the landscape 'as in itself it really is' on to the impression of an effect created by transitory weather conditions. Wingate's *Autumn sunlight* (1878), *Winter twilight* (1882), and *Autumn's Livery* (1898), McTaggart's *Through Wind and Rain* (1875), *Sunny Showers* (1877), *Summer Breezes* (1883), and *After the Storm* (1884), and Joseph Farquharson's *The Weary Waste of Snows* (1898)—titles in which the locality is not even mentioned—indicate an attitude very different from that of Nasmyth painting *View on the Banks of Loch Lomond near Tarbet* (1808) or Thomson in *Fast Castle, Berwickshire: St Abb's Head in the distance* (1824). Paradoxically, the partial atmospheric disintegration of natural objects which, for McTaggart and Lawton Wingate provided an artistic escape route from the tyranny of the spectacular tourist view, and an advance into new territory— technically speaking—in colour and handling, only provided, for men like Peter Graham, MacWhirter, and Joseph Farquharson a method for wringing the last remaining drops from the exhausted romantic tradition. Wingate's and McTaggart's paintings seldom contain any very pronounced natural landmarks. Graham's, MacWhirter's and Joseph Farquharson's contain, on the contrary, cliffs higher, lochs wider, mountains lonelier and rivers more dangerous than anything hitherto painted. Their winds are hurricanes and their burns, torrents.

Although McTaggart's practice has been compared to that of the Impressionists, it seems to have been the pre-Raphaelites who, in Britain, introduced the unwise habit of painting full sized pictures in oils out of doors, but leaving blank spaces so that any figures could later be designed and inserted in the

Fig 138
JOHN EVERETT MILLAIS
Chill October
no. 12.2

Fig 139
JOSEPH FARQUHARSON
A Winter Morning
no. 12.4

studio. 'My dear fellow you don't know the horror of a sprinkled palette, otherwise you would not be so eager for painting out of doors', wrote Millais, as he finished the background to Ruskin's portrait, seated on wet rocks at Glenfinlas, 'in biting rain which appears to come down *nine* days a week.'[1] Notwithstanding his occasional despair over this picture, Millais was undeterred, and his far bigger *Chill October* of 1870, a heroic undertaking, painted on location in a background

river. McTaggart's practice of taking huge canvases out onto the beaches where he was working, and anchoring them by ropes and stones, was also orthodox pre-Raphaelite, but the end result was so different in appearance that this has seldom been noticed. The famous photograph of McTaggart in action before his canvas, first published in 1918, has been tampered with in the cause of dramatic effect. It was not only the ropes and boulders that kept the vast canvas anchored to the ground,

Fig 140
WILLIAM McTAGGART
The Storm
no. 12.5

water of the Tay, set its stamp upon many a subsequent Scottish landscape. In imitation of Millais, Chalmers built his own platform out over the North Esk near Brechin, and, not content with painting still waters, struggled to record the river in full flood. His first picture of *Running Water* (now lost) was finished in 1874, despite immense difficulties, and the destruction of his platform by the furious

but also McTaggart's son John, who stood behind the easel, and presumably counteracted any tendency the picture had to swing in the wind. John's prosaic legs and feet were eliminated in the published reproduction.

Mc'Omish Dott, the dealer, who knew McTaggart, and owned his *Harvest at Broomieknowe*, claimed that he gave, 'the impression of Nature, not as seen from the safe shelter of a window...but as seen in the open air, allowing for the effect of dazzling light, wind, rain etc; on the painter's vision.'[2] One might also add, that the vast level surfaces of

L

sea, corn or meadow that McTaggart selected as fields for the study of these atmospheric vibrations, themselves contribute to the sensation the spectator experiences of being in a boundless continuum that extends away in all directions without heed to one point perspective or the rectangular window of the framed canvas. McTaggart conveys the curious sensation of having painted what lay beside, as well as in front of him. He himself declared that the artist should go out into the

storm to paint as well as the sunshine, and one of his watercolours, spotted by the raindrops that were splashing onto the paper while he worked, bears witness to a scrupulous following of his own advice.

McTaggart did not, however, leave the compositional structure of his outdoors pictures to the mercy of chance and the weather. Light areas, dark areas and general effect were determined in advance, and the plan adhered to, no matter what the sun or clouds

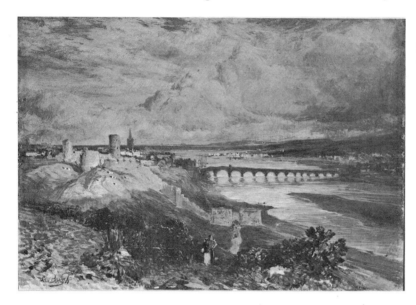

Fig 141
SAMUEL BOUGH
Berwick-on-Tweed
no. 12.7

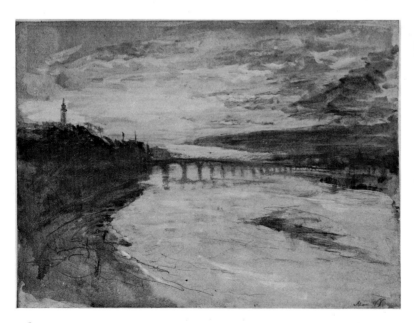

Fig 142
JOHN MacWHIRTER
Berwick-on-Tweed

might provide in the way of startling alterations. The placing, too, of the human figures was predetermined. Sketchy and careless as these sometimes appear, wispy transparent ghosts whose lineaments are little more than confusions amongst the grass and rocks, it would be a great mistake to assume that McTaggart was a bad figure painter or that he really could not be bothered with the trouble involved in painting people adequately. Nothing could be further from the truth. His figures, very often and significantly the figures of children, do not visit the landscape, or admire the view. They participate in it without conscious thought or intention, often rolling, or lying stretched along the ground, sharing the movement of wind and sunlight with trees and grass. The precise placing of a figure was of crucial importance. 'It was customary for him after having made up his mind that certain figures were to form part of his picture, and he had fixed the places they were to occupy, to leave a part of the white paper untouched for their reception.'[3] The scribbled careless handling was deliberate policy 'as he liked suggestions of things in preference to whole representations',[4] wrote T S Robertson, drawing on memories of working beside McTaggart. 'The eye and the heart feel the presence of his figures without dwelling on them', remarked Mc'Omish Dott, who had visited McTaggart in his studio while he was painting 'Newhaven fisher models into a "Storm".' After a week's work from the models, no great difference could be seen in the picture. His difficulty lay not in a realistic rendering of the models as they stood in the studio, but in placing them under the true effect of wind and rain...for many years his practice has been to paint a very small sketch from his larger pictures, then to insert into this sketch his figures (carefully designed from living models); afterwards he transfers these figures to his large canvas with certainty of placing and spontaneity of touch.'[5] This roundabout and complicated procedure would certainly not have been followed had McTaggart regarded his figures as inessential staffage. The division of the picture into landscape and figure, each painted from life, the first outside, the second in the studio, and each treated as a separate problem, was McTaggart's inheritance from Millais and the pre-Raphaelites but the small sketch seems to have been his own invented method of joining these necessarily disparate elements into a united whole.

Wingate stands somewhere between McTaggart with his adventurous, unprecedented uses of paint, and the already mentioned academics, Graham, MacWhirter and Farquharson, with their machinery of terror, destruction and gloom. Wingate developed from a meticulous pre-Raphaelite into an impressionistic sketcher of misty dawns and sunsets, but on the way he stepped momentarily into MacWhirter's tracks, and his Diploma picture, *The Wreck of the Wood* (1885) is a greyer and rather more subdued exposition of MacWhirter's conception of devastated woodland in *The Track of the Hurricane*, exhibited at the RA the same year (now in the Forbes Magazine Collection). MacWhirter's belief that a young artist should 'study the *moods* of Nature' and that his picture must 'be a *moment of the day*, and should suggest peace or unrest, quiet or storm, joy or sadness, glory or gloom'[6] shows that he pursued the transitory effects in which McTaggart also was interested, not as ends in themselves, but as a symbolic language reflecting human states of mind. His trees, which Spielmann with some justice accused him of humanising as Landseer had humanised dogs, do indeed seem to represent in *The Track of the Hurricane* victims of an almost human carnage. They become the objects in the landscape with which the observer can most easily identify himself, whereas water, in its various states, running or at rest, expresses the forces or emotions to which humanity is subjected, ranging from the destructive fury of a river in spate to the elegiac sadness and alienation characteristic of Millais' *Chill October*. Peter Graham's horrific *Spate* is amongst the earliest pictures of rivers in fury, initiating a trend that Ruskin was later to deplore, but was powerless to deflect or control. 'What makes nearly all the painters this year choose to paint their streams in a rage, and foul with flood, instead of in their beauty and constant beneficence?'[7] he querulously

demanded in 1875, but the raging continued unabated.

Although a contemporary of MacWhirter's claimed that Scotland would always find fresh artistic interpreters, and that MacWhirter was teaching the public a new appreciation of Highland beauty, he appears now rather as the expressionist exploiter of a language in its last extremes of decadence. In one of his two essays on *Sir Walter Scott's Country* (*Art Journal* 1887) he traced the course of the river Tweed

ings one has the impression of looking at meditations or commentaries upon earlier artists' feelings and conceptions, here, at a mistier and sadder Turner, the lees of a melancholy and decaying romanticism.

Berwick gains a kind of honorary place in an exhibition of Scottish landscape by virtue of its position at the mouth of the Tweed. 'One must not say of Berwick that it is either England or Scotland' wrote MacWhirter cautiously, but his pursuit of the Tweed in-

Fig 143
GEORGE REID
Tweedsmuir
no. 12.10

out to Berwick, and described a view of the town and bridges looking upstream where 'the hills making a brown or purple background to the whole, compose admirably together,' but in his watercolour of Berwick he discarded this view and took instead that chosen by Turner for his vignettes to Scott's *Poetical Works*. As in so many of MacWhirter's paint-

evitably carried him to Berwick as, three years earlier it had carried George Reid in his illustrated book, *The River Tweed from its source to the sea*. The river book, from source to sea, with historical, poetical, and descriptive notes appended to each plate, was a publication as characteristic of the end of the nineteenth century as the set of loch and mountain beauties had been of the middle century, or the illustrated Scottish tour of the late eighteenth. This type of book spanned the great gap between the remote pastoral regions

where the rivers sprang and the cities where they joined the sea. The journey downstream could become, for the artist, a way of travelling in time, from remote past to immediate present. The empty spaces round the source were succeeded by medieval towers, small towns, eighteenth century bridges, and, at last, by factory chimneys, railway bridges and soot laden smoke. In this gradual transition the Scottish river books of George Reid, and the Clyde set etchings of D Y Cameron, differ from Whistler's Thames set etchings, which are a group, not a series, though Whistler's etchings undoubtedly influenced those of Cameron. The river book was designed more for the resident in or lover of a particular region than for the ordinary tourist. It cut a cross section through the countryside as if through the trunk of an old tree, exposing its character from the inner heart to the outer rind, whereas a tourist's normal route is a loop that crosses rivers as often as it follows

Fig 144
DAVID YOUNG CAMERON
The Waning Light
no. 12.18

Fig 145
TOM SCOTT
Salmon leistering on the River Tweed
no. 12.6

them. The various river books convey the impression of a land still, at its core, solidly pastoral and agricultural, a country littered with historical debris, smudged only at its outermost rim by industry. Only there, on the perimeter, in the ports of Dundee or Glasgow, was the artist confronted by a new man made landscape, a horizon of smoke and metal, for which no aesthetic provision had been made. The cityscape of Glasgow was as strange to the painter of mountain pastorals as the bar-ren mountains had seemed to the eighteenth century English and Lowland visitors. Sam Bough was almost unique in occasionally attempting to treat Glasgow as if it were an organic landscape, but his undated view of Newark Castle at Port Glasgow, with its unexpected juxtaposition of the ancient tower and the modern railway engine, is an echo of Turner's *Rain, Steam and Speed*, rather than an original thought.

In his poem, *Glasgow*, Alexander Smith

Fig 146
MUIRHEAD BONE
Glasgow Cross, relaying tramway lines at night
no. 12.24

had, by setting against each other the irreconcilable images of pastoral and industrial landscape, begun the task of creating an urban industrial aesthetic.

'Ne'er by the rivulets I strayed,
And ne'er upon my childhood weighed
The silence of the glens.
Instead of shores where ocean beats
I hear the ebb and flow of streets.
 . . .
O fair the woods on summer days,
While a blue hyacinthine haze
Is dreaming round the roots!
In thee O City I discern
Another beauty, sad and stern.'

The succeeding stanza of this poem, evoking the 'other' beauty, was quoted on the title page of *Glasgow in 1901*, a small book on the city in the year of the international exhibition, illustrated with reproductions of drawings by Muirhead Bone. In the central section of this book, an urban aesthetic—inspired partly, it may be, by Smith's poem, but ringing with faint echoes of Baudelaire and very loud ones of Whistler's *Ten O'Clock Lecture*—struggles for voice, but struggles with some difficulty, since the quintessential Scotland, the pursuit of which had played so large a part in nineteenth century landscape painting, had always been held to be something quite different.

The name of the supposed author of this book is a fiction, covering the identities of three people, A H Charteris, James Bone, and Muirhead Bone, and it seems likely that chapter dealing with the pictorial potential lying unrealised in 'the great paysage intime of Glasgow', was written either by Muirhead or by James Bone under the influence of his brother's ideas, and that it constitutes a fairly correct statement of Muirhead Bone's artistic theory at that moment,[8] matching the various casual remarks about painting that Bone let fall at one time or another, and also the drawings of Glasgow that he was making at the turn of the century. 'Though the face of Glasgow does not yet glance at us from the walls of our picture galleries, still the austerity, the seriousness of great art is in her very marrow' we are told by *Glasgow in 1901*—a statement that corresponds with

Bone's complaint, that the Glasgow School did not paint Glasgow,[9] and his belief that the sentiment of the Glasgow streets was like that of Van der Heyden, Ruysdael, and Meryon. The harshness and austerity of this new, man made landscape seems, as it is described, to have a surprising resemblance to the grim Highland landscape from which men like Farington had recoiled a century earlier. In the suburbs of Glasgow, 'We are far from picturesqueness here, and the feeling provoked by that bare distant waste (Sighthill), peopled by the graves of a hundred thousand, belongs, perhaps, to the chastened pleasures whose cadence is music only to a Scot.'—'The very bleakness of the treeless waste one tramps over seems to hold something full of meaning.'— 'In the bare flats around there is something of melancholy grandeur; one apprehends at every turn a naked significant beauty stripped of embellishment.' How close this is to Scott's outcry, 'I like the very nakedness of the land; it has something bold, and stern, and solitary about it.' The emotion is the same; only the objects that summon it have been changed, and Muirhead Bone drew the sinister chimneys, the hospital, poor house, and prison of Glasgow with the same romantic fervour Thomson of Duddingston had formerly applied to the now devalued symbols, Fast Castle, and the Cuillins at Coruisk.

The other point that strikes one about the industrial aesthetic of *Glasgow in 1901* is its rarefied and limited appeal. To artists the writer claims, 'the very smoke from a chimney is "colour", and the dingy masonry, viewed through the envelope of smoke haze, has a "bloom" added to its tones whose quaint nuances yield a singular satisfaction to the eyes. Thus they have learnt to suck pleasure from the dark, bleak close of winter afternoons, when the rain holds off and the sun dies in a sky as colourless as water, for then the monochrome of houses and square sinks to a low velvety blackness, as of etching-ink or of the black habit in a Velasquez, that by its exquisite "sureness", flatters and surprises their modern sensitiveness to the charm of values. But the beauty of the black-and-white of the dull days is of a reticent kind that appears only to the trained eye. The man in

Fig 147
MUIRHEAD BONE
Blochairn Church
no. 12.26

162

Fig 148
MUIRHEAD BONE
Stockwell Bridge and the Gorbals
no. 12.25

Fig 149
JOHN Q PRINGLE
Muslin Street, Bridgeton
no. 12.27

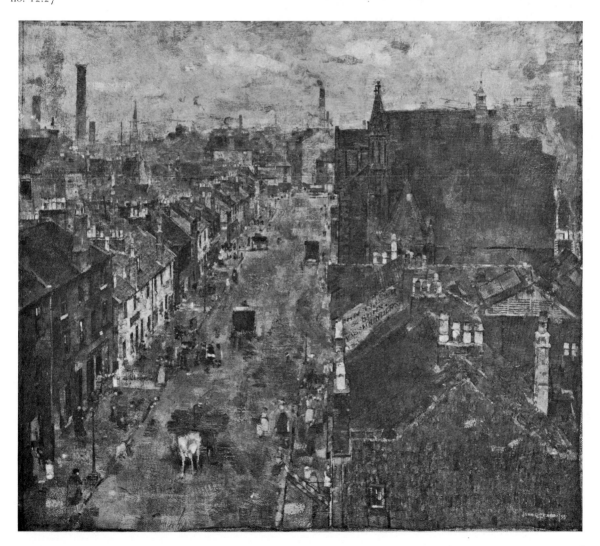

the street has a simpler faith. Nothing looks "fine" save on a "fine day"'.

It seems inconceivable that Muirhead Bone and Pringle should have shared classes at Glasgow College of Art, and have discussed painting—as we know they did—without exchanging any views on a topic close to both their hearts, the problem of representing contemporary Glasgow. But Bone, who recollected Pringle primarily as a miniaturist, seems to have been unaware of the other side to his art. 'It was a solitary occupation to draw Glasgow streets in those days' Bone wrote of his student years.[10] His attitude towards the city shows a combination of romantic intensity with a journalist's flair for the dramatic and the unexpected—but little apprehension of the beautifully ordinary. By contrast, Pringle's intricate, delicate, and loving portraits of squalid closes, back yards, and mean streets, as seen in his *Muslin Street* of 1896-6, possess precisely the quality that Bone's brilliant drawings lack. *Muslin Street* is really a piece of the 'paysage intime' evoked by *Glasgow in 1901*, a resident's daily view, not a tourist's, predating by a surprising number of years the Camden Town Group's paintings of London that are its nearest English equivalents. It comes as a shock to remember that McTaggart's *Harvest at Broomieknowe* and Pringle's *Muslin Street* were completed in the same year. Here are two pictures of mutually exclusive worlds, the one showing the 'green places where birds sang and children picnicked', the other the 'moving foot of the great city' that the author of *Glasgow in 1901* saw laying the green places waste. Yet these two pictures have something in common apart from the experimental spirit controlling their brushwork. Neither shows the face Scotland turns outwards to the tourist or summer visitor. The scenic and cultural strangeness that had drawn Sandby, Turner, Landseer and Millais to paint images of Scotland, no longer attracted foreign artists of this calibre. The annual crowd of visitors did not fail, but with the waning of the romantic movement, tourism and serious art had ceased to run together, and, for better or worse, Scotland was left to her own painters. It was the quality of intimacy or inwardness that

James Bone selected to dwell on when writing to James Caw about McTaggart:

'It's queer, isn't it? to think of a great Scot who never touched the Industrial Scotland, yet never touched the Tourist Scotland. He leaves Scotland to posterity still as a legend and an idyll, although he saw the twentieth century.... I think as years go on he will be hailed more and more as the still small voice of the uncontaminated Scots country; lyrics of the joys, not of the holidays in the country, but of the people who live there.'[11]

(1) From the transcript of an ms letter to John Leech, dated 13 June 1854. In 1969 the original ms of this letter was with the Sanders Gallery, Oxford.

(2) P M'Omish Dott *Notes technical and explanatory on the art of Mr William M'Taggart as displayed in his Exhibition of Thirty-two Pictures* 1901.

(3) Ms letter of 9 February 1915, written to James Caw by T S Robertson (in the National Gallery of Scotland).

(4) Ibid.

(5) See note 2, above.

(6) *Christmas Art Annual* 1903, p 7.

(7) John Ruskin *Academy Notes*, reprinted in the *Library Edition* of the works of Ruskin by Cook and Wedderburn, vol xiv, p 305. The painting criticised was 'The Head of a Highland Glen.'

(8) 'I was also busy illustrating, and partly writing...a book on Glasgow—"Glasgow in 1901"'. Muirhead Bone *From Glasgow to London, Art Work* Autumn 1929, p 156.

(9) Ibid, p 146.

(10) Ibid, p 151.

(11) This letter, was quoted by Caw in an article on McTaggart in *The Scotsman* 15 October 1935. No date for James Bone's letter was given.

PETER GRAHAM 1836–1921

12.1 **A Spate in the Highlands** fig 137

Oil on canvas. 120.0 × 176.8 cm

Signed: *P. Graham 1866*

Lent by Manchester City Art Galleries

JOHN EVERETT MILLAIS

12.2 **Chill October** fig 138

Oil on canvas. 141.0 × 186.7 cm

Signed in monogram and dated: *JM 1870*

This view was painted, according to a note by the artist on the back, from a backwater of the Tay below Kinfauns near Perth. It was painted direct from nature on a platform constructed by the artist for this purpose

Lent anonymously

JAMES LAWTON WINGATE 1846–1924

12.3 **The Wreck of the Wood**

Oil on canvas. 107.0 × 76.7 cm

Signed and dated: *Wingate 1885*

This is Wingate's Diploma work

Lent by the Royal Scottish Academy

JOSEPH FARQUHARSON 1846–1935

12.4 **A Winter Morning** fig 139

Oil on canvas. 81.2 × 121.3 cm

Signed and dated: *J. Farquharson 1901*

Lent by Manchester City Art Galleries

WILLIAM McTAGGART 1835–1910

12.5 **The Storm** fig 140

Oil on canvas. 121.9 × 183.0 cm

Signed and dated: *W. McTaggart 1890*

This was painted in the studio from a smaller version painted out of doors at Carradale in 1883 and now in Kirkcaldy Art Gallery. Another small version dated 1890 is in the Orchar Gallery, Broughty Ferry

National Gallery of Scotland

WILLIAM McTAGGART

12.6 **Harvest Moon Broomieknowe** pl xi

Oil on panel. 17.4 × 25.2 cm

National Gallery of Scotland

SAMUEL BOUGH 1822–1878

12.7 **Berwick-on-Tweed** fig 141

Oil on canvas

Signed: *Sam Bough*

Inscribed on the back: *Berwick-on-Tweed, from a sketch made in 1837, by Sam Bough/painted for J. C. Bell Esq./1863*

This view, from the North bank of the Tweed, closely resembles Turner's vignette of Berwick engraved for Scott's *Poetical Works* 1833–34

National Gallery of Scotland

JOHN MacWHIRTER 1839–1911

12.8 **Berwick-on-Tweed** fig 142

Pencil and body colour on grey paper. 25.3 × 35.6 cm

Signed: *MacW*

MacWhirter exhibited a painting of Berwick at the RSA watercolour exhibition of 1887

National Gallery of Scotland

GEORGE REID 1831–1914

12.9 **The Source of the Tweed (Tweed's Well)**

Pen and black ink. 20 × 15 cm (approximate size of area covered by drawing)

Signed: *R*

Reproduced in heliogravure in *The River Tweed* (1884)

National Gallery of Scotland

GEORGE REID

12.10 **Tweedsmuir** fig 143

Pen and black ink. 16.0 × 23.5 cm (approximate size of area covered by drawing)

Signed: *R*

Reproduced in heliogravure in *The River Tweed* (1884)

National Gallery of Scotland

GEORGE REID

12.11 **Ashesteil**

Pen and black ink. 15.4 × 24.0 cm (approximate size of area covered by drawing)

Signed: *R*

Reproduced in heliogravure in *The River Tweed* (1884). Ashesteil was for a short period the home of Sir Walter Scott

National Gallery of Scotland

After GEORGE REID

12.12 **Berwick**

Heliograph

After a pen drawing by Reid reproduced as the final plate in *The River Tweed from its source to the sea* published by The Royal Association for the Promotion of the Fine Arts in Scotland (1884)

National Gallery of Scotland

After GEORGE REID

12.13 **Dalmarnock bridge**

Heliograph

After a pen drawing by Reid reproduced in *The River Clyde, twelve drawings by George Reid* published by The Royal Association for the Promotion of the Fine Arts in Scotland (1886)

National Gallery of Scotland

After ROBERT BUCHAN NISBET 1857–1942

12.14 **Dundee near Tayport**

Photogravure

After a painting by Nisbet, reproduced as the final plate in *Illustrations of the scenery of the River Tay* (1891)

National Gallery of Scotland

After JAMES PATERSON 1854–1932
12.15 **The Nith in Holywood**
Photogravure
After the painting by Paterson reproduced in *Nithsdale* (1893)
Lent by the Trustees of the National Library of Scotland

TOM SCOTT 1854–1927
12.16 **Salmon leistering on the River Tweed** fig 145
Watercolour. 76 × 127 cm
Signed: *T. Scott '95*
Lent anonymously

DAVID WATERSON 1870–1954
12.17 **The North Esk near Brechin, Angus**
Watercolour heightened with body colour. 53.5 × 76.7 cm (sight size)
Signed: *David Waterson*
Waterson, an etcher and mezzotinter, was a native of Brechin and made many studies of the North Esk
Lent anonymously

DAVID YOUNG CAMERON 1865–1945
12.18 **The Waning Light** pl xii fig 144
Watercolour and body colour on pasteboard. 54.3 × 76.7 cm
Signed: *D. Y. Cameron*
Probably painted circa 1806–07
Scottish National Gallery of Modern Art

DAVID YOUNG CAMERON
12.19 **Elcho on the Tay**
Etching. 26.7 × 35.2 cm
Signed: *DYC*
Dated by Rinder 1900 (*D. Y. Cameron an illustrated catalogue of his etched work* 1912)
Lent by Aberdeen City Art Gallery and Museums

DAVID YOUNG CAMERON
12.20 **Evening on the Garry**
Etching and dry-point, third state of five. 10.0 × 15.2 cm
Signed: *DYC*
Dated by Rinder 1906
Lent by Aberdeen City Art Gallery and Museums

DAVID YOUNG CAMERON
12.21 **Afterglow on the Findhorn**
Etching and dry-point, second state of two. 22.9 × 22.8 cm
Dated by Rinder 1907
Lent by Aberdeen City Art Gallery and Museums

SAMUEL BOUGH
12.22 **Port Glasgow with Newark Castle and the Clyde**
Watercolour heightened with body colour on buff paper. 30.0 × 45.8 cm (sight size)
Lent anonymously

After MUIRHEAD BONE 1876–1953
12.23 **Old Houses off the Dry Gate, Glasgow**
Reproduced in *The Yellow Book* (Vol. XIII, April 1897)
Lent by the Trustees of the National Library of Scotland

MUIRHEAD BONE
12.24 **Glasgow Cross, relaying tramway lines at night** fig 146
Pencil. 24.4 × 36.0 (sight size)
Signed: *Muirhead Bone*
Reproduced in *Glasgow fifty drawings by Muirhead Bone* (1911)
Lent anonymously

MUIRHEAD BONE
12.25 **Stockwell Bridge and the Gorbals** fig 148
White, yellow and black pastel on buff paper. 25.0 × 37.8 cm
Signed in pencil: *Muirhead Bone*
Reproduced in *Glasgow fifty drawings by Muirhead Bone* (1911)
Lent anonymously

MUIRHEAD BONE
12.26 **Blochairn Church** fig 147
Pen and black ink, chalk and wash. 15.1 × 12.3 cm
Signed: *M. Bone*
Reproduced in *Glasgow fifty drawings by Muirhead Bone* (1911)
Lent anonymously

JOHN Q PRINGLE 1864–1925
12.27 **Muslin Street, Bridgeton** fig 149
Oil on canvas. 35.5 × 40.6 cm
Signed and dated: *John Q. Pringle 93*
In the catalogue of the *Pringle Centenary Exhibition* (Glasgow City Art Gallery and Museum 1964) it was explained that the date of 1893, hurriedly appended to the picture in 1922, was a mistake, and that a more likely dating was 1895–6
Lent by the City of Edinburgh Art Centre

List of Lenders

Her Majesty The Queen · 9.7, 9.9

His Grace The Duke of Atholl · 1.22, 6.31
His Grace The Duke of Buccleuch and
 Queensberry · 7.1, 7.2, 7.3, 7.9, 7.10, 8.14
His Grace The Duke of Hamilton · 3.2, 3.3
The Rt Hon The Earl of Mar and Kellie · 1.16
The Rt Hon The Earl of Wemyss and March · 6.29
Sir John Clerk of Penicuik Bt · 4.22, 6.23, 6.24, 6.25, 6.33
The Hon Sir Steven Runciman · 6.14, 6.34
Keith Adam Esq · 1.2
Brinsley Ford Esq · 6.16
Paul Harris Esq · 1.19
Colin Kilpatrick Esq · 11.14
Andrew McIntosh Patrick Esq · 11.12
Daniel Shackleton Esq · 10.25
The Trustees of the late Mrs Magdalene
 Sharpe-Erskine · 6.26, 6.27
Several private owners who wish to remain
 anonymous

Aberdeen City Art Gallery & Museums · 10.19, 12.19, 12.20, 12.21
The Ruskin Gallery, Bembridge, Isle of
 Wight · 9.13
The Fitzwilliam Museum, Cambridge · 1.28, 5.4, 8.2
Edinburgh University Library · 3.11
City of Edinburgh Art Centre · 12.27
National Library of Scotland, Edinburgh · 4.8, 4.40, 4.42, 8.8, 8.10, 8.12, 8.16, 9.12, 9.21, 10.3, 10.10, 10.11, 12.15, 12.23

National Museum of Antiquities of Scotland,
 Edinburgh · 2.5, 6.12
The New Club, Edinburgh · 9.22
Royal Commission on the Ancient &
 Historical Monuments of Scotland,
 Edinburgh · 5.2, 7.11
The Royal Scottish Academy, Edinburgh · 7.7, 9.2, 11.2, 11.8, 11.9, 12.3
The Scottish National Gallery of Modern
 Art, Edinburgh · 11.15, 12.18

The Scottish National Portrait Gallery, Edinburgh	1.1, 2.2, 4.3, 7.6, 7.21, 10.4, 10.5, 10.6
The Scottish Record Office, Edinburgh	2.1
Glasgow Art Gallery and Museum	9.17, 9.19, 10.14, 10.16, 10.17, 11.22
Baillie's Library, Glasgow	1.17, 1.18
The Hunterian Museum and Art Gallery, Glasgow	6.32
Broughton House, Kirkcudbright	11.14
The Walker Art Gallery, Liverpool	1.26, 5.10, 7.15
The British Library, London	4.1, 4.2, 4.7, 4.9, 4.10, 4.13, 4.21, 6.5, 6.6, 6.11, 6.28
The British Museum, London	4.11, 4.17, 4.20, 4.36, 4.39, 7.14
John Dewar & Sons, London	9.4
The Fine Art Society, London and Edinburgh	7.19
Somerville and Simpson Limited, London	4.27, 4.28
The Tate Gallery, London	5.5, 9.3
The Victoria & Albert Museum, London	7.16
Manchester City Art Gallery	12.1, 12.4
The Laing Art Gallery, Newcastle-upon-Tyne	5.9
The Ashmolean Museum, Oxford	1.5, 1.25, 5.7, 5.8, 8.6, 10.2, 10.7
Paisley Museum and Art Gallery	9.10, 11.7
Perth Museum and Art Gallery	9.14, 11.1

We wish to thank all those lenders who have given us permission to reproduce their paintings in this catalogue.

168

Topographical Index

Abbotsford, Roxburghshire	8.9a, 8.9e, 8.9d, 8.10
Aberdeen	1.6, 1.27
Aberfeldy, Perthshire	4.4
Alloa, Clackmannan	1.16
Altrive Glen, Selkirkshire	8.17
Arran	10.14
Ashestiel, Selkirkshire	12.11
Auchencass Castle, Dumfriesshire	6.8
Loch Avon, Banffshire	9.3
Balmoral, Aberdeenshire	9.7
Banff	1.19, 6.4
Barr, Ayrshire	11.6
Bass Rock, East Lothian	1.10
Ben Nevis, Inverness-shire	9.11
Berwick upon Tweed, Northumberland	12.7, 12.8, 12.12
Blackness Castle, West Lothian	1.11, 4.45
Blair Atholl, Perthshire	1.22
Bonar Bridge, Sutherland	9.1
Bothwell Castle, Lanarkshire	1.12, 4.31, 4.32, 4.33, 4.34, 4.35
Brechin, Angus	12.17
Broomieknowe, Midlothian	11.21, 12.6
Cairn Lochan, Angus	9.8
Carlops, Peebleshire	7.22, 7.23, 7.24, 7.25
Carradale, Argyll	12.5
Carrol, Sutherland	6.15
Carsewell, Midlothian	1.15
The Clyde	5.1, 5.2, 5.3, 5.4, 5.5, 5.6, 5.7, 5.8, 5.9, 5.10, 12.13, 12.22, 12.23
Cockburnspath, Berwickshire	11.13, 11.16, 11.17, 11.18
Corrieyairack Pass, Inverness-shire	4.3
Loch Coruisk, Skye	9.20, 9.21, 9.23
Cuillin Hills, Skye	9.20, 9.21, 9.22, 9.23, 10.7
Dalhousie Castle, Midlothian	7.4
Dalkeith, Midlothian	7.1, 7.2, 7.3
Dalquharran, Ayrshire	6.7
Drumlanrig, Dumfriesshire	4.20, 4.21

Duart Castle, Mull 4.6, 4.7, 4.8, 4.43, 4.44
Dumbarton Castle, Dunbartonshire 1.4, 1.25
Dundee, Angus 12.14
Dunfermline, Fife 1.14
Dunkeld, Perthshire 6.31, 6.33
Dunsinane Hill, Perthshire 6.12
Dunstaffnage Castle, Argyll 4.47

Edinburgh 1.7, 1.13, 1.28, 3.8, 4.11, 4.12, 4.13, 4.17c, 4.18, 4.19, 4.36, 4.46, 6.10, 6.11, 7.5, 7.18
Eildon Hills 8.2, 8.4, 8.6, 8.11
Elderslie, Renfrewshire 6.1
Enoch, Dumfriesshire 4.27, 4.28

Falkland, Fife 1.1
Fast Castle, Berwickshire 8.15, 8.16
The Findhorn 12.21
Fort George, Inverness-shire 4.10

The Garry 12.20
Gartcosh, Lanarkshire 11.15
Gatehouse of Fleet, Kirkcudbrightshire 11.4
Glasgow 1.24, 12.23, 12.24, 12.25, 12.26, 12.27
Glencoe, Argyll 9.17, 9.18, 9.19
Glen Finlas, Dunbartonshire 10.1, 10.2, 10.3
Glen Fruin, Dunbartonshire 10.8
Grey Mare's Tail, Dumfriesshire 8.1

Haddington, East Lothian 4.30
Hamilton, Lanarkshire 1.5, 4.39, 4.40, 4.41
Hawthornden, Midlothian 7.10, 7.16, 7.17, 7.21
Huntly Burn 8.9c

Inchmahome Priory, Perthshire 4.42
Inveraray, Argyll 4.23, 4.24
Inverlochy Castle, Inverness-shire 9.11
Iona 10.27

Loch Katrine, Perthshire 9.12, 9.13, 9.14, 9.15, 9.16a, 9.16b

Kilarow, Islay 6.5
Killiecrankie, Perthshire 9.2
Kinloch Rannoch, Perthshire 4.1, 4.2

Leith, Midlothian 1.23, 4.14
Linlithgow, West Lothian 7.15
Littledean Tower, Roxburghshire 8.4, 8.6
Loch Lomond, Stirling and Dunbartonshire 1.26
Loch Lubnaig, Perthshire 6.24

Melrose, Roxburghshire 6.9, 8.3, 8.5, 8.7, 8.8, 8.9b, 8.9f
Castle Menzies, Perthshire 4.25
Moffat, Dumfriesshire 6.26, 6.27
Moniaive, Dumfriesshire 11.3
Moray Firth 4.9
Musselburgh, Midlothian 1.2, 1.3
Muthill, Perthshire 11.5

Newark Castle, Selkirkshire 8.14
The Nith 12.15

Paisley, Renfrewshire 1.17, 11.7
Pencaitland, East Lothian 11.8, 11.9
Penkill Castle, Ayrshire 10.25, 10.26
Perth 1.20, 6.14
Port Glasgow, Renfrewshire 1.18

Roslin, Midlothian 6.28, 6.29, 6.30, 7.6, 7.7, 7.9, 7.11, 7.12, 7.13,
 7.14, 7.19, 7.20
Rothiemay House, Banffshire 1.21

Selkirk 11.2
Springfield, Midlothian 7.8
Castle Stalker, Argyll 6.23
Stenness, Orkney 6.6

Tantallon Castle, East Lothian 4.29
East Loch Tarbert, Argyll 6.2
The Tarff 9.9

Loch Tay, Perthshire 2.2, 2.6
The Tay 6.33, 6.34, 12.2, 12.14, 12.19
Taymouth, Perthshire 2.1, 2.2, 2.3, 2.4, 2.5, 2.7
Tioram Castle, Inverness-shire 4.8
The Tweed 8.2, 8.3, 8.4, 8.6, 8.7, 8.8, 8.9b, 8.9f, 8.11, 8.12, 8.13, 12.7, 12.8, 12.9, 12.10, 12.11, 12.16

Yarrow Water 10.15

Printed in Scotland for Her Majesty's Stationery Office by Bell & Bain Ltd, Glasgow Dd. 591290 53-2104